D0875475

ESSAYS IN ART AND CULTURE

Figuring Jasper Johns

Fred Orton

Harvard University Press

Cambridge, Massachusetts 1994

for Miranda, Daisy and Emmylou

N
6537
.J6
O78
1994

First published in the United States of America in 1994
by Harvard University Press, Cambridge, Massachusetts

Published in Great Britain in 1994 by Reaktion Books, London

Printed in Great Britain

This book is printed on 130gsm Fineblade Smooth, an acid-free
stock made from 100 per cent chemical woodpulp, and its materials
have been chosen for strength and durability.

Library of Congress Cataloging-in-Publication Data
Orton, Fred.
 Figuring Jasper Johns / Fred Orton.
 p. (Essays in art and culture)
 Includes bibliographical references.
 ISBN 0–674–30117–X
 1. Johns, Jasper, 1930– —Criticism and interpretation.
2. Johns, Jasper, 1930– —Philosophy. 3. Deconstruction.
I. Title. II. Series.
N6537.J6078 1994
709'.2—dc20 94-12431
 CIP

30516619

Contents

Acknowledgements

In writing this book I was helped by more people than it is possible to name. I owe a debt to Charles Harrison who was there when I started to write it and with whom some of it was written. Among the many people who guided me along the way, gave me information, argued points, corrected errors or whatever, were Michael Baldwin, Mike Belshaw, Lynette M.F. Bosch, T.J. Clark, James Cuno, Richard Francis, Francis Frascina, Beth Houghton, Tom Holert, Michael Ann Holly, Margaret Iversen, Jill Johnston, Nick Levinson, Keith Moxey, Michael Podro, Mel Ramsden, Vivien Rehberg, Rachel Rosenthal, Susan Siegfried, Richard Shiff, Hugh J. Silverman, Lisa Tickner, Ann Wagner and Paul Wood. The graduate students at the University of Leeds, 1989–90, who studied *Flag* with me and those at the University of California, Los Angeles, who worked on allegory in AH253, 1992, are thanked for the quality of their conversation and scholarship. Finally, I want to acknowledge J.R.R. Christie and Alex Potts, who read and talked me through the whole book – I am immensely grateful to them.

Beginnings

. . . for who himself beginning knew? John Milton,
Paradise Lost[1]

*One of the crucial problems in art is the business of 'meaning it'.
If you are a painter, meaning the paintings you make; if you are
an observer, meaning what you see. It is very difficult for us to
mean what we say or do. We would like to, but society makes
this very hard for us to succeed in doing.*
Jasper Johns to Joseph E. Young, 1969[2]

I remember it was in October 1963 that I saw 'The Popular
Image' at the Institute of Contemporary Arts in Dover Street,
London. This was a small exhibition that the ICA with the
Ileana Sonnabend Gallery, Paris, had organized of works by
artists associated – then as now – with Pop Art. Jasper Johns
was represented by *Flag above White*, *Flag on Orange Field* and
Figures. I still have the flimsy catalogue; my annotations are
there to remind me of my reactions to *Flag above White*. (These
were not the first of Johns's pictures to be seen in London: in
March 1963 *Grey Rectangles*, *False Start* and *Reconstruction* were
shown in 'Vanguard American Painting' at the American
Embassy; but I knew nothing about Johns then, or the
American Embassy.) In April 1964 I went to the large survey
show '1954–1964: Painting and Sculpture of a Decade' held at
the Tate Gallery, where I saw works by many of the artists I
had come across at the ICA. Johns was represented by four
pictures: *Flag*, *Target with Plaster Casts*, *Map*, and *Passage*.
There are annotations in my catalogue which indicate that
only *Map* seems not to have intrigued me. And then at the end
of the year I saw the 'Jasper Johns' retrospective that had
travelled from the Jewish Museum, New York, to London's
Whitechapel Gallery. I have kept the catalogue of that show
also. I remember on that trip to London I bought Leo
Steinberg's *Jasper Johns*, the Metro monograph only just
published by Wittenborn, and B.H. Friedman's *School of New
York: Some Younger Artists*, with its essay on 'Jasper Johns' by

Ben Heller. The Whitechapel Gallery catalogue remains free from annotation, a more or less pristine souvenir of my beginnings in modern art and Modernism, art history and criticism, and with seeing and understanding – as much as I did see and understand it then – the beginnings of 'Jasper Johns'.

The beginnings of this book can be located in my first year or so as a student at an art college in the English Midlands during 1963–4, in waking up to how far English art lagged behind the art that was being made in the USA, in reading about American art and travelling to London to see it whenever examples went on show there. Thirty years later, I'm still fascinated by and interested in Johns's work. I mention this at the outset by way of indicating that this book has not been written to generate another academically suitable 'Jasper Johns' to illustrate a preconceived thesis about Johns's art, but as a way of getting on terms with a body of work that matters to me, approaching it, and making sense of it in ways that seem relevant not only to it but to a lot of American-type painting of the 1950s to the present. That is a first beginning.

A second beginning can be located in the guest lecture I gave at the Open University 'Modern Art and Modernism' Summer School at Westfield College, University of London, in July 1983, which was reworked collaboratively and published the following year in the journal *Art History* as 'Jasper Johns: "Meaning What You See"'.[3] This work drew on lectures I had given over the years at the University of Leeds and was informed by a close involvement with the collective art practice of Art & Language, their paintings, conversation and writing.[4] In the pictures that Art & Language made in 1979 and in the early 1980s, each one a different *Portrait of V.I. Lenin in the Style of Jackson Pollock*, I glimpsed the way ambitious Modernist painting could work with surface-matter and sub-ject-matter, with abstraction and representation, not to priv-ilege the one over the other but to keep them in a dialectical tension where surface turned to subject and subject to surface and neither seemed to be quite what it was.[5] I took that way of seeing surface- and subject-matter into my work on Johns in the summer of 1983.

At the time I was fascinated by a series of paintings that Johns had produced in the mid-1970s, which were all primar-ily composed of crosshatchings: *Scent* (1973–4; illus. 14), *Corpse*

and Mirror (1974; Collection of Mrs Victor W. Ganz, *Corpse and Mirror II* (1974–5; illus. 64), *The Barber's Tree* (1975; Collection Ludwig, Aachen), *The Dutch Wives* (1975; Collection of the artist), and *Weeping Women* (1975; illus. 30), pictures that seemed to have their beginning in *Untitled*, 1972 (illus. 6), and a story Johns had told about seeing an eccentrically painted car on the freeway. Nowhere had Johns's concern with the self-sufficient surface been more apparent than in these cross-hatched paintings. *Scent*, for example, seemed positively High-Modernist in its insistence on the decorative and abstract qualities of pictorial art and its apparent assumption that these had to be located in an insistence on the flat surface. It seemed all vivid surface and no vivid subject. Yet many of those who had been concerned to explain it and its effect thought that there was more to it than met the eye; they thought that it had subject-matter, though they were hard pressed to say where or what it was. With Art & Language's way with the surface/subject opposition in mind and taking *Scent* and the other crosshatched paintings as a guide, I thought it might be possible to see and understand Johns's pictures as simultaneously indexical or descriptive subject-matter and decorative surface-matter, and vice versa. Art & Language's critical writings on realism, expressionism and expression claims were also important here in so far as they clarified what might be involved in inquiring into the conditions of production of Johns's pictures – or any pictures – and also into the conditions of production of statements about their expressive content and meaning.[6] Whatever the conditions of production of Johns's pictures, and whatever the conditions of production of claims for what they expressed or meant, it became clear that they would not be adequately explained by identifying what was depicted or described by them or by taking the artist's explanation as a reliable guide to what produced them and to what they meant. I had to establish the complex and mediated genetic relation between the pictures, understood as simultaneously surface and subject, what they might be seen and understood as referring to and what they were *of*.[7] The issue, then, was not what to look for, but *what to look at*, and *how* – with what disposition – *to look*.

A third beginning can be located between the end of 'Jasper Johns: "Meaning What You See"' and the publication in 1987

of my essay 'Present, the Scene of . . . Selves, the Occasion of . . . Ruses'.[8] What started as a study of the relation between Johns's *Foirades/Fizzles* etchings and *Untitled*, 1972, the painting from which they were derived, became a consideration of Johns's tendency to structure his pictures with parts that functioned as wholes and wholes that functioned as parts. My thinking here was informed by Roman Jakobson's writing on aphasia.[9] Jakobson identified two basic types of aphasic disturbance that he thought could be explained by the distinction, common in literary forms and genres, between metonymy, synecdoche and metaphor. Suffice it to say that for Jakobson, metonymy, synecdoche and metaphor constituted the opposing poles that structure virtually all operations of language. I was especially struck by Jakobson's claim that 'similarity connects a metaphorical term with the term for which it is substituted. Consequently, when constructing a meta language to interpret tropes, the researcher possesses more homogeneous means to handle metaphor, whereas metonymy, based on a different principle, easily defies interpretation.'[10] The connection between a metonym and the term it comes in place of is a contiguous one. The substitution is fortuitous, incidental, true-only-under-certain-conditions, with the result that a metonym is often difficult to interpret – more difficult than a metaphor. The distinctions between metaphor and metonymy and their effects seemed useful for explaining how Johns's surfaces were understood as metaphors or as metaphorically expressive even as they were felt to possess less obvious meanings or references. What Jakobson wrote about 'metonymical shifts . . . from wholes to parts' also seemed useful for thinking about Johns's way with wholes and parts.[11] It provided a convenient, schematic typology with which to approach the artist's work, and I started thinking about how any useful account of the possible meaning or effects of a picture had to relate its evident pictorial structure to structures of signification.

Working on the *Foirades/Fizzles* essay made me think about the subtleties of figuration. Jakobson pointed out that 'the study of the poetical tropes is directed chiefly toward metaphor'.[12] This is certainly the case with Modernist art, where, as with poetry, metaphor 'implies that special power of creative imagination to evoke a whole world of unified thought and feeling untouched by the crass contingencies of

everyday life'.[13] Moreover, 'it suggests a yet higher stage in the totalizing process, a moment of consummate or hypostatic union when the very difference between inward and outward realms would at last fall away, and imagination reign supreme through the gift of metaphorical insight'.[14] Metaphor and the idea of metaphor appeal to the 'aesthetically responsive' rather than the 'rhetorically aware' critic and historian.[15] Metaphor offers the line of least resistance. I began to plait and unplait metonymical chains. This was difficult to do. Sometimes it was impossible. Other times it didn't seem worth the effort. But it enabled a glimpse of how you might see and understand Johns's work – the way it used the Modernist surface/subject opposition, the way it seemed to have relatively public and relatively private meanings, the way its sensuous surface was structured with part-whole relations – as a visual language used figuratively in a selfconscious way. It also enabled a glimpse of what Johns's work could be seen and understood as *of*. The point is that you have to be both aesthetically responsive and rhetorically aware. You have to account for the sensuous fascination of the surface of the painting; but you also have to be suspicious. Not negatively suspicious. Rhetoric effects a hermeneutics of suspicion. And the hermeneutics of suspicion takes you to history. These are my concerns in 'Present, the Scene of My Selves, the Occasion of these Ruses', my first chapter.

Chapter Three, 'Figuring Jasper Johns', which focuses on and writes around *Painted Bronze* (1960; illus. 47), pursues further the concern with 'metonymical shifts' towards understanding Johns's work as structured by an extended trope that includes the functions of all the tropes. Another beginning. Beginnings are always only continuations. And the issue is still not what to look for but what to look at, and how. I have come to the conclusion that it is necessary to see and understand Johns's work as allegory. Several commentators have written about his work with reference to allegory, but to my mind only two or three have come close to explaining why and how it can be seen as allegorical or to characterizing what its effect and value is as allegory.[16] This is the work of 'Figuring Jasper Johns'. It is difficult work, which I have refused to make easier by conceptualizing and writing about allegory only as a matter of iconography and enigma, recognition and misrecognition, or as if it were equivalent to metaphor and analogy. To

have done so would have meant collapsing discussion of the complex and nuanced surfaces of Johns's pictures into quite traditional descriptions of how painting works or writing *allegoresis*. I have stayed as rigorously as possible with resources appropriated from that mode of literary criticism most concerned with the types and functions of figurative language convinced that the terms, concepts and points of view that are commonly and profitably used in the history, analysis and interpretation of literary works can be productively applied to the study of visual art. I found the various contemporary studies of allegory as a generic form very useful in this respect – especially those by Edwin Honig, Angus Fletcher and Maureen Quilligan.[17] The work of Paul de Man on the distinction between symbol and allegory understood not as two distinct orders of language but as two ways of making sense of figuration was crucial.[18] Following de Man's critical writing on the rhetoric of Romanticism, I write about Johns's work understood as allegory in relation to Modernist art conceived as equivalent to the Romantic symbol. The ideology of the aesthetic that supports the symbol is disrupted by allegory. No matter how or to what expense it is valorized, the illusion of the symbol always resolves into the material actuality of allegory.

It has not, however, been part of my project to argue any Post-Modernist character or value for Johns's practice as an allegorist. There is a discourse that argues for a break between Modernist or High-Modernist art – Abstract Expressionism and Colour-Field Painting, for example – seen and understood in terms of the symbol as autonomous, self-sufficient and transcendent, and so-called Post-Modernist art – the work of Laurie Anderson, Troy Brauntuch, Sherrie Levine, Robert Longo, Cindy Sherman, *et al.* – seen and understood in terms of allegory as contingent, insufficient and lacking in transcendence.[19] Though this argument is correct in the way it characterizes the qualities claimed for the symbol and the qualities possessed of allegory, it is flawed in the way it privileges Post-Modernism as characterized by 'a single, coherent [allegorical] impulse', and simultaneously acknowledges that, from its beginning, Modernism has been characterized by the same tendency.[20] Post-Modernist criticism, which writes the break between Modernism and Post-Modernism on the basis of this 'allegorical impulse', knows

that 'allegory is a structural possibility in every work', that 'modernism and postmodernism are *not* antithetical, that it is in theory alone that the allegorical has been repressed'.[21] In other words, the discourse that ratifies and values Post-Modernist art knows that all visual art has to be understood as troped and figured. It knows that Modernist and High-Modernist art is selfconsciously troped and figured to affect us as if it isn't, to affect us as symbol, and that Post-Modernist art is selfconsciously troped and figured to make us aware that it is, to affect us as allegory. Both symbol and allegory are alike as troped and figured forms and effects of language. There is no representation, no visual or verbal language, without a trace of allegory. The distinction between Modernist and Post-Modernist art should now be seen and understood as blurred. Why then does Post-Modernist criticism – which knows the distinction is blurred – want to hang on to it? It could be said that it merely rehearses the late eighteenth- and early nine-teenth-century argument about the relative value of symbol opposed to allegory, only reversing the valorization in favour of the latter. In other words, the distinction between the secularized symbol and allegory as the 'dark conceit' put against it is still actively in place effecting the same opposition in discourse. As for the distinction between the Modern and the Post-Modern as epochal descriptions, though the basic forces and relations that determine material existence and the forms of consciousness we make of it have changed, and continue to change, the presence of the symbol/allegory binary, unchanged in its meaning and value since the era of Romanticism, probably indicates that no finally distinctive break has yet occurred that might be represented in practical consciousness as Post-Modernism.[22] If this is not the case, and the Post-Modern is with us, then what is claimed to be its defining impulse in practical consciousness is a residue of the beginnings of the Modern. The symbol/allegory opposition still structures practical consciousness. And Modernism's structuring binary oppositions are still in place doing their work. The most that the best Post-Modernist criticism has been able to do, using the work of Jacques Derrida, is overturn some of the binaries that structure it and Modernist art.[23] But as Derrida has demonstrated, if one wants to try to move beyond the edge of metaphysics – Modernism or whatever – one has to do more than identify and overturn the binary

oppositions that operate within and on practical conscious-
ness. One is constrained to use the oppositions, and having
overturned them, prevent them from getting re-established.
This means making sure that an overturned opposition cannot
be reconstituted. One strategy for ensuring this, which Der-
rida developed, is to incorporate 'undecidables' in discourse –
undecidable, that is, in terms of the old opposition.[24] Derrida
makes them up. And sometimes he finds them already
effective in the texts he is studying. They can be found in
visual art also. For Derrida, *'différance'* is an important unde-
cidable: its very undecidability with regard to the 'difference'
and the 'deferred thing' that makes it is its meaning. And its
value in discourse is the way it marks and determines an
awareness that meaning is always an effect of the unpunctu-
ality within language that can never be made punctual, that
meaning is always an effect that can never be fixed.[25] *'Différ-
ance'* and allegory have much in common, especially in the
way they make clear the gap between signifier and signified,
in their resistance to aesthetic idealization, which relies on
belief in punctuality – and neither is determined, or overdeter-
mined, by conditions post-Modern or beyond Modernism. It
is here that some of Johns's work seen and understood as
'différance' and allegory has its value. I think that this is
certainly the meaning and value of *Flag* (1954–5; illus. 41). It is
a thoroughly undecidable object, but one that cannot be
placed in its circumstances of production and consumption,
circulation and exchange, beyond the resources of modern art
and Modernism. Rather, *Flag* tests them at, and to, their limits
– from within. This is the concern of chapter Two, 'A Different
Kind of Beginning', which is given over to writing the
aesthetics, rhetoric and history of *Flag*.

Finally, a brief comment on Jasper Johns and 'Jasper Johns'.
In my text Jasper Johns is the name of the agent who –
sometimes with assistance by others – made the objects I look
at, see and seek to understand. He is the intentional producer,
the real person who is known to no one but himself, and not
even to him. But 'Jasper Johns' names the imaginary or
symbolic character who stands in a causal relation with the
works, who is their producer and who enables their inscrip-
tion in discourse even as they and their inscription in dis-
course produce him. 'Jasper Johns' is a representation I have
made from the resources available in our culture – including

the works made by Jasper Johns and the discourses concerned to produce a knowledge of 'Jasper Johns' – and who, I am well aware, is but one moment in a pattern of possibilities. He works for me. Maybe he will work for you. Because he is unknowable, I saw no reason to go out of my way to make the acquaintance of Jasper Johns. I saw little point in questioning him about the work of 'Jasper Johns'. This puts a distance between this book and those books devoted to the study of 'Jasper Johns'. Most of them – all of them – try to conflate the distinction between Jasper Johns and 'Jasper Johns'. The art disrupts the attempt. I wanted to hang on to the distinction between Jasper Johns and 'Jasper Johns', in the knowledge that for me Jasper Johns would always be my 'Jasper Johns'. There was – and is – much to be going on with. We have hardly begun to look at the art. To have met with Jasper Johns as part of my research and writing would have complicated a project that was already complex and would have diverted me from what I was looking at, and how I was looking at it.

As far as beginning to make a work, one can do it for any reason. Jasper Johns to G.R. Swenson, 1964[26]

One assumes that one's relationship to the work is the correct or only possible one. But with a slight re-emphasis of elements, one finds that one can behave very differently toward it, see it in a different way. I tend to focus upon a relationship between oneself and a thing that is flexible, that can be one thing at one time and something else at another time. I find it interesting, although it may not be very reassuring. Jasper Johns to Christian Geelhaar, 1978[27]

1 Present, the Scene of My Selves, the Occasion of these Ruses

Such things run through my work, relationships of parts and wholes. Maybe that's a concern of everybody's. Probably it is, but I'm not sure it is in the same way. It seems so stressed in my work that I imagine it has a psychological basis. It must have to do with something that is necessary for me. But of course it is a grand idea. It relates to so much of one's life. And spatially it's an interesting problem. In painting, the concern with space can be primary . . . the division of space and the charges that space can have . . . the shifting nature of anything . . . how it varies when it's taken to be a whole and when it's taken to be a part. Jasper Johns to Christian Geelhaar, 1978[1]

There are kinds of images that make a single impact and there are kinds of images that express themselves as a multiplicity. And there are multiple images that can't be sensed at once, that have to be sensed separately in time as you focus on this thing or that thing. Such a changing sense of time and focus reinforces any indications of fragmentation. Jasper Johns to Roberta Bernstein, 1981[2]

. . . the wound of a fracture that lies hidden in all texts. . . . The rhythmical interruptions that mark off the successive episodes of the narrative are not new moments of cognition but literal events textually reinscribed by a delusive act of figuration or of forgetting. Paul de Man, 'Shelley Disfigured'[3]

Untitled, 1972 (illus. 6) is a painting of surfaces, four of them bolted together to make one. It begins with marks: a painted surface insisting on the fact of its flatness. Then, a series of more or less abrupt transitions from panel to panel, facture to facture, image to image, to something seemingly quite unlike that which began it, a surface below but in front of it – objects: emphatic, palpable, and human.

The first surface, oil on canvas, is a network of hatched green, orange and violet lines on a mostly white ground. Parallel to each other and in bundles of three to nine, these lines mark the surface in changing directions. There is something mechanical in the precision of their placing. Each orange bundle of hatchings is surrounded by several others alternately (clockwise) green, violet, green, violet, green, violet, so

that each bundle touches only the other two colours, never its own. It looks like changing-your-mind painting, but it is not. Here and there some overpainting, white usually, redefines an interval or area, or just *is*. Whatever else this hatched pattern is doing, it is being used to make the surface. Each bundle attracts attention to its own identity as a pictorial technique for crossing the canvas from edge to edge, pressing out everything flat and even. Johns has said that he derived the motif from a car that once passed him by on the Long Island Expressway: 'I was riding in a car, going out to the Hamptons for the weekend, when a car came in the opposite direction. It was covered with these marks, but I only saw it for a moment – then it was gone – just a brief glimpse. But I immediately thought that I would use it for my next painting.'[4] This panel is that painting.

Next to the hatchings, another oil on canvas pattern – flagstones. Near the top, a violet line crosses the two canvases and relates them by marking the flagstones; below that detail, a bit of black flagstone marks violet and red hatchings; and below that, a violet drip on a white flagstone draws attention to, and further evidences, the side-by-side character of the two surfaces. By 1972 this pattern had been in Johns's repertory of surfaces for five years. His story about finding it occurs in several versions; this is Michael Crichton's:

Johns was taking a taxi to the airport, traveling through Harlem, when he passed a small store which had a wall painted to resemble flagstones. He decided it would appear in his next painting. Some weeks later when he began the painting, he asked David Whitney to find the flagstone wall, and photograph it. Whitney returned to say he could not find the wall anywhere. Johns himself then looked for the wall, driving back and forth across Harlem, searching for what he had briefly seen. He never found it, and finally had to conclude that it had been painted over or demolished. Thus he was obliged to re-create the flagstone wall from memory. This distressed him. 'What I had hoped to do was an exact copy of the wall. It was red, black and gray, but I'm sure that it didn't look like what I did. But I did my best.'

Explaining further, he said: 'Whatever I do seems artificial and false, to me. They – whoever painted the wall – had an idea; I doubt that whatever they did had to conform to

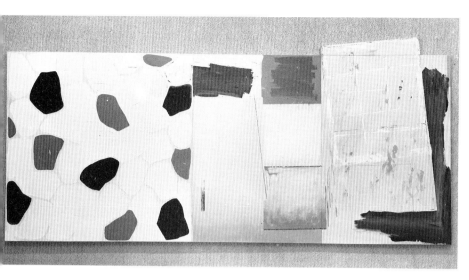

1 *Harlem Light*, 1967, oil and collage on canvas, 198 × 437. Private collection.

2 *Wall Piece*, 1968, oil and collage on canvas, 183 × 280. Collection of the artist, on loan to the San Francisco Museum of Modern Art.

anything except their own pleasure. I wanted to use that design. The trouble is that when you start to work, you can't eliminate your own sophistication. If I could have traced it I would have felt secure that I had it right. Because what's interesting to me is the fact that it isn't designed, but taken. It's not mine.'[5]

The flagstones were first used in *Harlem Light* of 1967 (illus. 1). But the surface of *Untitled*, 1972, most resembles the variation devised for *Wall Piece* made in 1968 (illus. 2). Some of the flagstones have been cut to shape out of silk and placed and 'painted' onto the surface – creamy white paint accumulates in ridges at their edges. Some flagstones are relatively flatly painted, others more thickly; brushstrokes track the pointing between them.

Next to the flagstones, more flagstones, this time in encaustic. Here Johns repeats an image in a different medium and observes the play between the two: oil and encaustic; the former relatively thin, opaque and glossy, the latter thick, somewhat transluscent and matt. Nothing journeys from the flagstones in oil to the flagstones in encaustic. At their meeting, the edges of the two canvases mark some kind of similarity and difference that has not been – and, maybe, could not be – overcome. What little transition there is from one to the other is in the manner of a mismatch of two halves – red oil and black encaustic – that do not quite fit together to make a whole flagstone. Crichton pointed out that 'if, in your mind, you move the right-hand flagstone panel midway over the left-hand panel, you get a congruity – a matching – that actually implies a secret square in the middle of it all'.[6] The effect, as Richard Shiff has described it, is as if 'a continuous wall of flagstones has . . . slid by'.[7] That, or 'the . . . viewer might imagine that the change in medium has caused a change in his own apparent position, so that in looking left and right he comes to see different sections of wall – and not the sections he would expect to see when looking left and right from a single fixed position.'[8] As with its neighbour, some of the flagstones have been cut out of silk to give them a slight relief effect; again, travelling brushstrokes track the pointing between them. Two lavender-pink brushstrokes, one on top of the other, mark the surface and dribble down it.

Last, another encaustic surface, and the wax casts: a female

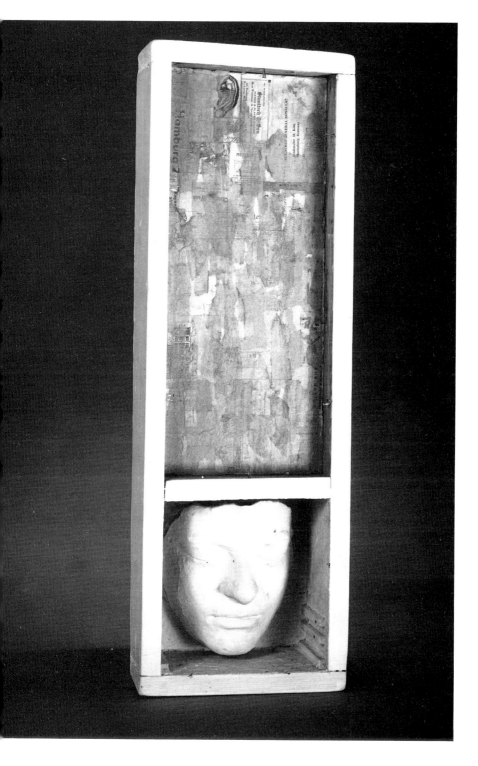

4 *Watchman*, 1964, oil on canvas with objects, 215.9 × 153. Private collection.

Eddingsville, 1965, oil on canvas with objects, 172.5 × 311. Museum Ludwig, Cologne.

face in profile (no eyes); a foot on a black sock, a hand next to it, both on floorboards; a buttock; a knee; a female torso, breast and navel; the back of a leg, calf and heel; and feet in green sling-back shoes, ankles crossed. Fragmented body parts have appeared in Johns's work since the mid-1950s, in plaster and individually boxed in *Untitled Construction* of 1954 (illus. 3), *Target with Plaster Casts* (illus. 7), and *Target with Four Faces* (illus. 34) of 1955; in wax and attached to the canvas by way of half a chair for *Watchman* (illus. 4) and *According to What* of 1964 (Collection of Mr and Mrs S.I. Newhouse), and bolted into place on *Eddingsville* of 1965 (illus. 5) and *Passage II* of 1966 (Harry N. Abrams Family Collection). Evidently Johns began with a blank canvas ripped in two places to reveal the stretcher bars and the wall behind, but this was replaced with another canvas that was silkscreened with two white targets, one whole and one cut off at the lower edge; then the battens with the wax casts fixed to them with wire netting, bandages and dollops of more wax were attached to the stretcher with blocks, bolts and wing-nuts; the targets were covered with a layer of encaustic in bright colours and then overpainted in grey; then the battens were numbered, stencilled 'l' and 'r' and colour-coded red, yellow, blue, green, violet and orange to aid assembly and disassembly.[9] Of course, you don't have to give instructions in this way. It is Johns's way. His instructions become part of the way he makes the surface. The grey encaustic was then changed to beige and two objects were used to imprint the surface: the rim of a can and the sole of a flat-iron – part of which also marks the encaustic flagstone

surface and makes a transition from one to the other in such a way that the two surfaces are seen together at this point. Both imprints have a history of use in Johns's work. The can imprint goes back to *Field Painting* of 1963–4 (illus. 60), while the iron imprint goes back to *Passage* of 1962 (illus. 12). Where the flagstones and the figure fragments meet, the red of two flagstones moves across the join. Overall, and keeping in mind the junction of the oil and encaustic flagstones, the logic is clear: 'wherever two panels of like medium meet, the physical surface of the painting is to be regarded as homogenous and continuous; but if the media differ, the physical surface becomes discontinuous.'[10] As James Cuno has pointed out, 'this causes the viewer to distinguish between the panels of *Untitled*, 1972, by media, to divide the picture in two, and to find relations between the two encaustic panels and the two oil ones.'[11] One more detail needs to be noted: some rectangular matter has been collaged to the surface above the place where the red batten is screwed to the stretcher at the left side. That will do as a description.

Untitled, 1972, met its first audiences at the Whitney Annual in the spring of 1973. One cannot generalize about what they made of it. Thomas B. Hess was the only person prepared to engage with it publicly, in print, at the time.[12] Initially he did little more than I have just done. He described its surfaces, media and imagery; he noted its reflexiveness to Johns's studio practices; and he drew on explanations provided by Johns. But he also pointed out how Johns 'seemed concerned with preserving memories and re-evoking lost experience' by painting these 'glimpses of Harlem and of Long Island that have haunted him, bits and pieces of four or five friends'.[13] I must say I find the idea that Johns's paintings are about his studio practices is a relatively uninteresting one, and also a relatively uninteresting practice *per se*. Modern artists cannot exclude art history from their project, and many choose consciously to carry their own art history with them, continually making reflexive paintings: paintings of their studios. Johns's *œuvre* is full of studios, but what is interesting about his practice as a studio painter is that it periodically becomes necessary for him to make a studio painting as an index of his practice in order to sort it out, to find out what he is doing and why and whether he should go on doing it. This, I take it, was the point of *Field Painting*, which is probably the first painting

to do this by design, and *Untitled*, 1972. Moreover, these paintings are not just practical or technical critical histories. I would want to argue that they are also moral histories in that they refer to Johns's character and conduct, to the character and conduct of others, to actions, events and feelings.[14]

I would like to think that Hess had something of this in mind when he referred to the surface of *Untitled*, 1972, as a 'metaphorical scaffolding' into which Johns had 'slotted auto-biographical elements'.[15] Though surely Hess was not writing the surface of *Untitled*, 1972, as a visual metaphor. Not in any straightforward way. Hess's choice of 'scaffolding' seems an unacceptable or inappropriate substitution for the hatching and flagstones patterns, and an all too literal description of the battens that support the wax casts in front of the beige surface. The working of memory and 'the bits and pieces of four or five friends' complicates the metaphor idea still further. No. Hess's use of 'scaffolding', loosened rather than tightened as metaphor by the addition of the adjective 'metaphorical', is best read as a metonym turned towards Johns's stories about the origins of the patterns, and especially towards the story of the flagstone wall that was lost, either 'painted over or demolished'.

One can take many approaches. One can think of all one's work as a fragment of something else. Usually in working I tend to take something that has seemed to be a whole and put it in a context in which it becomes a fragment. And I do the opposite: take an aspect of something and treat it as a whole. What one does is affected by the focus of one's thought at the time.
Jasper Johns to Roberta Bernstein, 1981[16]

Often one draws from things that one knows in working . . . and one works – I don't know what it's called – you see something but do something else, but, in your head, what you're doing has a relationship to something you're seeing. It's not . . . you can say it's very important or it's not important at all. Often, it's not something that you want to point to – to say. You don't want to say I get here by examining that, by drawing conclusions from that, because then it suggests that you're making a picture of that, you can make a better picture of that, copying it a little more carefully or something. Still the mind often works that way using something and making something unlike it and occasionally one wants to say what one is doing. . . . Jasper Johns to Richard Francis, 1982[17]

I have only to plant my tree in a locution; climb the tree, even project on to it the cunning illumination a descriptive context gives to a word; raise it (arborer) *so as not to let myself be imprisoned in some sort of* communiqué *of the facts, however official, and if I know the truth, make it heard, in spite of all the* between-the-lines *censures by the only signifier my acrobatics through the branches of the tree can constitute, provocative to the point of burlesque, or perceptible only to the practised eye, according to whether I wish to be heard by the mob or by the few.* Jacques Lacan, 'The Agency of the Letter in the Unconscious or Reason since Freud'[18]

Tropes are not something that can be added or subtracted from language at will; they are its truest nature. Friedrich Nietzsche, *Gesammelte Werke*[19]

Generally, explainers of modern art write meanings for paintings and bits and pieces of paintings as metaphors without giving much thought to what or how metaphors mean. Most of the time all that is meant when it is asserted that something is a metaphor or a visual metaphor, or that it is to be read metaphorically, is that it has in addition to its literal sense or meaning another sense or meaning. Metaphors are stock-in-trade for explainers who are thoughtless of, or unconcerned with, the subtleties of figuration, rhetoric and stylistics within the language of art. Other more precise discriminations are possible and we must be mindful of them. Once we are, we can be somewhat less abstract in what we do write about works of art.

Metaphor is based on a proposed similarity or analogy between the literal subject and a subject substituted for it. It invites the perception of a similarity between two otherwise quite distinct fields of meaning such that the sense of distance between them is preserved in the act of imaginatively leaping across them. If it is successful, a metaphor makes us attend to some likeness, often novel or surprising, between two or more things. The idea is that in metaphor certain words take on new, or what are often referred to as 'extended' meanings; this is to say that the class of entities to which a word in a metaphor refers is extended. For example, Shakespeare's 'Now is the *winter* of our discontent' (*Richard III*, I, i, 1), or 'How sweet the moonlight *sleeps* upon this bank (*The Merchant of Venice*, v, i, 54). A metaphor is usually easily understood because the metaphorical associations, the links between the literal subject

and its metaphoric substitute, are alive in culture. This is the conventional, but much debated, wisdom.[20]

Metonymy is based on a proposed contiguous or sequential link between the literal object and its replacement by association or reference: the substitution of one name for another; an invention by the name of its inventor or a possession by the name of its possessor; and vice versa. For example, 'the *crown*' can stand for the King, Queen or monarchy, or 'the *stage*' for the theatrical profession. It is the record of a lacuna, of a move or displacement from cause to effect, container to contained, goal to auxiliary tool, whole to part.[21] The metonymic processes are reduction, expansion and association, and these represent historical contiguities and remote relations of experience in particular exempla. Closely related to, and often taken as a kind of species of metonymy, is synecdoche, where we 'understand the plural from the singular, the whole from the part, a genus from the species, something following from something preceding; and vice versa'.[22] For example, we use the term 'ten hands' to mean ten workmen.

According to Roman Jakobson, who pointed out how important he thought were the concepts of metaphor and metonymy for understanding aphasia, and then went on to integrate his observations with Saussurian linguistics, language functions because of the kinds of associations that pertain between participants in the speech event, the speaker and the addressee.[23] The speaker selects words from the 'lexical storehouse' or 'filing cabinet of *prefabricated* representations' and combines them into sentences or utterances according to the syntactical system of the language he is using.[24] In Ferdinand de Saussure's terms the speaker selects from the vertical paradigmatic or 'associative' axis of related words, and then places those words along the linear 'syntagmatic' axis. The temporal and spatial separation between the speaker and the addressee is linked by an internal relation of equivalence whereby the symbols selected and used by the former are known by the latter. Without this knowledge of its coding the message would be more or less meaningless for the addressee. In terms of the language of art, we might say that the artist and the beholder of the work of art have the same set of prefabricated representations, with the same, or almost the same, relations holding between them, a syntax and grammar that structures them. The artist selects one or more of these

preconceived possibilities, uses them to make the work of art, and the beholder of the work is expected to make an identical, or more or less identical, choice from the same range of possibilities already foreseen and provided for. This is, in a sense, the common code of the artist and the beholder. However, it is not enough to know the code in order to understand the utterance. You need to know the verbal or non-verbal context that provides the necessary area of external relation of associative reference on which intelligibility depends. The components of any message are, then, linked by two modes of relation: the internal relation of similarity and contrast, and the external relation of contiguity and remoteness. Jakobson notes that metaphor and metonymy present the most condensed expression of these two basic modes of relation, and then goes on to argue that the two distinctive kinds of aphasia correspond to these relationships. On the one hand, aphasics with a 'similarity disorder', those whose selective capacities are affected but who still have the ability to combine partly preserved, show a marked tendency to metonymy. Aphasics with a 'contiguity disorder', on the other hand, those whose ability to combine simple linguistic elements is impaired, who have lost the syntactic rules of combination, choose their words on the basis of similarity and difference, that is to say, on approximate identifications of a metaphoric character. At this point Jakobson develops his ideas on the two kinds of aphasic disturbances towards the direction of a theory of discourse.[25] He argues that 'under the influence of a cultural pattern, personality and verbal style' normal, non-aphasic speech evidences a preference for either metaphor or metonymy.[26] He illustrates his case with reference to literature, fine art and film. It is what he writes about literature that seems most useful here. He points out that whereas the primacy of the metaphoric process 'in the literary schools of romanticism and symbolism has been repeatedly acknowledged . . . it is still insufficiently realized that it is the predominance of metonymy which underlies and actually predetermines the so-called "realistic" trend. . . . Following the path of contiguous relationships, the realist author metonymically digresses from plot to atmosphere and from character to the setting in space and time.'[27] Synecdoche is also involved. The writing of one of Jakobson's chosen examples, Gleb Ivanovič Upenskij, an author with a metony-

mic bent even before he began to suffer from a mental illness that involved a speech disorder, evidences a penchant for synecdochic detail. Jakobson understands this particular inclination to be a characteristic of the metonymic style.[28]

Jacques Lacan appropriated Jakobson's writing on metaphor and metonymy and applied it in his own fashion to Freud's theory of dream-work. He related metaphor to *Verdichtung* ('condensation') and metonymy to *Verschiebung* ('displacement'), both essential functions of unconscious processes.[29] This rereading of Freud involved not only a reinterpretation of metaphor and metonymy but also a considerable dislocation of another of Lacan's resources, the relation that Saussure posited between the signifier and the signified.[30] For Lacan, the so-called 'Saussurian algorithm' S/s, 'the signifier over the signified', represents not the unity and inseparability of the two sides of the leaf that is the sign but the difficulty of establishing any relation between them. Metaphor and metonymy are traditionally understood as based on relations between signifieds or referents, either relations of similarity and difference or of contiguity in space and time. Lacan understood metaphor and metonymy as based on relations between signifiers. This seems easier to grasp with regard to metonymy, with its relations between signifiers in a signifying chain, than it does with regard to metaphor as a substitution based on a purely formal similarity between signifiers. However, psychoanalysis is not my subject, and my use of Lacan's use of Freud is thoroughly expedient. I am, then, less inclined to argue with Lacan's text on metaphor and metonymy – somewhat oversimplified in my account of it – than I am to note and use some of what he writes about metonymy and displacement. In Freud's theory condensation produces collective and composite figures; for example, one dream figure may represent several personalities. Displacement occurs where the emphasis, interest or intensity of one idea becomes detached from it and is passed to other ideas that are of little interest or intensity but which are related to it by a chain of associations. Lacan described condensation as 'the superimposition of signifiers' and relates it to metaphor, whereby one signifier comes in place of another. In the case of displacement he suggests that the German *Verschiebung* 'is closer to the veering off of signification that we see in metonymy, and which from its first

appearance in Freud is represented as the most appropriate means used by the unconscious to foil censorship.'[31] But metonymy is not just a method of the unconscious mind. Especially when it comes to getting around censorship. And it should be noted that Lacan's amalgam of Jakobson and Freud, which he formulated in his lecture of 1957 on 'The Agency of the Letter in the Unconscious or Reason since Freud', was occasioned as much by his interest in Leo Strauss's recent book *Persecution and the Art of Writing* – an intriguing work of political philosophy – as it was by his interest in reading the founding texts of psychoanalysis through Saussurian linguistics.[32] Lacan seems to have taken from Strauss's book – which is much concerned with consciously 'writing between the lines' – the idea that metonymy provides the writer or speaker with the 'power to circumvent the obstacles of social censure' and to express 'truth in its very oppression', even as it shows its involuntary subjection to that oppression.[33] Strauss's book certainly enabled Lacan to glimpse the manner in which the connatural relation between writing and persecution when pushed to its limits 'imposes its form, in the effect of truth on desire'.[34]

Lacan discusses at some length the relation between metonymy and desire in his report of 1958 to the Colloque de Royaumont, which was published as 'The Direction of the Treatment and the Principles of its Power'.[35] After rehearsing that 'metonymy is . . . the effect made possible by the fact that there is no signification that does not refer to another signification', and stressing that 'the truth of this appearance is that desire is the metonymy of the want-to-be', he goes on to assert that 'long before Freud came on the scene, psychologists knew, even if they did not express it in these terms, that if desire is the metonymy of the want-to-be, the ego is the metonymy of desire.'[36] For Lacan, desire is a profound but always implicit longing for recognition by the Other that will make up the subject's fundamental lack of identity or being, 'want-to-be' or want-of-being. It can be understood as metonymy because it can only be known as an effect of speech by and in the continual movement from one signifier to another signifier, to another signifier and so on, as a chain of signifiers displaced from and linked to the 'want-to-be' or want-of-being. The ego has to be understood likewise because it is formed through a series of identifications with objects external

to it, objects connected metonymically to the chain of signi-fiers by means of which the subject articulates its fundamental want-of-being. Metonymy is a linguistic mechanism that takes the place of and represents the subject's want-of-being. With this in mind, we are now in a position to understand how it was that Lacan was able to write in 'The Agency of the Letter in the Unconscious' that the innate relation Strauss found between the art of writing and persecution 'imposes its form, in the effect of truth on desire'. Truth, which since Freud is associated not with reason but with the unconscious, only shows itself by the insistence of speech; though chary of language, it is produced in and by speech. The unconscious says what it knows, while the subject who speaks it does not know it. The psychoanalyst has to realize that speech is the 'key' to the 'domain of veracity', that it alone is truth's 'instrument, its context, its material, and even the background noise of its uncertainties'.[37] Analysis must attend to the signifying chain, and especially to the spaces between one signifier and another. It is in the movement through the chain that truth tries to make itself known and desire finds a way for expression. Metonymy as writing or speaking 'between-the-lines' is the form taken by the subject's want-of-being as it communicates the subject's want-of-being.

Metaphor and metonymy put twists in the tail of meaning. Depending on the author's purpose, or on his or her typical if unpurposed and unconscious mode of figuration, metaphor or metonymy can turn a new meaning into view or obscure it. With metonymy the move is escape. It represents not the object or thing or event or feeling that is its reference but that which is tied to it by contingent or associative transfers of meaning, and in this way it gives the utterer the power to bypass obstacles of social censure, including those that are consciously or unconsciously self-imposed. Metonymy accords a kind of privacy to language. 'A kind of privacy' because there can be no such thing as a wholly private language, possessing totally individualized and isolated meanings. Even the most private metonymy is public insofar as it is a language, a communication, has a history. It can, therefore, be pursued along its associative chain to the moment of its constitutive production, which will – and this is where I turn away from Lacanian psychoanalysis – in principle at least, reveal its reference and, perhaps, its meaning also.

Later, the metaphor/metonymy opposition will have to be understood as less secure than I have described it to be up to now, but we do need it here if *Untitled*, 1972 (illus. 6), is to be questioned about its order, the arrangement of its hatchings, flagstones and cast body fragments, and how that order and those surfaces might articulate and enable the production of meanings. *Untitled*, 1972, is a surface of metonyms and synecdoches. Metonymically, each object, imprint and pattern is tied by the contingent, contiguous and concomitant association of ideas and values to something else, to events and objects in New York, reflexively to Johns's own work, and, as we will see, to the work of other artists and other ideas and associations, and so on. At least two of its patterns are the result of his need or desire to relocate and represent a lost object. Synecdochically, it is a series of fragments: bits of surfaces; cast parts of the human body; traces of objects.

Among those who use language knowingly and selfconsciously, as Johns does, the disposition towards metaphor or metonymy as the preferred trope will have to be seen as produced, consciously or unconsciously, by the pre-given availability of certain cultural resources, by the social relations that include such resources and their users, and by the constraints and contradictions present in any particular historical situation. I would argue that Johns's trope is very much not metaphor. This is not to say that he has denied himself the use of metaphor or the look of metaphorically expressive painting in ways that might be quite important for his meanings. He has not. Indeed, it is difficult to see how anyone could deny himself the use of metaphor, or escape it completely. Metaphor has to be there, somewhere, as 'the initial equivocating insight into the system of doubly articulated correspondences and propositions upon which depends the analogizing logic of any troping proposition.'[38] What I am working towards arguing is that whatever it was – and maybe still is – that Johns wanted to represent, he did not want to represent it metaphorically. Or, maybe, he wanted to represent it metaphorically but could not, and so found his way to metonymy by way of his creative process – displacement, of course, working significantly in this process. Either that, or (and this seems very unlikely) he could find no metaphors for it in the resources available to him.

Johns's disposition towards metonymy has to be seen as *of*

6 *Untitled*, 1972, oil, encaustic and collage on canvas with objects, 183 × 487.5. Museum Ludwig, Cologne.

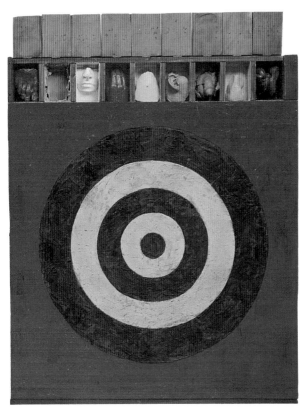

7 *Target with Plaster Casts*, 1955, encaustic and collage on canvas with plaster casts, 129.5 × 111.8 × 9. Private collection.

8 *In Memory of My Feelings – Frank O'Hara*, 1961, oil on canvas with objects, 101.6 × 152.4. Collection of Stefan T. Edlis, Chicago.

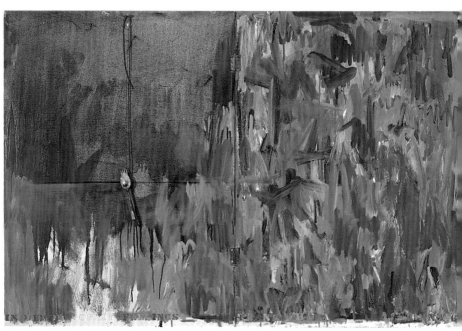

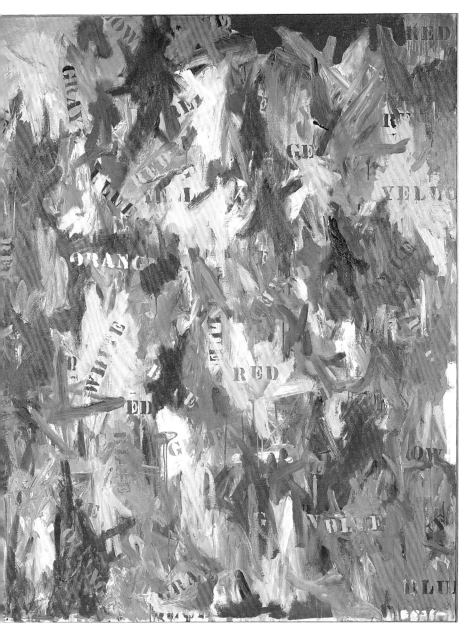

9 *False Start*, 1959, oil on canvas, 171 × 137. Private collection.

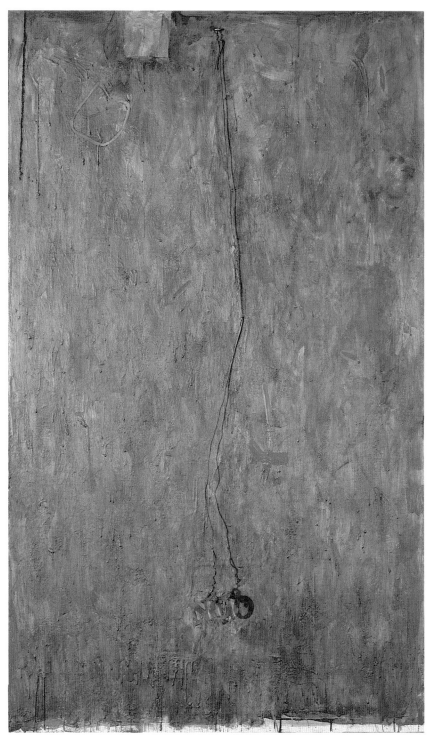

10 *No*, 1961, encaustic, collage and metal sculpture on canvas, 172.7 × 101.6. Collection of the artist, on loan to the National Gallery of Art, Washington, DC.

11 *Fall*, 1986, encaustic on canvas, 190.5 × 127. Collection of the artist, on loan to the Philadelphia Museum of Art.

12 *Passage*, 1962, encaustic and collage on canvas with objects, 137.2 ×
101.6. Museum Ludwig, Cologne.

13 *Periscope (Hart Crane)*, 1963, oil on canvas, 170.2 × 121.9. Collection of the artist, on loan to the National Museum of American Art, Smithsonian Institution, Washington, DC.

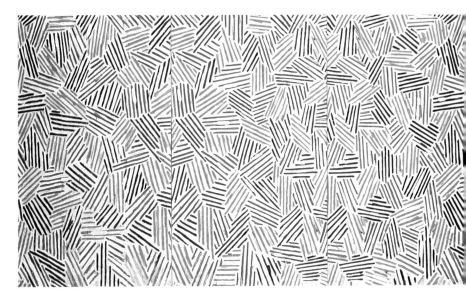

14 *Scent*, 1973–4, encaustic and oil on canvas, 182 × 320. Ludwig-Forum, Aachen.

Johns, who attempts, consciously or unconsciously, to escape censure by making paintings that resist, evade or control the interpretations and meanings that can be produced for them.[39] Johns's paintings have subject-matter, but it is elusive. With the mechanism of metonymy in mind one can understand how and why it is that the surfaces of his paintings are often, like *Untitled*, 1972, felt by those whose job it is to explain them, to be hiding or concealing subject-matter. This is a commonplace in the literature of Johns, and a view that the artist has on occasion encouraged, but without giving anything away. Over the years, Johns has developed many mechanisms of surface – ways of waxing, oiling, watering, metalling, collaging, dotting, dribbling, dripping, dusting, scraping, scratching, scumbling, spraying, sweeping, attaching, hanging, hinging, interposing, stencilling, screening, imprinting, camouflaging, veiling, permuting, reversing, rhyming – which give the beholder some more or less interesting busy-ness to look at, wherever the focus. These mechanisms make the fascination of Johns's painting. They are what attract attention, effect the organization and celebration of impressions, and then distract the inquiring mind. They give the explainer something to find, but at the same time keep explanations cutaneous. Johns's surfaces play hide and seek, impose and simultaneously resist interpretation in terms of subject.

Such a formulation may be reconstructed in terms of what conventional artistic wisdom has taken to be the feasible area of ambition in recent painting – painting of the last 120 years or so; that is to say, in terms of the supposedly antinomic, though actually contrasted, nature of two interests: the practical and/or conceptual concern with subject, and the practical and/or conceptual concern with surface.[40] Crudely, the putative evolution of Modernist painting has been characterized as the gradual victory of the latter over the former. For a painter in whose practice this contrast seems to be raised as a real issue – is experienced as if it were an opposition – it may seem as if all decisions that have to be taken in making a given painting can at some point or other be indexed to one or other of these concerns – vivid subject or vivid surface. The problem may then seem to be how to decide between the requirements of subject and surface as priorities in actual practice.

Clearly these two concerns have not always been seen as

antinomic, and it is possible to question whether they are now. Most artists continue to work with the antinomic structure as an unquestioned determinant, even – especially – those who are making so-called Post-Modernist art (which is as slavishly determined by the opposition as the Modernist painting it claims to have superseded). And because the dynamic, historical tendency of Modernism in its own self-image is to set decorativeness, holistic surfaceness and facticity against and over semantic detail, so that decorativeness is supposed to come out on top, ambitious Modernist painting has tended towards decorativeness. However, the surface of a Modernist painting is, according to the dominant theory, more than mere decoration. It results from a self-critical and self-defining tendency in practice that causes the artist to concentrate on the character and problems of the medium, to assert and use painting's flatness, not to represent ideas and notions 'but to express with greater immediacy sensations, the irreducible elements of experience'.[41] The formal and decorative potential of the surface is, then, used as a vehicle for the artist's feelings, state of mind and emotions.[42]

As a Modernist painter, Johns offers no exception. He works with the surface/subject opposition. But what is interesting about his strategy is that while he seems, by the efficacy and elegance of his various mechanisms of surface, to assert the decorative potential of surface and to sometimes establish that surface in terms of reflexive relations that go back either to his own art or the art of others, he has not been interested in using it to express his feelings, though it has been claimed by some of its beholders to do this, and he has been able to admit and develop the representation of vivid subject, albeit one that generally has been overlooked or, if noticed, misunderstood or undervalued. The decorum of Modernist criticism and history functions to restrict discussion to, or permits explanation to be restricted to, such matters as how the surface is made out of what it is technically made out of, how the hatching works, how the flagstones make a hidden square, how the physical construction and arrangements iterate other works in Johns's *œuvre* and so on. Constrained by the Modernist paradigm it is almost impossible to pursue into real criticism or history the possibility glimpsed by Hess that there might be more to *Untitled*, 1972, than surface.[43] Now, twenty years or so after Hess wrote about *Untitled*, 1972, an increasing

number of less able persons are turning their attention away from matters of surface to matters of subject, from experiencing and judging feelings to tracking shadows to an identity. This does little other than shift the hierarchy within the opposition. And the opposition is still in place, as are the limits it imposes on understanding.

In or before 1964 Johns noted in one of his sketchbooks: 'There seems to be a sort of "pressure area" "underneath" language which operates in such a way to force the language to change. (I'm believing painting to be a language, or wishing language to be any sort of recognition.) If one takes delight in that kind of changing process one moves towards new recognitions, names, images.'[44] This may have testified to an 'artistic' reading of the philosophy of Wittgenstein, whose works Johns read in translation in 1961.[45] But given the negative status of descriptive representation in modern art, particularly post-Pollock, its actual implications would have been entirely untenable – which is to say that painting would not have been a feasible enterprise – were the possibility of representation not sustained by a pressure from within that forced it to change, forced it to identify new 'images' and 'names', metaphors and metonymies and to continue troping properties not originally or naturally possessed by what was chosen for depiction and was depicted by way of making the surface. Johns takes selfconscious delight in doing this. And we recognize it when in front of his painting. It could be said that we are able to do this or see it because all 'grammatical' utterances (sentences or pictorial representations) are composed of elements traceable back – albeit not in a mechanical or unilinear fashion – to contexts of use in other utterances. Alternatively, it could be said, following Noam Chomsky, that we know the rules of grammar as an evolved species characteristic and make meaningful transformations in virtue of this knowledge.[46] Whichever determines it, whether it is a sense of the 'grammatical' sustained by a causal theory of reference or by a theory of an innate mechanism of language, we recognize *Untitled*, 1972, as a coherent visual representation, even if we do not know what meaning coheres in it or is represented by it.

What I have attempted to do so far is justify and corroborate Hess's perception that *Untitled*, 1972, offers more than an empirical or phenomenal experience of a vivid surface. I have

also tried to avoid prising apart surface and subject. The recurrence over a considerable period before each one was used to make *Untitled*, 1972, of a particular type of brush-stroke, the mark of a particular can and iron, wax casts taken from the human figure, and even a certain kind of collaged matter, hints that these things are not to be understood only as reflexive formal devices making the surface. Certainly they are contingent on making the surface. But they seem to be more than that. And this observation applies likewise to the flag-stones and, after *Untitled*, 1972, to the crosshatchings. As well as a grammar, a context for the configuration is also there sufficient for the possibility of other meanings to be glimpsed beyond literal surfaceness. My speculation is that these repeated formal devices that are more than formal devices are discrete synecdoches and metonyms in a private language, at least as 'private language' is colloquially understood as a relatively socially-closed linguistic mode rather than a socially-open one. They contribute to the composition of more or less socially-open surfaces, but at another level they signify concepts privy only to Johns and the few close friends who would know the contextual field, possess some of the necessary interpreting skills, categories, model patterns, habits of infer-ence and analogy, and who would be able to adopt the appropriate 'cognitive style' to scan and understand them otherwise.[47]

There is, then, in Johns's work a conventional tension between public and private. On the one hand, there is the assertion and use of the decorative surface in ways that seem to affirm the functions of Modernist painting by displaying meanings that are more or less readily available and by seeming to offer, for those who desire it, the possibility of an expressive effect. On the other hand, the surface is used for the representation of private matters that are concealed from more or less everyone except for the artist and his friends. The dominant theory of Modernist art holds that the surface of a painting carries an emotional experience that is available to all persons who are sufficiently disinterested and sensitive to feel it. Experiencing the expressive effect, which must be a private affair, paradoxically confirms the beholder as part of a wide public. Translating the surface into a subject-matter that is not immediately or obviously apparent occasions an interested engagement with the painting that takes the beholder away

from the public space wherein that surface is experienced and ratified, valued and explained as vivid surface towards private matters and private places.

My enquiry starts out from and mediates these two spaces of relative private and relative public significance, and I have to admit that they cannot be easily fitted together to produce an adequate or coherent account of *Untitled*, 1972. However, I can undertake an enquiry that goes someway towards opening up the private code by trying to reconstruct the contextual field, to inquire into the significance of crosshatchings, flagstones, figure fragments, brushstrokes, imprints, collage matter, and so on, to establish relations of reference and association that match contexts of use to what can be learned of the world in which they are used. I might then be able to re-pose private and public in a different register. I have already suggested that the surface of *Untitled*, 1972, is made of metonymic relationships. So when considering what or, rather, how it might mean I must be considering the mechanism of reference and meaning, the metonymic chain of contiguity and concatenation 'writing between the lines'. And this will entail causal as well as hermeneutic enquiry, not simply into the conditions of production and consumption, but into the complex genetic history of imagery – in Johns's case this is a category that includes style as a property open to quotation and translation – that itself will be a history of transformations. This is to say that such an inquiry will not merely be a matter of connecting a surface or a bit of a surface back to that which it iconically (descriptively) corresponds to in the world (a paint-job on a car, a wall in Harlem, a previous painting by Johns, a painting by another artist, a can and an iron), in order to see how it has been reworked according to the interests of artistic style. I will have to recognize that within some complex and heterogeneous constellation of conditions, the genetic history of a surface, or a bit of a surface, a figure fragment, a brushstroke or an imprint goes back into a world of events and feelings. And I will also have to acknowledge that no one such history will close off inquiry into any other. That I might also trace a brushstroke back to other brushstrokes in other paintings or an imprint back to an object made by another artist in no way disqualifies the claim that it is for Johns referring to some specific event or feeling. Rather the reverse, given that metonymy entails just this kind

of displacement or transfer. With this in mind, the resources of the art historian can be used to map points of reference for the awareness of a genetically alive subject-matter in and as these surfaces that signifies dispositions or states or whatever which the usual closures on Modernist descriptive writing render opaque to critical analysis. To justify the relevance of this project I have to go back to two earlier moments of Johns's work: 1954–5 and 1961–2.

Roberta Bernstein: *What about the fact that the human figure has always been presented as fragmented and incomplete in your work?*

Jasper Johns: *In part, I think, it has been determined by a psychological predisposition, and partly by convenience. It is simple to cast part of the body in the way that I do it, but a complete figure would require an enormous amount of time and a technique that I don't have. I have nothing against the total figure!*

And if I had a complete cast to work with I might use it, but nothing I've wanted to do has required me making that kind of effort.

Roberta Bernstein: *But it seems to me that the fragments are so expressive* as *fragments.*

Jasper Johns: *But isn't that always true of any fragment of the human form? There's a kind of automatic poignancy connected with the experience of such a thing. Any broken representation of the human physique is touching in some way; it's upsetting or provokes reactions that one can't quite account for. Maybe because one's image of one's own body is disturbed by it.*[48]

Roberta Bernstein: *I always think one of the powers of your work conceptually is that there are so many different directions to your thinking, so many ambivalent, even conflicting meanings. And I find, even with the counteracting elements, there is something about those fragments that creates a disturbing quality.*

Jasper Johns: *I think that's true and I focused on neutralizing that aspect. Of course the fact that I felt that need indicates something about the state of affairs at the time. But it's important to see that another person in the same situation could have taken a different point of view and could have attempted to give it greater intensity, to make it a stronger part of a statement. I was trying to let the thing itself have whatever meaning it had and at the same time move in a sense against the grain of its psychological implications.*[49]

The idea that the mature work of Johns begins with *Flag* in 1954–5 (illus. 41) was established as a commonplace by 1964.[51] This is acceptable as a commonplace so long as we bear in mind that the value it carries in discourse as the work of 'a finished artist sprung from nowhere' is a very dubious one.[52] *Flag* will do – and does do – as Johns's beginning. With it he hit on a novel way of making surfaces with encaustic and collage on canvas that were holistic and two-dimensional in the manner of the advanced abstract painting of the moment while at the same time, and with obvious calculation, reintroducing the cultural element, subject-matter, which the typical Abstract Expressionists had tended to exclude or found difficult to hang onto.

The painting that Johns made directly after *Flag* was *Target with Plaster Casts* (illus. 7). The main area, concentric bands of blue and yellow set into a square field of red making a kind of neutral target that cannot be associated with any particular contest (there is no hierarchy of focus, no variation of value, no bull's-eye), is, like its immediate predecessor, made of encaustic and collage on canvas. But above it, attached and related to it, is a row of wooden boxes with hinged lids that contain – all but two of them – plaster casts of parts of the human body. Johns has explained how these disparate bits and pieces came together. *Target with Plaster Casts* was intended to be a kind of large version of *Construction with Toy Piano* of 1954 (illus. 15): 'the lids of the boxes would have been keys prepared in such a way that touching them caused noises from behind the painting', the wooden keys became boxes and unpainted white plaster casts, around the studio as left-overs from another project, were cut to size and put into them; the casts, which seemed 'clinically and photographically morbid,' were then painted to 'neutralize . . . their more obvious psychological impact'.[53] The casts are not easy to make out. Each one is painted with the same colour as its box: a purple foot; white nose and lips but no eyes; a red hand with the little finger missing; a pink breast; an orange ear; a green penis; and a yellow heel. A greenish-black object that suggests the female genitals is, in fact, a bone. One box, the blue one, is empty. The casts were taken from three or four persons, male

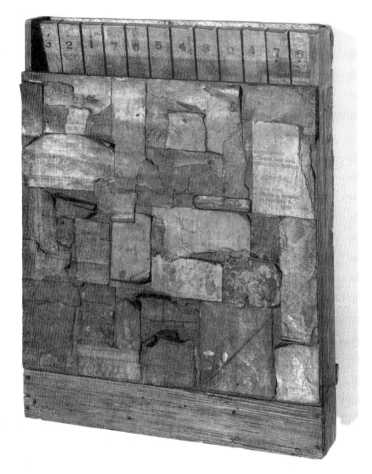

15 *Construction w*
Toy Piano, 1954, t
piano with collag
on canvas, the
whole tinted witl
graphite, 29.3 ×
23.2 × 5.6.
Öffentliche
Kunstsammlung
Basel,
Kunstmuseum.

and female. Scanned and understood separately, each cast is a synecdoche for the body that provided it. But taken together the casts cannot be understood synecdochically. Together they cannot represent a whole – unless the whole they turn us towards is an imagined one that is neither male nor female but both male and female. There is really no body represented by the sum of these parts.[54]

On two occasions in the late 1950s the sex of at least one of these plaster casts proved something of a problem for the curators and museum officials who wanted to exhibit *Target with Plaster Casts*. Johns told Roberta Bernstein that it was not included in the 'Artists of the New York School: Second Generation' exhibition of 1957 at the Jewish Museum, New

York, because 'someone on the selection committee suggested that if the *Target* were to be shown, some of the boxes should be closed to make the piece more "mysterious" '.[55] According to this story Johns interpreted the suggestion 'to mean the boxes with the penis and the bone that looked like female genitalia were considered offensive and that the piece would be acceptable only if they were hidden from view'.[56] Since it was not included in the show we must assume that Johns refused to allow the boxes to be closed. Much the same closure was proposed the following year, by which time *Target with Plaster Casts* had entered published discourse with 'slightly sinister overtones' and 'various parts of a dismembered body'.[57] Leo Castelli, Johns's dealer, has told this story about Alfred H. Barr Jr, Director of Collections at the Museum of Modern Art, New York, who wanted to acquire *Target with Plaster Casts* for the Museum. Of all the works in the Castelli show of 1958 Barr 'especially liked *Target* but he felt uncomfortable about it because in one of the nine wooden boxes on the top of the canvas was a plaster cast of a penis painted green. I can still remember the day vividly. Barr felt that the museum would reject it. He asked me to summon Jasper. When Jasper arrived, Barr asked him, ' "Could we keep this one box closed?" Jasper replied, "It all depends. All of the time or some of the time?" Barr answered, "Well, to be quite honest, all of the time." Then Jasper said, "I'm afraid, Mr Barr, that I wouldn't find that acceptable." '[58]

The juxtaposition of a target or targets with a whole figure or *corps morcelé* is an uncommon image in modern art.[59] As Johns puts it together, the juxtaposition is also an unusual one. Usually it is a female figure, whole or disintegrated, that is used. What makes Johns's *Target with Plaster Casts* unusual is the use it makes of the male and female body and especially the salience it gives to, or which attaches to, the cast of the penis. If a cast of the female genitalia had been used in place of the bone the effect would have been to make *Target with Plaster Casts* more obviously representative of the male and the female than it is. It is that. But it is not obviously that. Also, if a cast of the female genitalia had been used the beholder would have been presented with something that in modern art is regarded conventionally as the sign of erotic obsession, and the effect of the cast of the penis would have been dissipated. As it is, *Target with Plaster Casts* is an image that interpellates a

beholder to a sign of erotic obsession, but it also effects a resistance to interpellation by making that sign disrupt convention. And this, I take it, is part of the intent. The effectivity of *Target with Plaster Casts* depends on the penis being visible, if not all of the time then of some of it. Though the casts were taken from several persons, male and female, this is the only one that we can with any security regard as gendered. It is quite definitely a male part, and this is important not only for the effect of *Target with Plaster Casts* but also for the meanings that we might write for it.[60]

Although they were initially understood as different, *Flag* and *Target with Plaster Casts* quickly came to be seen and discussed in terms of their 'similarities' as subjects that are man-made commonplaces of our environment, 'things the mind already knows'.[61] We have to keep to the difference. In what Johns wants to be taken as his first two works as an artist he posited alternative directions. *Flag* and *Target with Plaster Casts* are two very loaded images, but they work in different ways and have different effects. To put it somewhat inelegantly, *Target with Plaster Casts* with its body fragments and target almost inescapably evokes the artist himself, and *Flag* almost inescapably does not. Some of those persons – especially non-formalist critics – who have written about *Target with Plaster Casts* have been 'richly inventive' in translating their own psychological and emotional responses to it into conditions that originated in and with Johns.[62] It is a work that has always set the psychologizing mind to psychologizing. Leo Steinberg was the first person to write about it at length in an article published in 1962, and what and how he wrote about it set the tone and tenor of subsequent discussions for a considerable period.[63] This is his summation:

Apparently the artist wanted to know (or so he says) whether he could use life-cast fragments of body and remain as indifferent to reading their message as he was to the linage in the newspaper fragments pasted on the canvas below. Could our habit of sentimentalizing the human, even when obviously duplicated in painted plaster – could this pathetic instinct in us be deadened at sight so as to free alternative attitudes? He was tracking a dangerous possibility to its limits; and I think he miscalculated. Not that he failed to make a picture that works; but the attitude of

detachment required to make it work on his stated terms is too special, too rare, and too pitilessly matter-of-fact to acquit the work of morbidity. When affective human elements are conspicuously used, and yet not used as subjects, their subjugation becomes a subject that's got out of control. At any rate, no similar fracturing of known wholes has occurred since in Johns' work.[64]

That last sentence was perhaps still just defensible when it was written in December 1961, but, as Steinberg later acknowledged, only just. What is of interest here is both the disposition that could be seen as represented by *Target with Plaster Casts* and the reasons for its apparent rejection in the character of Johns's work over the rest of the decade.

The artistic culture of the mid-1950s in New York has by now been well-enough characterized in terms of its distinctiveness from, even reaction against, the culture of the Abstract Expressionist generation. The difference may not have been that great – and it is possible to exaggerate it – but it seems to have been there and represented, for example, in the general apolitical (though not depoliticized) demeanour of social and artistic practices and in changes of image and sexuality. If the art historians and gossips have got it right, the self-professed male avant-gardeist of the 1950s was likely to be intellectually and sexually different from the Abstract Expressionist. He had a dandy-like elegance of body and manner, delighted in cool and elegant plays of the mind, and was probably homosexual, bisexual, or experimenting with his sexuality. That description, for the most part taken from Moira Roth and Calvin Tomkins, can be and is applied to Johns and Rauschenberg, John Cage and Merce Cunningham as members of one relatively socially closed group among several others in the comparatively socially open subculture that was the New York artistic culture in the 1950s.[65]

It is not my intention here to attempt a sociological account of the New York avant-garde community of Johns's generation or to discuss the ways in which intellectual and sexual difference has, until recently, been avoided or glossed over in studies of the New York School.[66] It is important, however, to establish some plausible characteristics and tendencies of that culture that will at least serve to relate it to its comparatives. Any selfconsciously avant-garde formation has to be under-

stood as a historically specific subcultural group that is made up of many discrete groups whose members

> explore 'focal concerns' central to the inner life of the group: things always 'done' or 'never done', a set of social rituals which underpin their collective identity and define them as a 'group' instead of a mere collection of individuals. They adopt and adapt material objects – goods and possessions – and reorganise them into distinctive 'styles' which express the collectivity of their being-as-a-group. These concerns, activities, relationships, materials become embodied in rituals of relationship and occasion and movement. Some-times, the world is marked out, linguistically, by names or an *argot* which classifies the social world exterior to them in terms meaningful only within their group perspective, and maintains its boundaries. This also helps them to develop, ahead of immediate activities a perspective on the immedi-ate future-plans, projects, things to do to fill out the time, exploits. . . . They too are concrete, identifiable social form-ations constructed as a collective response to the material and situated experience of their class.[67]

Here it is important to avoid that form of idealization of the artist that identifies a constant type against a changing background. The New York avant-garde community of the mid-1950s was part of a burgeoning artistic culture that was geographically and stylistically more diffuse and diverse than any previous artistic culture New York had known, and its growth was accompanied by an increasing public awareness. And beyond it and affecting it, as it had been affecting all sections of American society since 1946, there was the general institution of a pervasive Cold War climate of repression which linked heterosexuality to 'Americanness' and homosex-uality – criminalized throughout the United States – to 'un-Americanness'.[68] The 'artist' and 'art' are socially produced categories. In the 1950s in New York the idea of 'art' – the kind of object a painting was, or a piece of music was, or a dance was, or a poem was, or a play was – and how it should be made or performed, and the idea of what kind of identity 'artist' was, and what his or her responsibilities comprised, were subjects of debate, serious ambition, recategorization, difficulties and obligations. With regard to dissident form-ations within and outside the avant-garde community I would

expect a tendency to the private, relatively socially limited or closed exchange of meanings and a matching cultivation of public euphemism (which entails metonymy) and irony; a withdrawal from prevailing forms of self-identification in social behaviour, including those that structure sexual relationships; a stance of public indifference towards those issues which invite the parading of commitment and belief; and a protective solidarity between intimates. One difficulty that certainly seems to have been more of an issue for Cage and Cunningham, Rauschenberg and Johns than for others was how in the pursuit of an expressive (representational or cognitive) but not expressionistic character for their art they could arbitrate between the conditions of individual and relatively socially closed, private life and the relatively public and socially open conditions of art.

In effect Johns opted for *Flag* as his inaugural work and the direction it suggested and withdrew for the rest of the 1950s from the dangers – real or imagined – of self-exposure that could be identified with and in the *Target with Plaster Casts*. *Flag* seems to have been understood as not *of* Johns at all, except in so much as he fabricated it in art. It raised questions of surface- and subject-matter but not of subjectivity or self-identity – at least, not in any obvious way. *Target with Plaster Casts* raised questions about an artist with 'a subject that's got out of control'.[69] *Flag* indicated a direction to go that seemed personally and philosophically neutral, even Wittgensteinian: 'Is it a flag, or is it a painting?'[70] Is it in art all vivid surface or all vivid subject-matter? Could you make it out in words? Was it important to know? No, you could not. And yes, it was. Johns pursued this idea of putting perplexity in paint – of explicitly questioning the visual – for six years: first with more flags and targets – after *Target with Four Faces* (illus. 34) always without plaster casts; then with paintings of alphabets (illus. 16); and numbers (illus. 17); and thereafter with paintings of colours and the names of colours (illus. 9). Of course, these were not the only thing he made. Along the way he also made things like *Grey Rectangles* (Collection of Mrs Victor W. Ganz), *Book* (Collection of Anne and Martin Z. Margulies), *Canvas* (illus. 18), *Drawer* (Rose Art Museum, Brandeis University), *Coathanger* (private collection), *Tennyson* (Des Moines Art Center), *Shade* (Collection Ludwig, Aachen), and *Painting with Two Balls* (illus. 57), things that obviously have their dark side and

16 *Gray Alphabets*, 1956, encaustic and newsprint on canvas, 167.6 × 124.5.
The Menil Collection, Houston.

17 *Numbers in Color*, 1958–9, encaustic and newsprint on canvas, 168.9 ×
125.7. The Albright-Knox Art Gallery, Buffalo, NY.

18 *Canvas*, 1956, encaustic and collage on canvas with objects, 76.2 × 63.5. Collection of the artist, on loan to the Art Museum, Princeton University.

signify otherwise but which did not effect the possibility of a psycho-sexual author-subject in the seemingly almost direct way that *Target with Plaster Casts* did – and does.

> *There are evidently more persons in him than one.* John Cage, 'Jasper Johns: Stories and Ideas', 1964[71]
>
> *'I think you can be more than one person,' he says finally. 'I think I am more than one person. Unfortunately.' And then he laughs.* Michael Crichton, *Jasper Johns*, 1977[72]

In the autumn of 1961 Johns's subject-matter and mode of representation changed.[73] After the philosophical innocuity and the frequent high coloration of the previous years, the works from this moment are subdued in colour; they are predominantly grey, and titled to connote emotional con-

ditions like dishonesty, anger, denial, negation or rejection; feelings lost or recalled. Steinberg, who was the first to write about them, understood these paintings – *Liar* (illus. 19), *Good Time Charley* (illus. 20), *No* (illus. 10) and *In Memory of My Feelings – Frank O'Hara* (illus. 8) – as the work of a painter who 'past thirty dares to be frankly autobiographical because his sense of self is objectified, and because he feels secure in the strength of his idiom'.[74] They could, of course, mean precisely the opposite. I shall consider two of these paintings here: *No* and *In Memory of My Feelings – Frank O'Hara*.

When Steinberg saw *No* in Johns's studio at the end of 1961 he described it like this:

Among Johns's December 1961 paintings, and in the same group with LIAR, is a larger picture called NO. Its painted field is made up of soft mottled grays. Fastened to a hook near the top is a long straggling wire hung loose and free. From its lower end dangle two letters, an N and an O, cut out of aluminum foil and casting a vagrant shadow. The shadow writes NO near a place that's already big with the same message – the word NO raised on the canvas in sculpmetal relief.[75]

19 *Liar*, 1961, encaustic, graphite pencil and sculpmetal on paper, 54 × 43.2. Private collection.

20 *Good Time Charley*, 1961, encaustic on canv with objects, 96.5 × 61 × 11.4. Private collection

Rudolph Burckhardt photographed it in this state, but afterwards, and probably not long afterwards, Johns returned to its surface and reworked it.[76] The 'straggling wire' that hung 'loose and free' from a 'hook' was replaced by a straightened wire coat-hanger attached to the stretcher by a screw eye, its movement arrested by a stitch it was made to make with the canvas (it goes through the surface and re-emerges) about halfway along its length. The aluminium letters were replaced

by letters of lead. The NO becomes fixed, denser, heavier. It is given a kind of *gravitas*. At the same time the surface was given more encaustic, a ruled line at the top left, and – between it and an already-in-place bit of collage matter – the delineation of Marcel Duchamp's 'erotic object', *Female Fig Leaf* (illus. 21), a bronze cast of which Johns acquired when he visited Paris on the occasion of his one-person show at the Galerie Rive Droite in the summer of 1961.[77] Johns told Crichton that the *Female Fig Leaf* 'was something metal that could be heated and pressed into the wax, and it was something I had around the studio'.[78] I take it that all these additions, which were made at the end of the year or early in 1962, were and are significant. But none of them seems more significant than the outline of *Female Fig Leaf*, which was carefully placed over, so that its delineation outlines them, two brushstrokes, clearly visible in the Burckhardt photograph, crossed in such a way as to make an 'X'. Maybe it was a case of 'X' marking the spot, the correct place. But as the mark of incorrectness, wrongness and error this 'X' contributes to the general meaning effected by the lead NO, the sculpmetal NO, and the shadowed NOs that *No* 'is a picture full of No'.[79]

There is a sketchbook note that, though it doesn't refer to *No*, shows that Johns, who for part of his military service had been stationed in Japan, was amused by the idea that 'no' in

Marcel
Duchamp, *Female Fig Leaf*, 1961
bronze cast of 1950
plaster original, 8.9
× 13.6 × 12.7.
Philadelphia
Museum of Art,
Gift of Mme Marcel
Duchamp.

Japanese translated the preposition 'of'.[80] In *No* the suspended NO and the other NOs are 'of' the canvas and each other. With this information we could – we are already in this mode – continue approaching the painting by attending to its surface and the relations between representations of NO. 'In many ways the word NO seems to caution the observer from jumping to conclusions about the nature of what he is seeing.'[81] ' "No" is a pun on "know", referring to the importance of the conceptual aspect of Johns' work.'[82] For Cage, 'Someone must have said Yes (*No*), but since we are not now informed we answer the painting affirmatively.'[83] You might even carry on: 'no' is 'on' spelt backwards. Or you might wonder if Johns appropriated the idea of using the word 'no' from Duchamp's illustration for Pierre André Benoit's poem 'Première Lumière', an etching of the word *NON*.[84] Or, with Duchamp in mind, you might wonder whether by marking the surface with the outline of *Female Fig Leaf* he implemented the instructions given in *Musical Erratum* 'To make an imprint mark with lines a figure on a surface impress a seal on wax.'[85] The point is not that such speculation is necessarily informative. It is rather more important to observe that the almost irresistible invitation to engage in it is distracting, and that such distraction – induced by the mechanisms of surface – may, at one level, be what Johns intended.

However, if we focus on mechanisms of surface as subject and ask what does it mean to quote Duchamp's *Female Fig Leaf*, because that is effectively what Johns is doing, and to do so in a relation of association to the negative 'no', we are obliged to consider a work concerned not so much with the production of a diverting surface as with the signification of a perplexing subject. The delineated trace does not just mark the surface. It is an index. There is an existential bond between it and its object, and between its object and that from which it was taken – female genitalia. (It is a cast not from life but possibly of an impression taken from the naked figure in *Etant donnés: 1° la chute d'eau, 2° le gaz d'éclairage* now in the Philadelphia Museum of Art. Johns would probably not have known this when he acquired it.[86]) The outline of *Female Fig Leaf* is made a sign that might function metonymically with reference to what the cast reproduces and to how making it enabled a kind of access to a particular object of desire and then closed or

denied it. This is one, and only one, chain of contiguity that can be written for the outline in *No*. It might also refer to – and probably does – the time and place, circumstances and events associated with Johns's acquisition of his *Female Fig Leaf*. In this sense it is a souvenir of his trip to Paris, of what caused or necessitated the trip, of events and feelings associated with it, and of what its effects were, among which we may include the imprinting of *No*.[87] I know the sign is arbitrary, but I also know that there is a cultural route from the non-arbitrary trace to the culturally produced sign.

The other painting I want to consider, *In Memory of My Feelings – Frank O'Hara* (illus. 8), has its title stencilled along the bottom of its two hinged but immovable canvases. An authenticating 'J. JOHNS' is also stencilled there. And the date '[19]61'. The title refers to a poem by Frank O'Hara that was written in 1956, published in 1958, and anthologized in 1960.[88] O'Hara, Associate Curator of Painting and Sculpture at the Museum of Modern Art, was a figure of frenetic centrality in the artistic culture of New York in the 1950s and 1960s.[89] The literature of that culture constructs him with fondness and affection as a poet (primarily) and playwright, a critic and collaborator with artists. Though his friendship with Larry Rivers was and probably still is most public, recorded as it was in the published reminiscences of both as well as in the poetry of the one and the painting of the other, his closest friendships were with Joe LeSeur, with whom he lived between 1955 and 1965, and Vincent Warren, the object of the *Love Poems (Tentative Title)* written between 1959 and 1961. O'Hara also loved, and was loved by, two women, one of whom, the painter Grace Hartigan, is the dedicatee of the poem 'In Memory of My Feelings'. Johns and O'Hara probably met around the time of the Castelli show in 1958. By the summer of 1959 they were friends, and remained so until the poet's death in 1966. In July 1959 O'Hara wrote to Johns about Jack Kerouac's *Doctor Sax*, recommended the work of Gary Snyder, Philip Whalen and Mike McLure to him, and compared Robert Duncan and Charles Olson as West Coast and East Coast poets.[90] Johns turns up in O'Hara's poetry this year also. In August, in 'Joe's Jacket', O'Hara and Johns with Vincent Warren take a train to Southampton, Long Island, for a weekend party at Janice and Kenneth Koch's, where O'Hara will fall in love with Warren.[91] The next year, in 'What

Appears To Be Yours', O'Hara is 'zooming downtown' to Johns.[92] And a few years later, in the letter-poem 'Dear Jap' of 10 April 1963, O'Hara made reference to the rubber cast of his foot that Johns had taken in 1961 for the sculpture *Memory Piece (Frank O'Hara)* (private collection).[93] (In the sculpture, which was not completed until 1970, the cast is attached to the underside of the lid of a three-drawer sand-box in such a way that when the lid is closed it footprints the sand.) It was in 1963 that Johns and O'Hara began a print-poem collaboration that was published in 1965 as the lithograph *Skin with O'Hara Poem* (illus. 26).[94]

In Memory of My Feelings – Frank O'Hara, which was painted some five years before the poet's death, cannot be interpreted as an *in memoriam* for O'Hara. But using the title of the poem and the name of its author to make and title the surface may well have enabled Johns to produce a painting that represented his own feelings, something he had not been able to do, or had not wanted to do, perhaps, since *Target with Plaster Casts*. Here the words 'In Memory of My Feelings – Frank O'Hara' function as a kind of hinge between the painting and O'Hara's poem, designating difference and articulation, marking a correspondence and co-operation between the meanings that proliferate for the painting and the poem, the painter and the poet, their practices and lives.[95] Attending to *In Memory of My Feelings – Frank O'Hara* in this way produces a surface that represents Johns's feelings by way of a contiguous relation or contact with the meanings of the poem and the life story of the poet.

'In Memory of My Feelings' has been valued not only as the best of O'Hara's autobiographical poems but also as 'one of the great poems of our time.'[96] It is a poem whose central theme is concerned with 'the fragmentation and the reintegration of the inner-self – a self that threatens continually to dissipate under the assault of outside forces'.[97] Grace Hartigan read it as defining 'inner containment' – 'how to be *open* but not violated, how *not to panic*'.[98]

My quietness has a man in it, he is transparent
and he carries me quietly, like a gondola, through the streets.
He has several likenesses, like stars and years, like numerals.
My quietness has a number of naked selves,

so many pistols I have borrowed to protect myselves
from creatures who too readily recognize my weapons
and have murder in their heart!

It is not a poem in which the poet recalls events; it is not about
what has happened. For most of the poem what the poet
recalls is how he felt or how he feels about how he felt when
something happened.[99] 'New feelings generate new selves',
and 'from the midst of the poet's many selves a vision of an
essential self emerges – a self that is always *becoming* but never
is content to be singly what it is, a self that constantly asserts "I
am *not* what I am," and is determined to escape beyond the
boundaries of a fixed personality.'[100] The image of the
serpent, the poem's leitmotiv, has been taken to represent
either 'the poet's true self – the self that must triumph if he is
to become an artist' or 'the essential self that must be
preserved despite the constant passing away of one identity
after another.'[101] The 'serpent's turn' comes at the end of the
poem:

<blockquote>

And yet
I have forgotten my loves, and chiefly that one, the cancerous
statue which my body could no longer contain,

against my will
against my love
become art,
I could not change it into history
and so remember it,
and I have lost what is always and everywhere
present, the scene of my selves, the occasion of these ruses,
which I myself and singly must now kill
and save the serpent in their midst.
</blockquote>

These last lines seem to give us some 'forgotten . . . love[s]
. . . [which] become[s] art . . . and so [is] remember[ed]'; the
public display of selves that is also the event or cause of
eluding or dodging that display; and something 'lost' that 'is
always and everywhere present' which must be killed to save
the self. What are we to make of this? One interesting
commentary reads these last lines as signifying a poet who
'writes poems to define his feelings and to abolish them as
definitions of himself. The single, essential self that emerges

. . . is the unfaithful, self-betraying serpent shedding selves like skins.'[102] In a sense we do not have to make anything of it because whatever we do make of it will not necessarily access what Johns made of it in 1961. And what Johns made of it is realized there in and as the surface of *In Memory of My Feelings – Frank O'Hara*.

In Memory of My Feelings – Frank O'Hara does not illustrate O'Hara's poem. The painting refers to the poem, and by referring to it alludes obliquely to the poem's main themes of feelings remembered and metaphorical deaths of selves. Though the painting 'has a man in it' he is hardly 'transparent'. I take it that the 'feelings' are there on the surface of the two canvases and that the 'man in it' is underneath. The grey brushstrokes that dominate the right and mark the white ground and turpentine-like brown-greyness of the left canvas are there not as the direct expression of feelings but as signifiers of the expression of feelings appropriated from the pictorial language of Abstract Expressionism. In the context of Johns's surface they refer to the idea of the unmediated association of feelings and facture, but their very identity as appropriated signifiers inhibits our seeing and understanding them as marks directly expressive of Johns's feelings. By the early 1960s brushstrokes like these had become an integral component of Johns's repertory of surface mechanisms. As they enter *In Memory of My Feelings – Frank O'Hara* they mark it, albeit at a certain remove, as *of* Johns. They function as a signature brush-marking that guarantees authorship, keeps past present and comforts us that the strangely novel is never completely new. They also obscure and hide other surface matter laid down in primary and secondary colours. And they almost bury the words 'DEAD MAN' that are stencilled across the lower edge of both canvases: 'D' on the left canvas, 'EAD MA[N]' on the right, and then, over that, but only on the right canvas, again – this time in smaller letters – 'DEAD MAN' (illus. 22). And they completely cover the human skull that Johns pictured, probably with a crude stencil of his own devising, in the top right of the right canvas. You can make it out from its pentimenti. With these dead men and the skull – not forgetting the outline of Duchamp's *Female Fig Leaf* in *No* – Johns returned, in words and pictures, to figuration after years of painting flags and targets, numbers and alphabets, colours and the names of colours.

Cage concluded the essay he wrote for the catalogue of the
retrospective exhibition of Johns's work at the Jewish
Museum, New York, in 1964, 'Jasper Johns: Stories and Ideas'
with a note he had come across in one of Johns's sketchbooks:
'A Dead Man. Take a skull. Cover it with paint. Rub it against
canvas. Skull against canvas'.[103] This note relates the 'DEAD
MAN' and the stencilled skull in *In Memory of My Feelings –
Frank O'Hara* to *Arrive/Depart* of 1963–4 (illus. 23), with its
imprints of a brush, a shell, a hand, and a skull and outlines of
two cans and Duchamp's *Female Fig Leaf*; and, thereafter, to
the screenprint *Untitled (Skull)* of 1973 (illus. 24) and the *Tantric
Detail* paintings of 1980–81 (illus. 54, 55, 56) – all, in this
accounting, by way of some drawings that he had made in
1962 by covering parts of his body with oil and pressing them
against sheets of draughting paper that were then dusted and
rubbed lightly with graphite. One of these, *Study for 'Skin I'*
(illus. 25), provided him with the prototype ground for
O'Hara's 'The Clouds Go Soft', the poem chosen for the
collaboration *Skin with O'Hara Poem* (illus. 26).[104]

> The clouds go soft
>
> change color and so many kinds
> puff up, disperse
> sink into the sea

One commentator has claimed that O'Hara was rarely 'so
conscious of the inexorability of fate' as he is in this poem: 'he

65

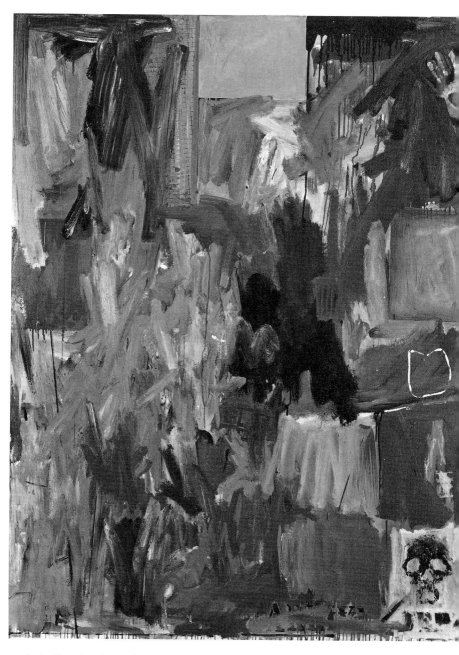

23 *Arrive/Depart*, 1963–4, oil on canvas, 173 × 131. Bayerische
Staatsgemäldesammlungen, Munich.

Untitled (Skull), silkscreen, the portfolio *ty & Paradoxes*, 83.8. ished by ciples, Inc, York.

can escape neither his shirt size nor the sand that gets in his eye ("the same eye").[105]

at 16 you weigh 144 pounds and at 36

the shirts change, endless procession
but they are all neck 14 sleeve 33

and holes appear and are filled
the same holes anonymous filler
no more conversion, no more conversation

the sand inevitably seeks the eye
and it is the same eye

In this reading, the 'holes' are not, of course, armholes but graves'.[106]

But why the fork and spoon, bound together, used, suspended on the straightened coathanger screwed to the top of *In Memory of My Feelings – Frank O'Hara*? Are they connected by some family resemblance to the other household objects –

25 *Study for 'Skin I'*, 1962, drafting paper with powdered graphite, 55.9 ×
86.4. Collection of the artist.

26 *Skin with O'Hara Poem*, 1963–5, lithograph, 55.9 × 86.4. Published by
ULAE.

68

the beer-can, the coffee-can, the coat-hanger, flashlight, light-bulb, and so on – that find themselves in Johns's studio and thence in his art? Or do they signify in some more distinctive sense? In relation to *Painting Bitten By A Man* of 1961 (private collection), perhaps?[107] I should make it clear that to ask such questions is not to invite a reply that organizes Johns's practice into a rational iconography. The point, rather, is that coherence might be found in the underlying mechanisms of reference and association.

In 1967 Johns illustrated O'Hara's 'In Memory of My Feelings' for a posthumous edition of a selection of his poetry published by the Museum of Modern Art.[108] The principal illustration is of a place-setting – a knife, fork and spoon (illus. 27). At the end of the poem there is a single spoon. One of O'Hara's poems – a poem associated by him with 'In Memory of My Feelings' – was titled 'Dig my Grave with a Silver Spoon'.[109] It seems likely that there is some private set of associative references or meanings at work in *In Memory of My Feelings – Frank O'Hara* between Johns and O'Hara, Johns and O'Hara's poem, the poem and feelings felt when something happened, a poem and metaphoric death, death (metaphorical or actual) and a spoon, fork and knife; a set of moves or 'games' in a language that signifies to those who know the language and its terms and are able to perceive its significance. We realize this because the mechanisms of language are public. We know the language but not the dictionary. To say that the spoon signifies death (metaphorical or actual) is not to

Illustration for
Memory of My
lings', 1967,
phite and
phite wash on
stic sheet, 31.9
8.4. The
seum of
dern Art, New
k.

say that it signifies death (metaphorical or actual) wherever it appears. The meaning of the cutlery, which is a recurrent signifier in Johns's work after 1961, depends on the context of its use in each specific work. However, the genesis of a metonymic exemplar goes to some kind of consistency, just as the genesis of a word may be what serves to determine appropriate contexts of use.[110]

Portrait – Viola Farber (illus. 28), begun in 1961 and finished in 1962, has been seen as 'a direct variation on' *In Memory of My Feelings – Frank O'Hara*.[111] Perhaps it is. It is larger, but not that much larger; it is painted mostly in greys; it uses a hinged canvas; and its 'VIOLA' has been stencilled with superimposed capitals in more or less the same place in the same manner as 'DEAD MAN'. Here the spoon and fork get their next context of use after *In Memory of My Feelings – Frank O'Hara*, each bent to make a right-angle, fixed to the surface as if to function as brackets, and joined by a rubber-band. The hinged canvas above them can be unhooked and pulled down to reveal its back painted grey, the open space into which it had been inserted, and, through the opening, the wall. If some of these mechanisms come into this surface from or via *In Memory of*

28 *Portrait – Viola Farber*, 1961–2, encaustic on canv with objects, 122 157.5. Private collection.

My Feelings – Frank O'Hara, where, in a relation of association, does 'VIOLA' come from? Viola Farber, who had been a featured dancer in the Merce Cunningham Company since the mid-1950s, was, like O'Hara, one of Johns's friends. Perhaps the use of her name on the surface and in the title hinges something about her and her dancing to Johns's painting in much the same way that O'Hara and 'In Memory of My Feelings' had been hinged to *In Memory of My Feelings – Frank O'Hara* with its spoon and fork.[112] Metonymy. Memories and feelings. Naming.

In 1986 the spoon, not an actual spoon but the picture of a spoon painted with metallic paint, turned up in the *Fall* canvas of Johns's selfconsciously autobiographical and retrospective four paintings collectively titled *The Seasons* – another practical and moral studio project (illus. 11). Here the context of use seems a return to the moment that determined *No* and *In Memory of My Feelings – Frank O'Hara* and *Liar* and *Good Time Charley*. In its place on the surface of *Fall* the spoon connects several fragments from Johns's past work to each other in a more or less coherent relation. Specifically, it relates an outline taken from Duchamp's *Self-portrait in Profile ('Marcel dechiravit')* and a Swiss sign, with its skull, crossed bones and *'chute de glace'*, warning of avalanches, where in translation *'chute'* makes the obvious pun on 'fall' and provides a synecdoche of *'Etant donnés: 1° la chute d'eau, 2° le gaz d'éclairage'*, to the diseased figure – always camouflaged but never completely hidden in Johns's work – from the 'Temptation of St Anthony' panel in Matthias Grunewald's complexly hinged *Isenheim Altarpiece*, an image associated by Johns with skin – 'yes, but it's skin'.[113] Memories: a Duchampian outline, death, sexuality, 'skin', and a spoon – altogether in a 'scene of my selves'.

We can now begin to reconstruct some of the contiguities and relations of human experience that Johns may have associated with the cutlery and imprints in the paintings made at the end of 1961, and if we can do so in terms of subject rather than surface then perhaps we can think about doing the same for the cast fragments, imprints, brushstrokes and surfaces of *Untitled*, 1972.

I have suggested that when Johns's work underwent its distinct and discernible change in 1961, that change entailed a shift of emphasis from the kind of work in which his initial,

and considerable, success was based – the flags, targets with and without plaster casts, numbers, letters and so forth of 1954–61 – to a form of painting, 'sentimentalizing the human', adumbrated in and with the *Target with Plaster Casts* but apparently rejected immediately thereafter. In speculating on the causal conditions of this shift (it is speculation that can now be brought in from the margins of this essay) I resort to the reproduction of biographical gossip. The years 1954–61 were the years in which Johns and Rauschenberg were together as a couple. The following excerpt is taken from Calvin Tomkins's biography of Rauschenberg, *Off the Wall*, published in 1980:

> Sometime in 1961, Johns began spending a large part of his time in a house he had bought on Edisto Island, off the coast of South Carolina. Rauschenberg had moved, meanwhile, from Front Street to a huge, fifth-floor loft in a commercial building on Broadway near Twelfth Street, in Greenwich Village. They continued to live together when they were in New York, but their friends felt a growing strain between them. Before, as Ileana Sonnabend once said, they had been 'so attuned to one another that sometimes it was hard to tell who was who,' but now Johns was guarded and withdrawn, and sometimes bitingly sarcastic.
>
> They both went up to Connecticut College in the summer of 1962, to work with Merce Cunningham, who was there under the college's dance residency program. By the time the summer ended they were no longer together. The break was bitter and excruciatingly painful, not only for them but for their closest associates – Cage and Cunningham, and a few others – who felt that they, too, had lost something of great value.[114]

There are two more bits of gossip that seem relevant to understanding the change in Johns's work in 1961 and the significance of *In Memory of My Feelings – Frank O'Hara*. Johns would have known that in 1960, the year prior to making *In Memory of My Feelings – Frank O'Hara*, O'Hara's relationship with Grace Hartigan had ended. Evidently, between 1951 and 1960 Hartigan and O'Hara 'saw each other or spoke on the phone almost every day. They frequently spent weeks – even months – together in the country. . . . In 1960, after a major quarrel with Frank, Grace left New York, married, and settled

in Baltimore. She sent him a strongly worded letter breaking off all relations. They did not see each other again for five years, and then only briefly.'[115] O'Hara's 'In Memory of My Feelings', written in 1956, may have been read somewhat differently in 1961. With the intimacy between the poet and the poem's dedicatee by then terminated, the poem would have gained a new context for reading and a changed biographical reference which maybe Johns utilizes. Perhaps – this is my second bit of gossip – it is also significant for the analysis of the possible references mobilized in *In Memory of My Feelings – Frank O'Hara* that Johns, who was there when the love affair began in July 1959, would have known in the summer of 1961 that O'Hara's romance with Warren was ending.[116] The last of O'Hara's *Love Poems*, 'A Chardin in Need of Cleaning', is dated 6 July 1961.

I assume that those who knew of the break between Johns and Rauschenberg, and were personally or socially involved in some way during 1961–2, were potentially able to respond to paintings like *No* and *In Memory of My Feelings – Frank O'Hara* on at least two levels: they would have been able to admire the mechanisms of surface and to have read the details as meaningful by reference and association – metonymy snatching the socially-closed subject from the beholder's grasp while never subverting the socially-open and highly valued surface. What is of interest here is not that these meanings are exclusive but that they are publicly kept at a distance by metonymy.

Meticulous, past midnight in clear rime. Hart Crane, 'Voyages V'[117]

I felt that Passage *suggested a state of affairs that might not be static, a state of change or a detail of a larger state of affairs.* Jasper Johns to Christian Geelhaar, 1978[118]

Johns probably started looking for a property in South Carolina at the end of 1960, around the time of his retrospective exhibition at the Columbia Museum of Art. By mid-January 1961 he was planning to buy a house at Edisto Beach, where he could 'settle in quiet solitude for several months each year'.[119] As Tomkins noted, the removal in 1961 of part of his life and art practice to the house at Edisto Beach – the

0 through 9 variations for his exhibition at the Galerie Rive Droite were painted there – coincided with, or was a concomitant of, the breakdown of his friendship with Rauschenberg, which came to an end in the summer of 1962. It was at this moment in 1962 that he began to produce several paintings in his Front Street studio, New York, whose surfaces and titles evoke the seaside or, more specifically, the life and poetry of Hart Crane: *Passage* (illus. 12) and *Diver* (Collection of Irma and Norman Braman) of 1962, and *Land's End* (San Francisco Museum of Art) and *Periscope (Hart Crane)* (illus. 13) of 1963. Before I re-engage with my discussion of *Untitled*, 1972, I want briefly to consider the way *Passage* – another painting that uses cutlery, this time a fork suspended horizontally in front of the surface, pulled into place from the left by a chain and from the right by a wire – relates to *In Memory of My Feelings – Frank O'Hara*, to its mechanisms of meaning and possible meanings.

It was Alan Solomon who, in his introduction for the catalogue of Johns's exhibition at the Jewish Museum in 1964, pointed out that the title of *Periscope (Hart Crane)* was taken from these lines in Crane's 'Cape Hatteras', part IV of *The Bridge* (1930):

> What whisperings of far watches on the main
> Relapsing into silence, while time clears
> Our lenses, lifts a focus, resurrects
> A periscope to glimpse what joys or pain
> Our eyes can share or answer – then deflects
> Us, shunting to a labyrinth submersed
> Where each sees only his dim past reversed . . .

Solomon sensed 'a subjective response [by Johns] to the poet's anguish, for some deep personal reason' but gave little away as to its character and causes.[120] He continued: 'His [Johns's] reserve about himself (which has been respected here) masks a profound vulnerability; one wonders about his own submersed labyrinth, how he sees his own dim past reversed, like the words in the painting. These occasional overtones of feeling in the work have become more prevalent, in contrast with the complete personal detachment to which we were accustomed earlier.'[121] Solomon also pointed out, somewhat misleadingly, that Crane's poem described 'Johns' country, the Carolina coast'. Taking the hint from Solomon, it seems

that this group of paintings, their meanings associated with Crane and his poetry, are to be read not only as *of* Johns's evacuation from New York but also as *of* a dimmer past – a past not clearly perceived or remembered but, nevertheless, not completely forgotten. The past of Johns's childhood and adolescence, perhaps. This is not my concern. All we need to do here is keep in mind that he relocated part of his life and practice in the state of that childhood and adolescence. *Passage* and *Periscope (Hart Crane)* may also be *of* that bit of Johns's biography: past and present, youth and maturity, joined and broken by the references to Crane and his poetry.

What, then, is outside the surface of Johns's painting that gets inscribed within it by the appropriation of the title of one of Crane's most important poems – 'Passage'?[122] There has been little agreement about what it is that 'Passage' is trying to communicate.[123] Those persons who have tried to make sense of it have usually begun by situating it within a story of Crane's life, some of them by mentioning his homosexuality but most of them by writing around it. The outline of the story is this: Crane was not in good shape in the spring of 1925: his year-long affair with Emil Opffer – celebrated in his series of six love poems collected under the title 'Voyages' – was over; he was suffering from headaches and urethritis; he had resigned his job; needing to remove himself from the oppressions of New York he went to rest and recuperate with friends at their house near Patterson in the foothills of the Berkshire Mountains in New York state; and while he was there he wrote 'Passage'. Conventional readings of the poem note that it is set near the sea, which for Crane is usually a motif of benevolence:

> Where the cedar leaf divides the sky
> I heard the sea.
> In sapphire arenas of the hills
> I was promised an improved infancy.

The 'I' of 'Passage' desires a new beginning, a new origin of knowledge and self-authorization, and to this end the 'I' tries to rid itself of memory – a 'casual louse' that among other things 'wakens alleys with a hidden cough' – by abandoning it in a ravine. However, finding it impossible to pass beyond memory, he returns; and having returned confronts his daemon, or whatever or whoever the 'thief' is that has his

'stolen book in hand,' to argue with, or about, honour and
fame or time and art or whichever:

The evening was a spear in the ravine
That throve through very oak. And had I walked
The dozen particular decimals of time?
Touching an open laurel, I found
A thief beneath, my stolen book in hand.

'Why are you back here – smiling an iron coffin?'
'To argue with the laurel,' I replied:
'Am justified in transience, fleeing
Under the constant wonder of your eyes –.'

One of the richer and more complex explications of this bit of
the poem has the 'I' return 'to the scene of his abandoned
memory to confront himself in the evening, the (historical)
lateness or modernity of his life. . . . If the poet is "justified"
he will not be justified in a religious sense, for that would
assign him a transcendental being, one with too fixed an
identity. In "Passage," he is justified only "in transience," in
the materiality of history, the materiality of the signifier, the
materiality of the body.'[124] At the end of the poem the 'thief'
closes the book and both he and the 'I' are 'troughed . . . into a
glittering abyss':

A serpent swam a vertex to the sun
—On unpaced beaches leaned its tongue and drummed.
What fountains did I hear? what icy speeches?
Memory, committed to the page, had broke.

Whatever it was that Johns made of 'Passage', he seems to
have taken the 'I' of the poem 'smiling an iron coffin' into his
painting as the imprint of the sole of an iron named in stencilled
letters 'IRON'. He probably read it conventionally, and, as he
would have read O'Hara's 'In Memory of My Feelings', which
borrows from it, as a poem obsessed with memory, with crisis
in life and art, with the need to transcend the self by a loss of
self and with the failure of that attempt. But he would also have
read it, as many readers would not have done, as another
instance, like O'Hara's 'In Memory of My Feelings', of com-
plexly displaced homosexual autobiography, as a poem deter-
mined by and effecting a knowledge of a homosexual self or
identity or want-of-being in a moment of transition.[125]

The foregoing suggests something of what might be hinged to the surface of *Passage* by way of reference to Crane's poem. But this is not all that there is to it. Explanation of the relation of association that might be hinged to, or exist in, the gliding displacements between Crane's 'Passage' and Johns's *Passage* does not begin to account for the painting's surface as surface. It also has to be bluntly stated that neither the surface nor the subject of *Passage*, or of any painting by Johns, should be reduced in explanation to the representation of a homosexual self. There is no self present in the surface/subject relation which makes Johns's works what they are. Nor can one be fixed to it convincingly. Attempts to do so are bound to fail. But not to understand surface and subject in some extended way as *of* a self in its alterity – in motion and translation – is probably to seriously misunderstand it.

> *Seeing a thing can sometimes trigger the mind to make another thing. In some instances the new work may include, as a sort of subject matter, references to the thing that was seen. And, because works of painting tend to share many aspects, working itself may initiate memories of other works. Naming or painting these ghosts sometimes seems to be a way to stop their nagging.*
> Jasper Johns to Richard Francis, 1982[126]

As I noted earlier, the hatched surface appears for the first time in Johns's work on the left canvas of *Untitled*, 1972 (illus. 6). It has been argued that its use there and the change of style it inaugurated evidences his late interest in the work of Pollock, an interest that began with, or was accompanied by, an interest in Picasso and his work.[127]

Philip Leider wrote of Pollock in 1970 that it was 'as if his work was the last achievement of whose status every serious artist is convinced'.[128] This was particularly true for New York artists in the later 1950s and the 1960s. Pollock had established American painting as something in relation to which they could establish their practice. Thanks to his legacy they were liberated from the need to go back to Cubism. They had to transcend it, and transcend it by way of Pollock. This was part of the conventional wisdom of Modernism then.

Johns seems to have been an exception to that generalization. There is little sign before the early 1970s – that is to say, before he started producing the hatched surfaces – that he

was interested in Pollock.[129] Yet in 1973 he gave the first of his independent all-over hatched paintings – an extended development in oil and encaustic of the surface in *Untitled*, 1972 – the same title as the painting that is generally taken to be Pollock's last, or penultimate, work on canvas, *Scent*, 1955 (a painting once owned by Mrs Leo Castelli: illus. 14 and 29). Johns has said that he did not choose the title 'Scent' as a reference to Pollock's painting.[130] In which case it was an accidental naming, consistent with his persistent and identifiable use of this kind of reference. And its effect is much the same. Whether intended or not, the title takes a knowledge of Pollock and his art practice back into Johns's *Scent* and the hatched surface of *Untitled*, 1972. The surface mechanism would have done that anyway – the accidental title only serves to make the reference more engaging and emphatic. Both title and surface pick up on, or recall, Pollock's concern with subject. According to O'Hara it was with *Scent* that Pollock 'turned again toward his beginning and the manner of *Eyes in the Heat*' of 1946.[131] I take this to mean that O'Hara thought it was with *Scent* that Pollock resumed his practice of concealing subject-matter in between and under the painted activity that made the surface. The idea of concealment and various procedures of concealment – of veiling the imagery – were important to Pollock's practice.[132] They were also important for Johns, and, as we have seen, had been for many years prior to *Scent* and *Untitled*, 1972. Both artists seem to have had in common the need to represent something in their painting, and then to conceal it. But not completely. A sketchbook note, which seems to relate to the oil and encaustic flagstone surfaces in *Untitled*, 1972, asks: 'to see that something has happened. Is this best shown by "pointing" to it or by "hiding" it[?]'.[133] With this in mind we may be alerted to the idea that what is veiled, camouflaged or hidden in Johns's work, as it is in Pollock's, is nevertheless alive, signifying or referring. Indeed, putting it out-of-sight, veiling it, camouflaging it or hiding it – whatever 'it' is – is a way of keeping it in mind, signifying or referring.

Taking *Scent* as a key allows us to see and understand the hatched surface and its use in *Untitled*, 1972, as a reference to Johns's concerns with, or problems of, surface and subject, or even as a way of creating a lineage and history whereby he paints himself into a tradition while differentiating his work

29 Jackson Pollock, *Scent*, 1955, oil on canvas, 198.1 × 146.1. Collection of Larry Gagosian.

from it. Maybe Johns, whose currency and value in the 1970s was fast establishing him as the pre-eminent artist of his generation, glimpsed his own place in the successive episodes – surfaces – of art history after and along with Pollock's, and painted to confirm it. If this explanation is correct, if Johns was concerned to acknowledge, refer to and establish his place with Pollock and to assert the distinctiveness of his own work, he might well have felt the need to adopt a form of 'holistic', 'flat', factitious surface as an appropriate reference. However, he would have found this difficult to achieve by means of his usual mechanisms of surface, his usual mention of Abstract Expressionist-derived protocols and procedures. He had to adopt a novel means of producing such a surface, a new mechanism that would establish some distance. Johns could not produce his all-over surface by means compatible with Pollock's, but the effect had to be more or less the same. The story of the decorated car on the Long Island Expressway is apt in this sense at least. Johns's mechanisms of surface – as he said with reference to the flagstones – tend to be appropriated rather than invented. But the story of the decorated car is dubious in another sense, because the hatched motif seems to have been appropriated not from it but, via it, from Picasso. If we can defensibly say that the use of the hatched surface and the change of style it occasioned is significant of a late interest in Pollock, then there is a sense in which that very lateness renders the reference to Picasso more plausible. In the metonymic chain the mention and use of Pollock refers to Picasso, as does the mention and use of the decorated car, but that mention and use should not be mistaken for meaning.

Johns's triptych *Weeping Women* of 1975 (illus. 30) provides a clue to the network of interests within which aspects of Pollock's and Picasso's work were capable of being synthesized on the same picture plane. The title refers to Picasso's *Weeping Woman* of 1937 (Tate Gallery, London) and takes a knowledge of it and its producer back into Johns's painting. There is just enough striation or hatching in Picasso's painting to cast further doubt on the role of the decorated car as a determining factor. However, it is relatively unimportant whether the hatchings are derived from Picasso's *Weeping Woman*, as has been suggested, or from his paintings of 1907–8 – *Nude with Drapery* in the Pushkin Museum, Moscow, is an

example that comes to mind – or, as seems most likely, from the hatchings in the *Women of Algiers* of 1955 (illus. 31). For Picasso, striations were a form of autonomous decoration organizing and controlling a surface of a painting with vivid imagery – usually female figures. (In the literature of art around the time that Johns was working on *Untitled*, 1972, this vivid imagery was being scrutinized with reference to the *Women of Algiers* and questioned as to why Picasso would scar and mangle, dismember and fragment the female body in the process of representing it. Johns was probably aware of this and possibly found the discussion interesting.)[134] It is not hard to see why he should have been interested in Picasso's use of striations, particularly if I am right in calling attention both to the practical determining power of the surface/subject opposition in Modernist painting and to the disposition on his part to turn the decorative value of the supposedly expressive surface towards the signifying power of subject-matter.

It may be that the paint-job on the car answered the problem, or triggered an answer, to the problem of how to adapt Picasso's striations in the interests of addressing Pollock, of how to organize appropriated aspects into an all-over 'abstract' painting. And if this seems plausible, I offer the following suggestion: that in *Scent* Johns engaged with, or referred to, the Abstract Expressionism of Pollock by way of the late Cubism of Picasso, and that in *Weeping Women* he engaged with, or referred to, the late Cubism of Picasso by way of the Abstract Expressionism of Pollock. For those who

30 *Weeping Wome* 1975, encaustic ar collage on canvas 127 × 259.7. Private collection

can accept that the historical tendency of Modernism is to set decorative surface against vivid subject, but who believe – or want to believe – that vivid subject prevails, *Weeping Women* might be regarded as evidence of a heroic struggle to preserve vivid subject. For those disposed to divine 'difficult', 'hard won' paintings, *Weeping Women* could be claimed to be just that, on the basis of conventional evidence at least. It has been claimed that you can almost see a figure or figures 'trapped within' or 'suggested by' the hatchings.[135] The iron imprints and can-marks have been seen as arms or breasts, legs, hands and tear-drops.[136] Certainly *Scent* looks more confident and composed, as if Johns was more thoroughly in control of his various mediums in the wilful navigation of the surface to decorative effect. However, that a surface looks more controlled in no way enables one to say whether it was any more or less difficult to produce, conceptually or practically. What is more significant is that Johns appears to treat the surface/subject opposition with a degree of selfconsciousness or insouciance, that is to say that he treats discursively what is usually taken as constitutive of Modernist painting.

Johns's story about the decorated car now has to be seen as a feinting – though not a disingenuous – retrodiction rather than as an adequate explanation of what the hatched surface is *of*. We may accept that the sight of the eccentrically painted car

Pablo Picasso, *nen of Algiers* ʼsion 'O'), 1955, ɔn canvas, 116.8 49.9. Collection ⁄rs Victor W. ₁z.

provided a stimulus or impulse or link in a causal or metony-mic chain, but this is far from according that glimpse a privileged status in any explanation of his use of and vari-ations on the hatched surface. It is necessary, however, to realize the story's importance to Johns as a way of talking about the hatching motif in a manner that draws and diverts his and our attention from what and how the hatched surface means. The hatched surface of *Untitled*, 1972, may perhaps best be seen as signifying some point of intersection and dispersion between Johns's thinking about Picasso and Pol-lock and the means and meanings of certain paintings by them. If so, that intersection and dispersion is a surface and subject – and an explanation of that surface and subject – rendered feasible or possible for Johns by connection with, and by reference to, a decorated car.

There are no fragmented figures in the hatched surface of *Untitled*, 1972, but we are directed to them by it. Johns uses Picasso's hatching to refer to the subject that, for example in the *Women of Algiers*, it surrounds or edges. He uses the perimeter to signify the centre. What is presented refers to what is absented. But at the end the fragmented figures are there, plain for all to see, battened over the right surface. The move from left to right is one of revelation: Johns shows us what is referred to by the hatchings taken from Picasso, and, perhaps, what is veiled or hidden in the work of Pollock. The move from right to left is a different kind of revelation: the figure fragments become abstract patterns.[137] Either way, the surfaces are turned in a dialectical relation.

As far as I know, Johns has not commented on the right panel of *Untitled*, 1972, with its collage matter and brush-strokes, can and iron prints, battens and wax casts except to say that whatever 'happens' with the wax casts – and in at least one of them there is 'something happening' – compared with the plaster casts in *Target with Plaster Casts* (illus. 7) occurs in 'a different way' and on 'a different level'.[138] Its obvious reflexivity seems to make any story about its origin or meaning superfluous. Yet it does more than reflect a previous work. At some point in its making Johns associated targets with the casts, had them there on the surface, and then hid them, which suggests that for a moment history was repeated and *Target with Plaster Casts* was almost made again. If so, the recurrence of, or the return to, that moment – or a moment like

it – would have to be considered part of its meaning. However, that moment was not so much repeated or returned to in 1972 as carried forward from the mid-1950s as the always present 'truest nature' of Johns's art. The two imagistic relations of part to whole and whole to part and of contiguous or concomitant association that were established in *Target with Plaster Casts* as visual themes were also established as the meaning producing tropes, synecdoche and metonymy, which served him as the model of figuration in general. *Untitled*, 1972, I think more than any other painting by Johns, makes its structures of meaning visible as mechanisms of surface. What began as a visual image of figure fragments in association with concentric circles became a figure of a figure of speech, and this is what we are reminded of here in *Untitled*, 1972 – whatever and wherever the meanings are that we are turned away from and towards. We experience it as the figure of a figure of speech.

Of course, no one is in a position to provide a secure account of what *Untitled*, 1972, means. The production of meaning is social and institutional, differential and dispersed, contestable and continually renewed. The problem is to discover not what experience or meaning is referred to by the picture's aspects or elements of depiction, but how those aspects or elements might constitute or evoke an experience or meaning. All I have done is attend to those aspects or elements on the reasoned assumption that they should be understood and explained not on the basis of a supposed metaphorical adequation between two experiences but as synecdoches and metonymies evoked by and evoking associations or references to other surfaces, to poems, to authors, events, memories, feelings, associations defined by the most momentary contiguities in time and space. It is in the spirit of this inquiry – of trying for a language in which it might be possible to describe what and how Johns's pictures do what they do – that I to refer to some paintings by René Magritte as means of scanning and understanding the transition from the hatched surface to the surface with the body fragments, and vice versa, across the Harlem 'wall' of flagstones.

Johns's interest in Magritte is well known, and attested by his ownership of *The Interpretation of Dreams* of 1936 which he acquired in 1963.[139] The possible relevance of Magritte's *The Elusive Woman* of 1929 (private collection) to *Harlem Light* and

32 René Magritte,
The Literal Meaning,
1929, oil on canvas,
73.3 × 54.5.
Collection of
Robert
Rauschenberg.

Untitled, 1972, has been pointed out elsewhere.[140] In this painting a naked female figure is embedded, with four large right hands, in a wall of eccentrically shaped and placed stones not unlike – but not that 'similar' to – the red and black flagstones in Johns's paintings. More relevant in this context, however, might be the Magritte owned by Rauschenberg, *The Literal Meaning* of 1929 (illus. 32), with its framed *'femme triste'* and wooden batten, both placed against a much flatter – more Modernist – painted wall of stones quite like, but still not that 'similar' to, the flagstones of *Harlem Light* (illus. 1) and *Untitled*, 1972 (illus. 6).[141] Magritte's wall can be seen in several paintings of the late 1920s and early 1930s. As the façade of a building, drapes drawn across the windows, it turns up in *The Empty Mask* of 1928 (National Museum of Wales, Cardiff), *The Six Elements* of 1929 (illus. 33), *On the Threshold of Liberty* of 1930 (Museum Boymans–van Beuningen, Rotterdam), and *Act of Violence* of 1932 (Groeningemuseum, Bruges). *The Six Elements* would have been closest to Johns. It was acquired by Duchamp for Louise and Walter Arensberg in 1937, and entered the Philadelphia Museum of Art as part of their bequest in 1950. These are all pictures of

René Magritte,
Six Elements,
9, oil on canvas,
3 × 99.7.
ladelphia
seum of Art.

accumulated surfaces, seemingly unrelated fragments, brought together, compartmentalized or framed like bits of paintings. *The Six Elements* has flames, a female torso, a forest, a lead curtain with sleigh-bells, a sky with clouds, and a flagstoned façade. Some of these surfaces, like the flagstoned façade, appear more often than others – the fragment of blue sky with clouds is another constant element – but always in a relation of association to a body fragment, the female torso, breasts and navel.

As with hatched surface of *Untitled*, 1972, so with the red and black flagstones of *Harlem Light*: lost and reconstructed; almost forgotten and almost remembered. What I am considering here is not some mechanical action by contact – a painted store-front seen while driving through Harlem, or a simple case of 'influence', a relatively straightforward appropriation from Magritte's work – but a more or less fortuitous and exploitable sighting of an oddly painted store-front by means of which some of Magritte's work and the meaning and references Johns could produce from it and for it could be made to serve his representational aims and his need to represent them obliquely by means of the modernistic plaus-

85

ibility of his surface and his account of its genesis. My guess is that the memory of the wall in Harlem was appropriated and adapted in order to refer to some of Magritte's paintings in which a wall similar to that one in Harlem – 'similarity' is all right on the streets – surrounds, or is associated with, the female, body fragments and other matter.[142] But, just as the reference to Pollock and Picasso made by the hatchings was not the meaning of the hatchings, this reference is not the meaning of the flagstones in *Untitled*, 1972. Much depends on its context of use and the movements betwixt and between the other references. Meaning is always veering off the surface, always signifying something other.

It has never been my intention to write the meaning of *Untitled*, 1972 – establishing the necessary ground on which meanings could be established and maintained is more what I have in mind. It is in this sense that it is not at all fanciful to suggest that Johns's paintings are structured to put us in pursuit of an elusive meaning, and that the end of the pursuit is likely to be a fragment, or a negation or a bit of the surface placed *sous rature*.[143] This is not simply what may be seen as represented by individual paintings, it is also the visual aspect of the mechanism by which they represent Johns and the cultures he paints from and for.

What can be explained and understood ought to be explained and understood, albeit no explanation is ever sufficient and no understanding ever secure. Closures protect mystiques. If mysteries can be explained they are no longer mysteries, and that is that. But they remain mysteries, if they do, by virtue of their capacity to evade open enquiry by the 'mob'. Johns's work has eluded explanation partly because those who undertake to explain it are constrained by the closed explanatory system with which they approach the job in hand, and because Johns's visual language effects a kind of closure in so far as it allows certain meanings to escape from all but the 'few' persons who know what procedures to carry out, competences to execute, or techniques to apply to produce those meanings from it. You could say that Johns's work effects its ratification and validation as metaphor, but achieves that effect by the way it uses synecdoche and metonymy. Those persons who know why, or have glimpsed why, Johns's synecdochical and metonymical figures are required,

or who know how his work is effecting meaning between-the-lines and can scan and understand it in the appropriate way, have remained more or less completely silent. These are the relatively socially-open and the relatively socially-closed worlds that are mediated in and by Johns's work: the world of Modernist art praxis, criticism and history, and that distinctive other world in Modernism where Johns's self-interests and desires were structured and formed to be insistently returned to in figured relations of parts and wholes. Modernist consequentialism has tended to restrict enquiry and explanation to 'artistic' and 'technical' matters, to surface-matter and metaphorical equivalence rather than subject-matter and mechanisms of reference and meaning. A lot of Modernist art criticism and history, and a lot of writing on modern art generally, swings between an insistence on the surface and the way it is formed and on the subject and biographical detail. Modernist art practice is caught in the same oscillation between surface and subject, the relatively socially-open and the relatively socially-closed. In my accounting, 'Jasper Johns' knows this, and takes it seriously. What is distinctive about his art is the degree to which it acknowledges the dichotomy and the movement between its oppositions as a problem or impasse to be thematized or worked out, but one that can only be thematized or worked out from within the dichotomy and the resources it makes available.

2 A Different Kind of Beginning

I pledge allegiance to the Flag of the United States of America and the Republic for which it stands, one Nation, under God, indivisible, with liberty and justice for all.

Some people thought he was anti-American . . . that he was a man who protested against the symbols of America, the flag. At the time there really was no special reason for it: there was no Vietnam War. . . . There was McCarthy. No, McCarthy had disappeared a long time before that. Leo Castelli to Emile de Antonio, 1970[1]

My Aunt Gladys once, when she read a thing in a magazine, wrote me a letter, saying she was so proud of me, because she had worked so hard to instill some respect for the American flag in her students, and she was glad the mark had been left on me. Jasper Johns to Emile de Antonio, 1970[2]

As the flag of the United States of America, the Stars and Stripes dates to 14 June 1777, when Congress resolved that it should consist of thirteen stripes for the colonies, alternately red and white, and that their Union be thirteen stars, white on a blue field.[3] According to legend, Betsy Ross, an official flag-maker to the Pennsylvania Navy, designed it and sewed it together out of separate bits of cloth. However, there was no set design until 4 April 1818, by which time seven more states had joined the Union. It was then that Congress set the number of horizontal stripes at thirteen and the number of stars at twenty, and ordered 'That on the admission of every new State into the Union, one star be added to the union of the flag; and that such addition shall take effect on the fourth of July next succeeding such admission.'[4] No mention was made of the arrangement of the stars or the proportions of the flag, but on 18 May that year the Navy Commissioners approved a design with four staggered rows of five stars in the canton that was one-third the length of the flag and extended as far as the eighth stripe.[5] On 10 September President James Monroe modified these specifications in an order that required that the rows be placed one above the other instead of staggered.[6] And yet, despite these more or less clear specifications, there was

little uniformity in United States flag design until after the Civil War, and mass production of flags became common in the late nineteenth century. Even then, it was not until an executive order of President William H. Taft, issued on 24 June 1912, that the design of the flag was laid down as a standard set of relative proportions.[7] Taft's order made available a blueprint plan, obtainable on request from the Navy Department, which could be used to determine the precise location and size of the, by then, forty-eight stars for flags in any of the twelve official sizes whose dimensions were determined by the measure of the hoist, or vertical width, in relation to the fly, or horizontal length, in the ratio of 1:1.9. These specifications were, and still are, regularly ignored; the most common proportions used by manufacturers are not the legal 1:1.9, which is mandatory for flags displayed by Government departments, but either 2:3 or 3:5. In 1934, during the presidency of Franklin D. Roosevelt, the exact shades of blue and red were specified and given numbers in the Federal Standard Stock Catalogue.[8] These colours were slightly modified in 1960, after Alaska, in 1958, and Hawaii, in 1959, achieved statehood, and the flag gained its forty-ninth and fiftieth stars.[9]

As defined in law, and as understood in conventional wisdom, the flag of the United States is more than a piece of bunting or other material to be attached at one edge to a staff or halyard.[10] Little or no distinction is made between the Stars and Stripes as it is made to be flown from a flag-pole, draped against a wall, hung above a street or as it might be painted or printed or otherwise put on any surface. But when it is made of fabric for public display, especially outside or in public buildings, it is rarely printed. The convention, following the way the first Stars and Stripes was made, is to sew it together. Each red and white stripe and each star is a separate element, a discrete bit of cloth. The stripes are sewn together in two panels: one of six stripes for the area below the canton; the other as a panel of seven stripes for the area beside it. The canton is another panel, and each star of the Union is individually sewn or embroidered in place on both sides of its blue field. These three panels are then sewn together to become the Stars and Stripes.[11]

There is a code for the use of the flag that dates from 1923 when, four months after the War Department had issued a

circular on flag usage and respect, representatives of sixty-eight patriotic groups and civic organizations met in Washington D.C. as the National Flag Committee of the American Legion to draft a uniform set of rules of flag etiquette.[12] The Committee – and another that met the following year – accepted most of the War Department's code, and subsequently the Department published this code as a pamphlet. It gained wide acceptance and became law on 22 December 1942 when it was adopted by Congress as a 'Joint Resolution to codify and emphasize existing rules and customs pertaining to the display and use of the flag of the United States of America'.[13] The code instructed – and still instructs – citizens on how to display the flag, hoist and lower it, on where and how to display it, in what manner they should show respect for it, and on how to conduct themselves while it is hoisted, lowered, passed, and during the playing of the national anthem, 'The Star-Spangled Banner', and while making the solemn promise of loyalty to the United States, the pledge of allegiance: 'I pledge allegiance to the Flag of the United States of America and the Republic for which it stands, one Nation, under God, indivisible, with liberty and justice for all.'

Towards the end of 1954, or maybe early in 1955, Jasper Johns, who since his discharge from the army in 1952 had been working on the fringes of New York's avant-garde art community, began making his own version of the Stars and Stripes.[14] It is a largish object, 107.3 × 153.8 cm, made – and I will reconsider this description in a moment – of encaustic, oil and collage on fabric that is titled deceptively simply, which is to say quite complicatedly, *Flag* (illus. 41). Without the definite or indefinite article, without any adjective, addition or attribute, the title of this Stars and Stripes gives us to understand that it is something which is neither definite nor indefinite but both definite and indefinite, that it is only, and precisely, *Flag*.

Flag is now owned by the Museum of Modern Art, New York. It was one of several works that Alfred H. Barr Jr, Director of the Museum's Collection, wanted to buy from Johns's first solo show held at the Leo Castelli Gallery during January–February 1958. Barr was at that moment looking for new work by young artists that seemed to offer a radical alternative to the modes based on an understanding of the various kinds of Abstract Expressionism that had developed

in the late 1940s and early 1950s. On 17 January he participated with Thomas B. Hess and Harold Rosenberg on a panel at the Club – the most important and famous of the meeting-places of New York's avant-garde artists – when it considered the question 'Has the Situation Changed?' According to one set of recollections,

> Barr challenged the audience with a series of questions: Is the younger generation rebellious or is it basking in the light of half a dozen leaders? Are Tenth Street artists living on the energies of the painters of the forties and early fifties? Should there have been a rebellion by now? (Barr said that he looked forward to it but had not seen it yet). Are painters continuing a style when they should be bucking it? . . . Barr acknowledged that the vein of gesture painting might be rich enough for a whole generation to mine, and more time might be required for boredom to set in. But even so, working veins that were already opened could only yield minor discoveries, and Barr again called upon younger artists to reject their elders more strongly.[15]

As far as Barr was concerned there was a vacuum in New York's art community: there was no viable avant-garde reaction to Abstract Expressionism, no discernible attitude of rebellion, style or position; artists followed or conformed with slight, synthetic variations; this wasn't good enough; the situation demanded change. In his scheme of things the time was certainly right and ripe for it. As he knew, and many of those persons who gathered at the Club that night knew also, the Museum of Modern Art had just organized an exhibition of paintings by seventeen 'first-' and 'second-generation' Abstract Expressionists that was to tour eight European countries as 'The New American Painting' and which was scheduled to open at the Kunsthalle Basle in April. This was the first exhibition that the Museum had organized under the auspices of the International Council that it was able to put on show in its own building for domestic viewing; it was to open at the Museum in March 1959. The patriotic imperatives behind 'The New American Painting' and the previous shows sent abroad by the Museums' International Council – 'Modern Art in the United States from the collection of the Museum of Modern Art' and the posthumous exhibition of the work of Jackson Pollock – were, and are, well known.[16] Barr was no

doubt labouring on his introductory essay to the catalogue when he went along to the Club to make his challenge. His essay (it is dated March 1958, but he was a slow writer) is an art-historical discussion of the origins, development and 'triumph' of the New American Painting – he didn't approve of the terms 'Action Painting' or 'Abstract Expressionism' – as the most recent manifestation of an internationally accepted and ratified avant-garde art, well placed on paper to occupy, as it would come to do, the final rooms in the permanent collection of the Museum of Modern Art.[17] Although he wrote its history, it seems that Barr did not value Abstract Expressionism very highly.[18] Even as he was writing his essay he was backing a return to figuration or representation. Remember, it was in January–February 1958 that he was wanting the Museum to make a considerable investment in the art of 'Jasper Johns'. He thought that his paintings were a 'refreshing change from abstract expressionism and evidence of a new spirit', and he recommended that the Committee on the Museum Collection should take up options on four items from the Castelli Gallery: *Target with Four Faces* (illus. 34); *White Numbers; Green Target* (illus. 35); and *Flag*.[19] The decision came down to acquire just three, which in itself was a very controversial thing for the Museum to do.[20] In the art community, the purchase was regarded as a political act. Barr and the Museum 'came under criticism for having bought three works by one artist and he rather little known', and Johns came to be regarded by some persons 'as much as a pawn in the current art world game of power politics as the bearer of a new individual image'.[21] However, the acquisition also involved a different kind of political consideration on the part of the Committee on the Museum Collection and, subsequently, on the part of the Board of Trustees. Evidently someone on the Committee wondered if buying *Flag* 'might not leave the Museum open to attack from groups like the American Legion'.[22] Barr answered 'that the artist, whom he described as "an elegantly dressed Southerner", disclaimed any unpatriotic intentions, and, in fact insisted that he had "only the warmest feelings toward the American Flag" '.[23] Nevertheless, Barr agreed that the opinion of the Board of Trustees should be sought. The matter was referred to the Board, which decided against buying *Flag*, 'fearing that it would offend patriotic sensibilities'.[24] It was not until 1973

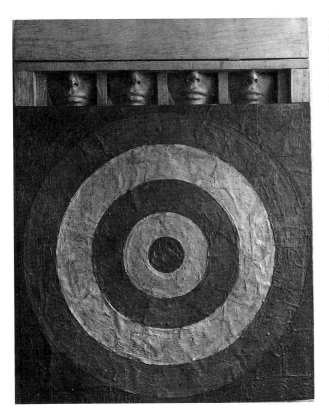

34 *Target with Four Faces*, 1955, encaustic and collage on canvas, surmounted by four tinted plaster faces in wood box with hinged front; 85.3 × 66 × 7.6. The Museum of Modern Art, New York.

35 *Green Target*, 1955, encaustic on newspaper and cloth over canvas, 152.4 × 152.4. The Museum of Mode Art, New York.

that *Flag* entered the permanent collection of the Museum of Modern Art, the gift of Philip Johnson – who, as a member in 1958 of the Committee on the Museum Collection, had not been impressed by Johns's work – in honour of Alfred H. Barr Jr on the occasion of his retirement.[25]

Vladimir: *We could start all over again perhaps.*
Estragon: *That should be easy.*
Vladimir: *It's the start that's difficult.*
Estragon: *You can start from anything.*
Vladimir: *Yes, but you have to decide.*
Estragon: *True.*
 Samuel Beckett, *Waiting for Godot*[26]

The mature work of Johns begins with the first Flag, *painted in 1955. Since he has never shown anything done before this, the extraordinary initial impact of the flag image and the authority with which it is painted give the impression of a finished artist, suddenly sprung from nowhere.* Alan R. Solomon, 'Jasper Johns', 1964[27]

Johns was especially concerned with beginning, with establishing the material and ideological, practical and theoretical point at which his art would depart from all other art practices, establish relations of difference and similarity, antagonism and continuity with them.[28] Given that a beginning is, as it were, a project always already underway, his beginning, his idea of how to begin and where, was consciously inaugurated in 1954. Sometime in that year he 'decided to stop becoming and to be an artist'.[29] At that moment, or maybe a little later, after he had made or had in mind the work that he would make to provide the main entry to what he and his art had to offer, he deliberately and methodically destroyed whatever he still had in his possession of the work he had produced before.[30] This destroyed work is almost completely unknown in quantity and quality. A few things Johns made before his arrival in New York have shown up here and there, but, if known, they have been avoided or by-passed by those persons concerned to write about and explain the art of 'Jasper Johns'. Several pieces made in New York in 1953 and 1954 survived the destruction because they were in the possession of friends or in other private collections. These works – I am thinking of *Untitled* (Collection of Edwin Janns), *Construction*

with Toy Piano (illus. 15), *Untitled Construction* (illus. 3), two densely worked drawings of oranges (Collection of Robert Rauschenberg, and Collection of the artist), and a fragment of *Cross* (private collection), all of 1954 – do have a place in Johns's history, albeit one peripheral to his beginning.[31] Evidently Johns has never been that interested in discussing this 'juvenilia' or 'early work', or in trying to locate other works that may exist, but if something is brought to his attention – and this presumably involves acquiring it – he destroys it.[32]

A beginning is rational and enabling. It is a kind of action or work and it is also a frame of mind, an attitude or a consciousness. We might understand Johns's destruction of his work as an attempt to make his art as a different kind of art and his self as an artist as a different kind of self as an artist in an achieved or produced absence of past events and narratives. It was his thoroughly Modernist way of attempting to erase or cancel his history and to obscure the immediate initial context of his being as an artist. The destruction of the work was intended to negate one identity in the desire to establish another. However, the negation of the negation, which is the process of continually trying to remake the self, ensured, of course, that something of the negated self survived to be taken forward, but always negated in the, necessarily, unfulfilled desire to make an Other. Although it was bound to fail, it seems that Johns intended his beginning to be seen as almost transcendentally originary, yet when he begins as an artist he does so with a work neither of originality, because he seems to invent nothing, nor of negated biography, because it is a work which is very much *of* him. To begin is first of all to know with what to begin. As far as Johns was concerned, and thereafter art criticism and history also, 'Jasper Johns' begins with *Flag*.

Although *Flag* can be seen to have established Johns's ideal, the dominant view or central concept of his system of beliefs, the theme or motor force of his work, and even his principal trope, he seems, in certain respects, to be peculiarly absent from it. He has no property rights or authority with respect to *Flag*, for the Stars and Stripes is a design that nobody owns and which is associated with no one except, possibly, Betsy Ross. Also, his own interest in it in terms of artistic subjectivity seems insecure in as much as he has not signed it – assigned it – to his authoring artistic self. And yet, *Flag* is an object in

which he has something invested to such an extent that it will gain a peculiar value in the discourses of art as a signature work or an alter-materialization. It achieves this status not only by becoming established as the work that begins 'Jasper Johns' but by being repeated by Johns himself. He continually returns to it and retrieves it, makes another *Flag* or paints another Stars and Stripes, to mark the progress of the changing surface appearance of his art and thus reassure those, including himself, who need the ideological and financial security it provides, that all his work is indexed to it and to the 'Jasper Johns' who produced it and whom it produces. That is to say, the dynamic of repeating *Flag* keeps 'Jasper Johns-ness' present even as a new beginning is made and a new kind of 'Jasper Johns' is created. The repetition of *Flag* is part of a process, as was the destruction of the work close to it, of remembering and forgetting a self and a beginning in art. In contradistinction, therefore, to its originary status, the repetition of *Flag* or the Stars and Stripes might indicate that it is not the assignable origin of 'Jasper Johns' but the sign of the fiction and arbitrary character of any such origin. If this is the case, then *Flag* may have to be understood not as a necessary beginning *of* 'Jasper Johns' but as an almost chance event whose value Johns understood only after he had made the connection between the idea of beginning and the need to locate one.

Strangely enough, the image did come to him that spontaneously; he explains simply that he dreamed one night of painting a large flag! However, this by itself does not explain Flag, *and Johns does not choose to discuss how he arrived at this point.* Alan R. Solomon, 'Jasper Johns', 1964[33]

Peter Fuller. *In 1954, you had a dream in which you saw yourself painting a large American flag, and the next day you began painting one. People dream of many things. Why did you decide to make the flag?*
Jasper Johns. *I don't know. I have not dreamed of any other paintings. I must be grateful for such a dream! (Laughs). The unconscious thought was accepted by my consciousness gracefully.*[34]

To those persons who asked him why he made *Flag* – and the other flag paintings of the 1950s – or how he came to make it or

what it meant, Johns initially replied that he 'intuitively' liked to paint flags.[35] Later he would reply, and thereafter always reply along the same lines, that 'he dreamed one night of painting a large flag' and afterwards began to paint one.[36] In several additions to that basic story-line he has said that 'using the design of "the American flag" took care of a great deal' for him because he did not have to design it; that 'it had a clearly defined area which could be measured and transferred to canvas'; and that it was something he could do which would be his.[37] In various embellishments on the story, for which Johns may or may not be responsible, it seems that he told one or other of a couple of close friends, Rachel Rosenthal and Robert Rauschenberg, about the dream and that one or the other, or maybe both, thought that it presented him with a good idea for a painting.[38] But what status should we give to Johns's story of the dream, and what is its relationship to the object that is *Flag*? How is the statement useful, that 'he dreamed one night of painting a large flag' and then did so? Or is it useful? And what should we make of the later additions and embellishments? What does the story do in Johns's narrative about himself and his creative process? And what does it do, in its basic and extended versions, in other people's narratives? The statement that 'he dreamed one night of painting a large flag' is not a representation of the dream. There is little or no secondary revision, and without it and Johns's free association there is nothing that would make the dream a 'royal road' to the desires and fears that might have motivated it and so in part may have determined the decision to paint a large flag. In effect, the story is just a statement about the dream's manifest content, which in a proper analytic context would signal, straightaway, that the dream was neither about a large flag nor Johns painting one. It is also worth noting that not only do we lack any secondary revision and free association but we also lack Johns's primal statement or anything like a first-telling of the story, which enters published discourse some ten years after the dreaming of the dream. It is as a tale retold by Alan Solomon in his 'Jasper Johns' essay of 1964 that we come to know that Johns 'dreamed one night of painting a large flag'.[39]

I have been careful during this discussion of Johns's dream to refer to the flag he dreamt of painting as 'a large flag'. As far as I know, it was not until 1966 that it was referred to by Johns

in published discourse as 'a flag of the United States of America'.[40] In 1970 he referred to it as 'a large American flag'.[41] Is there something significant, here, in the transition from Solomon's 'a large flag' (1964) to Johns's 'a flag of the United States of America' (1966) and 'a large American flag' (1970), either as Johns rewriting the published history of *Flag*, maybe correcting Solomon's parapraxis, or as a kind of parapraxis on Johns's part? Which version of the story should we privilege as closest to stating the manifest content of the dream? And does it matter? Yes, in the sense that 'a large flag', 'a flag of the United States of America' and 'a large American flag' are not necessarily the same object, and that none of them is necessarily 'the American flag' or 'the Stars and Stripes'. This might be significant for explaining *Flag*. On the other hand, it doesn't matter, in the sense that none of the stories seems particularly useful in giving access to the dream's manifest or latent contents or in providing an explanation of what *Flag* means. But then, it is the lack of access the story offers to understanding *Flag* that makes it interesting and potentially useful. The story of the dream places the origin of *Flag* in Johns's unconscious, in the repressed or partially erased contents of his autobiography, and thus at a level of meaning of which he must have been more or less ignorant. Although, according to the story, *Flag* must be regarded as *of* Johns, it is not *of* him in terms of intentional meaningfulness; rather, it is *of* him, but it is empty of intentionality. This *of*-ness and not *of*-ness is carried into the later additions and embellishments. *Flag* is *of* Johns in as much as 'he dreamed of painting a large flag', but it is not *of* him in as much as he didn't design the flag he went on to make; he only transferred the proportions of the Stars and Stripes to canvas. *Flag* is *of* him because he makes it, but his authorship is made even more complex and mediated when Rosenthal and Rauschenberg are written into the pattern of empty intentionality, the latter, in one account, almost providing the injunction to make it.[42]

The story of the dream promises explanation but in effect stymies it. We might understand its significance to be simultaneously enabling and dis-enabling. It seems to direct attention, Johns's and ours, both towards and away from understanding what and how *Flag* means. The story convinces those it does convince because it marks the point of radical discontinuity necessary for any beginning. But for others the story

prompts a doubt as to whether Johns really had the dream. Did he or didn't he dream of painting a large flag? Is the story true or not? Should it or shouldn't it signify in the explanation of *Flag*? The point about the dream is that it *is* part of Johns's story about himself and his art, and that it *is* part of the discourse *of* Johns, *is* already signifying for him and art criticism and history. And because it *is* already signifying something, somehow it has to be dealt with. The main options seem to be to follow the story along a psychologistic or psychoanalytic route of interpretation, one fraught with theoretical difficulties, to wherever it may go, or simply to note it and then ignore it because it does not provide enough detail to work with practically and effectively. But neither option has to be decided on as necessary from a methodological or interpretative point of view. We can't ignore it, but what needs to be recognized, more than anything, is the way it effects a dimension of equivocation. And this is where we should locate the story's usefulness, not in any singularity and certainty but in the doubleness and uncertainty that it effects in discourse. In much the same way that the destruction of the work functioned in the production of an equivocal artistic self, the story of the dream works to establish a kind of equivocation as the form, limit and system of Johns's beginning in art, a beginning that was realized and represented in visual terms as and by *Flag*.

I do not see how one could paint the American flag in 1954 and claim, as Johns did, that it was merely inspired by a dream. Perhaps so, but dreams are ultimately connected to reality. Nineteen fifty-four was in reality, a year of hysterical patriotism. Johns could not have been insensitive to this. Moira Roth, 'The Aesthetic of Indifference'[43]

Although it seems doubtful that Johns ever said that *Flag* 'was merely inspired by a dream', there can be no doubt that patriotic expression was a highly emotional – 'hysterical' – issue in 1954, and Johns would not have been ignorant of – 'insensitive to' – that fact. The coercive and repressive paranoia of the Cold War, which since 1947 had been affecting almost every aspect and institution of American life through anti-Communist legislation and investigations of un-Americanness, through loyalty boards and hearings, anti-liberal

purges and censorship of the whole cultural apparatus, reached its high-point that year between 22 April and 17 June when Senator Joseph McCarthy, as Chairman of the Permanent Investigations Sub-Committee of the Senate's Committee on Government Operations, investigated supposed subversion of the Army and State Department.[44] The 'Army–McCarthy hearings' was the first time that a Senate investigation had been broadcast by television to the nation. The hearings lasted thirty-six days, and all but one of them was televised. Millions watched McCarthy become more and more vituperative and theatrical as he pressed the Government's policy of anti-Communism to the point where it and he became ridiculous. Thoroughly embarrassing the Senate, the Army, the State Department and the White House, he had gone beyond his moment of usefulness to the powers that be and destroyed his national popularity. By the end of July the Senate had begun to move against McCarthy, and in December, by an overwhelming vote, passed a motion of censure against him. Maybe it is not surprising in this year of particularly hysterical anti-Communism and un-Americanness that attention was focused more than usual on the Stars and Stripes as a symbol of nationhood, patriotic feelings and national values. Indeed, it was not just a moment of focusing on the Stars and Stripes as the symbol of national identity – American and 'un-American', pro- and anti-McCarthy, Republican and Democrat – but of re-establishing it as such.

The American flag and Flag Day were especially vivid issues in 1954. In his Flag Day proclamation of 4 June President Eisenhower urged citizens to honour their 'colours by displaying them . . . and by giving prayerful consideration to their duties as well as their privileges under this glorious banner.'[45] And on Flag Day, 14 June, he approved the legislation that added the words 'under God' to the Pledge of Allegiance as a way of 'reaffirming the transcendence of religious faith in America's heritage and future; in this way we shall constantly strengthen those spiritual weapons which forever will be our country's most powerful resource in peace and war.'[46] On 10 June, New York State Governor Thomas Dewey urged all to join in observation of Flag Day.[47] And he was followed three days later by New York's Mayor, Robert F. Wagner, who in his Flag Day speech reminded citizens to observe the holiday and called for an unprecedented show of the national colours.[48]

Never before in the history of our country has there been a greater need for a recognition of those precious ideals which unite us all as American citizens. First among these symbols is the American Flag.

In recent years national holidays have come to be looked upon as days of recreation, providing an opportunity to forget our daily toil. As a consequence, display of our Flag has been more or less forgotten. A return to old-fashioned patriotism and universal flag display will do much to unite us all, regardless of our creeds or political affiliations.[49]

There is a clear note or urgency here. Just six days after McCarthy's humiliation by special army counsel Joseph N. Welch, and three days before the hearings recessed in disarray *sine die*, Flag Day, coincidentally and contingently, was used to emphasize the heterogeneity and diversity of United States citizens and to affirm the need, at that moment, for tolerance and unity – which is to say, it was used to obscure the intolerance and disunity of that moment. The Stars and Stripes was available as the symbol of that unity 'with liberty and justice for all', but citizens had to be reminded and urged to display it – even on Flag Day. And they also had to be reminded of its history and meaning.

On the day before Flag Day *The New York Times* carried a brief, pedagogic essay titled 'Flag Day: Fancy or Fact?', in which several myths about the Stars and Stripes were discussed: that Betsy Ross made the first one; that it was designed by a known individual; that it was extensively carried in Revolutionary battles; that the stars in early flags were popularly arranged in a circle; and that the colours had some official symbolism.[50] Then on Flag Day the same newspaper carried an editorial on 'The Discipline of the Flag'.[51] This linked honouring those things that the Stars and Stripes stood for with courage and discipline, and especially the latter, which was required of all those citizens who, in preparation for a Russian nuclear attack, had to take part in the first national air-raid drill that morning: 'we are all soldiers now'.[52] On the same editorial page, under the title 'Topics of Our Time', there were five more pedagogic paragraphs concerning the American flag: the first discussed 'The Origin of Flag Day'; the second, 'Philadelphia and Betsy Ross'; in the third, 'Over Fort McHenry', it was pointed out that 1954 was

the 175th anniversary of the birth of Francis Scott Key, who after witnessing the British attack on Fort McHenry on 13–14 September 1814 composed 'The Star Spangled Banner'; in the fourth, 'The Stars and Stripes', it was explained why the flag was often referred to as 'Old Glory'; and last, in 'Three Other Flags', readers were reminded that they had loyalties not only to the Stars and Stripes but also to the flag of the United Nations, the flag of NATO, and to the flag of the Pan-American Union.[53]

It is not necessary to chronicle all the events and activities that, in 1954, were associated with the Stars and Stripes, but the dedication on 11 November of the Iwo Jima Marine Memorial at Arlington National Cemetery, Virginia, is worthy of mention.[54] This is the giant sculpture by Felix de Weld based on the widely distributed Associated Press photograph of the flag-raising on Mt Suribachi, Iwo Jima, on 23 February 1945. Eccentrically, but effectively, the marines atop the 75-foot-high bronze monument are planting a real flag-pole from which flies a large fabric Stars and Stripes.

Those few references, taken from *The New York Times*, to the importance of Flag Day in 1954, to the need to recuperate the Stars and Stripes as the symbol of national identity, and to the dedication of the Marine Memorial can be taken as symptomatic of the social and political residue of the day that may have been appropriated to and transformed in and by Johns's dream. That residue might even be what Johns reworked and represented – artistic and national identities being joined in the process of reworking and re-presenting – when he made *Flag*. But none of this seems especially useful in explaining why he thought that 'painting a large flag' or 'a large American flag' or 'the American flag' or 'the Stars and Stripes' was something he could do that would be his, or in what ways he might have understood it as *of* him.

> . . . *even the most unexpected dream is a rebus that conceals a desire or, its reverse, a fear . . . dreams are made of desires and fears, even if the thread of their discourse is secret, their rules are absurd, their perspectives deceitful, and everything conceals something else.* Italo Calvino, *Invisible Cities*[55]

I have shown how the language of visual representation as Johns has developed it evidences a predilection for met-

onymy, where the relation is one of contiguity or concomitance, rather than metaphor, where the relation is one of similarity and difference. This preference represents a cognitive preference. Why Johns prefers to represent things metonymically is a difficult question to answer, but possible answers can be glimpsed. For example, if you accept that metaphor effects a familiarity or intimacy between speakers and their world – because relations of similarity are usually easy to grasp – then a preference for metonymy might indicate a desire to effect or to represent a strangeness and distance, because it is based on a different principle, one that defies easy interpretation. Here, it is important to see Johns's *Flag* as troped metonymically and to understand its meaning or 'truth' as the Stars and Stripes turned to some other meaning – object, event, feeling – or 'truth' by way of a series of contiguous or concomitant and remote associations of meaning.

In principle we can construct or order a chain of associations that relates *Flag* to Johns, and then to his father, and then to their namesake. This is a chain that connects *Flag* to a recollection of a place and an event, that recollection to persons and names, and those persons and names to a flag. For some time it was thought, because it was so unusual, that Jasper Johns had made up his name. Then, in 1977, it was confirmed that he had not made it up, that his name was Jasper Johns Jr – his father was William Jasper Johns – and that he was, as had been suggested, named for Sergeant William Jasper, 'one of the South's most glorious Revolutionary heroes [who] distinguished himself by twice saving our fallen flag', and that 'as a boy Johns was shown a statue of Sergeant Jasper by his father who told him that the figure was the namesake of them both' (illus. 36).[56] Johns used this biographical detail in 1990 during a conversation with Paul Taylor which was subsequently published in *Interview* magazine:[57]

> Paul Taylor: *It has been said that the American flag in your paintings is a stand-in for yourself.*
> Jasper Johns: *Hm?*
> PT: *People have said that the flag, in your early paintings, represents you. Is that true? Is that how you used the flag?*
> JJ: *I haven't said that. Is that what you're saying?*
> PT: *No, but it has been said about you.*

JJ: Well, a lot of things have been said about me.
PT: Nevertheless, I wonder if you think it's true.
JJ: Do we have to go through this about everything that's been
 said? Do you think something true just because it's been said?
PT: No, but I wonder whether this thing is true even if it had
 never been said.
JJ: That the flag is a stand-in for me?
PT: Yes.
JJ: Where?
PT: In your paintings.
JJ: In my paintings? I don't think so. The only thing I can
 think is that in Savannah, Georgia, in a park, there is a statue
 of Sergeant William Jasper. Once I was walking through this

park with my father, and he said that we were named for him. Whether this is in fact true or not, I don't know. Sergeant Jasper lost his life raising the American flag over a fort. But according to this story, the flag could just as well be a stand-in for my father as for me.[58]

In that fragment – which was set epigraphically above the text in *Interview* magazine as the Stars and Stripes – Johns moves, veers away from the suggestion that he used 'the American flag' as a 'stand-in' or representation of himself via a childhood memory of a park in Savannah, from the statue of Sergeant William Jasper who 'lost his life raising the American flag over a fort', and from being told by his father that Jasper was the person they were named for, to the idea that 'the flag' could just as well be a 'stand-in' for, or representation of, his father as for or of himself.

Sergeant William Jasper (1750–1779), who served in the 2nd South Carolina Infantry under William Moultrie, distinguished himself during the British bombardment of Fort Sullivan, Charleston – known afterwards as Fort Moultrie – on 26 June 1776 by recovering the fort's flag after it had been shot down and, under heavy fire, remounting it; then, in October 1779, when accompanying Generals Moultrie, Marion and Lincoln in the assault on Savannah, he was mortally wounded while rescuing the colours from a lost redoubt.[59] The following account of his bravery is extracted from Charles C. Jones Jr's essay of 1908–9, 'Sergeant William Jasper'.[60] This is how Jones describes Jasper saving the colours at Fort Sullivan:

During the severest stage of the bombardment the flag-staff of the fort, formerly a ship's mast, from the head of which floated the garrison flag eagerly watched by thousands who lined the Battery in Charleston, anxious spectators of the exciting scene, and by those who held the fortifications in the harbor, was shot away, and fell with the colors outside the fort. Sergeant Jasper, perceiving the misfortune, sprang from one of the embrasures, and deliberately walking the entire length of the front of the fort until he reached the fallen colors on the extreme left, detached them from the mast, called to Captain Horry for a sponge-staff, and having with a thick cord lashed them to it, returned within the fort and amid a shower of balls planted the staff on the summit of the merlon. This done, waving his hat, he gave three

cheers, and then shouting 'God save Liberty and my country forever', retired unhurt to his gun where he continued to fight throughout the engagement. This flag so gallantly reinstated had been designed by Colonel Moultrie, and consisted of a blue field with white crescent on which was emblazoned the word LIBERTY. Its restoration revived the hopes of many at a distance who, ignorant of the cause of the disappearance, feared the fort had been struck.[61]

And this is how the same author describes Jasper saving the colours at Savannah:

During the assault the colors of the Second South Carolina regiment, which had been presented by Mrs Elliott just after the Battle of Fort Moultrie [the former Fort Sullivan], were borne, one by Lieutenant Bush, supported by Sergeant Jasper, and the other by Lieutenant Grey, supported by Sergeant McDonald. Under the inspiring leadership of Colonel Laurens they were both planted upon the slope of the Spring-Hill redoubt. So terrific, however, was the enemy's fire that the brave assailants melted before it. Lieutenant Grey was mortally wounded just by his colors, and Lieutenant Bush lost his life under similar circumstances. When the retreat was sounded Sergeant McDonald plucked his standard from the redoubt where it had been floating on the furthest verge of the crimson tide, and retired with it in safety. Jasper, already sore wounded, was at the moment endeavoring to replace upon the parapet the colors which had been struck down upon the fall of Lieutenant Bush, when he encountered a second and mortal hurt. Recollecting however, even in this moment of supreme agony, the pledges given when from fair hands . . . this emblem of hope and confidence had been received [Jasper had vowed to Mrs Elliott he would never give up the colors but with his life], and summoning his expiring energies for the final effort, he snatched those colors from the grasp of the triumphant enemy and bore them from the bloody field.[62]

Johns, who was born in Georgia and brought up in South Carolina, would surely have known all about Sergeant Jasper even if he needed his father to tell him that they were named for him. So it is interesting that, in conversation with Taylor,

he associated Jasper's mortal wounding at Savannah with the flag-raising at Fort Sullivan and referred to Jasper's flags as 'the American flag'. Alexander Doyle's Jasper Monument in Madison Square, Savannah – the statue 'in a park' – does imply that Sergeant Jasper is actually *raising* his flag even as he presses his sword-hand to the wound in his right side. And though the flag he raises may be not that obviously *not* the American flag, that knowledge would surely be possessed by anyone born in Georgia and raised in South Carolina. In both instances, the flag that Sergeant Jasper recovered was not the American flag but the so-called Fort Moultrie flag, a variant on South Carolina's flag of 1775, with a blue field in which was one white crescent and the legend LIBERTY.[63]

We need to go further, but not much further, into biography at this point. Johns is usually described as being a very reticent person, private and guarded about himself and his art. His predilection for metonymy would seem to determine and substantiate this characterization. However, we know quite a lot about him, and a good deal of what we do know has been communicated by Johns himself. The older and more secure his existence and currency – his 'author-function' – as 'Jasper Johns' has become established in the discourse of art, the more biographical detail he has made available. This would seem to indicate that he has always been aware of the power, albeit the limited power, he has to control the explanations that might be contrived (kinds of biography) concerning his work. That he chooses to enable biographical explanation of his work now to an extent that he once did not is worth commenting on, but no more than that. Suffice it to say that there are several stories of the life, but for my purposes here little needs to be added to the story as it was first written, in 1964, by John Cage for the catalogue of the Johns retrospective held that year at the Jewish Museum in New York. Here is Cage's story of Johns's life in South Carolina:

> He does not remember being born. His earliest memories concern living with his [paternal] grandparents in Allen-dale, South Carolina. Later, in the same town, he lived with an aunt and an uncle who had twins, a brother and a sister. Then he went back to live with his grandparents. After the third grade in school he went to Columbia [South Carolina], which seemed like a big city, to live with his mother and

stepfather. A year later, school finished, he went to a community on a lake called The Corner to stay with his Aunt Gladys. He thought it was for the summer but he stayed there for six years studying with his aunt who taught all the grades in one room, a school called Climax. The following year he finished high school living in Sumter with his mother and stepfather, two half sisters and his half brother. He went to college for a year and a half in Columbia where he lived alone. He made two visits during that period, one to his father, one to his mother. Leaving college he came to New York . . .[64]

To that fragment of Cage's narrative of thoroughly unmotiv-ated events I need only add that after Johns was born his parents separated and his mother moved away from Allen-dale. That is why he went to live with his paternal grandpar-ents. We know, because Johns told Peter Fuller – though it can be read between Cage's lines – that his childhood 'wasn't specially cheerful'.[65] Of the several stories that he has told about that time, some contain recollections of life with his grandfather and some recollect aspects of his relationship with his father.[66] There are no published stories about those times when he was living with his mother and stepfather. It is not without interest or significance, then, that one of these stories is a recollection of walking through a park in Savannah, seeing there the statue of Sergeant William Jasper, and his father, William Jasper Johns, telling him that Jasper was the person they were named for.

Names and events, persons and identities, memories and flags. 'Jasper Johns' has his beginnings and begins to make *Flag* at a moment when national unity is perceived as both necessary and urgent and when the symbol of that unity, the Stars and Stripes, has to be recovered and re-established in the public imagination. But, if I am figuring it correctly, the public, national and patriotic value of *Flag* as the Stars and Stripes was turned to other more private and remote values, to the residues of a life. We do not have to interrogate the possible psychological and sociological determinations of the chain of associations to glimpse, in fundamentals if not in details, some of the contiguities and relations of human experience, memories, fears and desires that might have got displaced onto the idea of painting 'a large flag' or 'a flag of the United

States of America' and how that was something Johns could do that would be his. The Fort Moultrie flag's 'LIBERTY' seems crucial here. The idea of 'liberty' displaced from Jasper's flag to Johns's *Flag* through the Stars and Stripes has to be seen as facilitating the possibility of various – never to be achieved – freedoms: from a past to a present; from one life-story to another; from a reliance on the art of other artists to something more original and self-sufficient; from trying to be an artist to being one.

> *What I think . . . is, that, say in a painting, the processes involved in the painting are of greater certainty and of, I believe, greater meaning, than the referential aspects of the painting. I think the processes involved in the painting in themselves mean as much or more than any reference value that the painting has.*
> Jasper Johns to David Sylvester, 1965[67]

> *The first flag . . . was a collage of paper, rags, newspaper, any kind of paper. Some things I stitched onto the canvas with thread, I think. I don't know what the canvas was. I think it was a sheet, probably a sheet, so it was very thin cotton. Things were sewn on and there was that use of enamel paint and then a change to the wax, so it's really a mess . . .* Jasper Johns to Emile de Antonio, 1970[68]

Johns began making *Flag* with what, in the 1950s, would have been regarded as respectable avant-garde materials: enamel paints on a bed sheet. But, according to his own account, he could not make the enamel paint do what he wanted it to do.[69] It was important for him that the history of the creative process should be part of the finished object, a conventional avant-garde strategy of making in which Johns was unskilled. Its past had to be there, visible and on display in its presented state. Johns wanted to show what had gone before and what was done after. He wanted the process and history of the making of *Flag* to be part of its meaning and effect. But when he applied the paint, the second brushstroke smeared the first: unless, of course, he waited until the paint was dry; and the paint took too long to dry. One story has it that someone suggested wax as a medium. Another story has it that while working as a sales assistant at a Marboro bookstore he had read a book on artists' techniques in which he came across a reference to encaustic and decided to try it out. Either way or

whichever, the idea of using hot wax as a medium was useful to him. Hot wax dries very quickly. As soon as one stroke had cooled and hardened he could add another without it altering the first. Splashes, drips and dribbles round out as they dry like enamel paint does but more so, just like wax dribbles down the side of a candle. He found the medium very easy to control and adapted it to the technique he had used for building up the surfaces of several works he had made in 1954, such as *Construction with Toy Piano* (illus. 15), *Untitled* (Collection of Edwin Janns) and, as far as I can tell, *Cross*. In *Construction with Toy Piano* and *Cross*, for example, more or less rectangular, more or less regular-sized bits of paper, some printed, some plain, were stuck down next to each other, or slightly overlapping, here and there not quite adhering, standing proud at the corners, slightly curling at the edges. The textual material – mainly in German, Spanish and Italian – is clear enough to be read on the surface of *Construction with Toy Piano*. On the surface of *Cross*, if there is any text, it is covered by a unifying all-over coat of white gloss paint. The process Johns used for *Flag* involved dipping cut and torn pieces of paper and cloth into hot pigmented wax – blue, red and white – and fixing them to the fabric before the wax cooled and hardened (illus. 37). This meant that the various textures,

Detail of illus.
Flag.

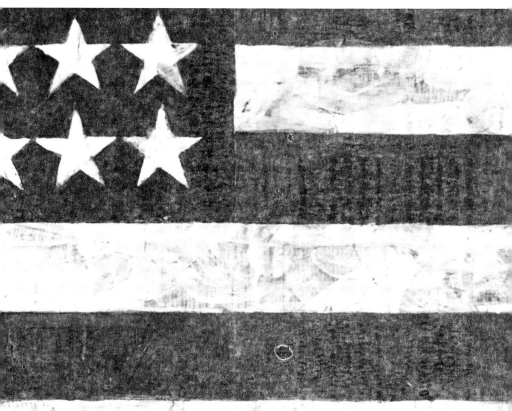

value contrasts and texts would remain visible at the same time as their individualities were subsumed and unified by an all-over, coloured surface-gloss. In some places drips and dribbles of wax cross the edges of stars and stripes and link various areas as surface, but this factitiousness is never allowed to disrupt, spoil or break the genuine flagness of *Flag*. Wherever the wax has run from a red stripe over and across a white stripe or from a white stripe over and across a red stripe it has been overpainted, corrected with either white or red paint, to preserve the integrity of the structure and coloration of the Stars and Stripes (illus. 38). The American flag signifies, but whatever meanings it had and has for Johns, handling, touch, texture and textuality all have their meanings too. However, discussion of what these meanings might be must give way for the moment to more discussion of *Flag*'s facture.

The complex proportions of the Stars and Stripes, pencilled on to the fabric to provide *Flag*'s structure, control the size and shape of the individual bits of paper and cloth (illus. 37). In the stripes, the various bits of stuff are generally placed either parallel or at right-angles to the stripes. The bits are smaller

38 Detail of illus. 41, *Flag*.

and denser in the canton. They are also placed multi-direc-tionally and are more varied in colour, hue and value. Each star, for example, is unique, and made so that it is set into, rather than on top of, the blue canton. It might be cut out of a single piece of newsprint. Or it might be made of several bits – in which case it might be made up of fragments of star shapes or of bits of star shape and bits of canton. As the flag of the United States of America, you might think that *Flag*'s other side is, literally, this side in reverse.

It was pointed out early in the literature on Johns how 'The red and white stripes do not – as in a normal striped pattern – form a figure-ground hierarchy. They are, in their familiar symbolic role, wholly equivalent. In other words, the altern-ation of red and white stripes on the American flag is much flatter than stripes on a T-shirt would be.'[70] Quite so: but it is also the case that the motif on a T-shirt is usually printed onto the fabric; whereas, as we have seen, it is usually the case that the American flag has no such fabric ground, that usually each stripe is sewn into place to a neighbour or neighbours and then all together to the canton. So the Stars and Stripes

controls not only *Flag*'s structure and pattern, but also its illusionistic and fabricated lack of all-over figure/ground relationships. Which is not to say that Johns does not employ all his technique to further cancel the difference. He does.

It has become usual in discussions of *Flag*'s facture to use the terms, suggested by Johns himself, 'encaustic, oil and collage on fabric'.[71] But two of these terms are somewhat misleading. 'Encaustic' makes sense only if we take it to refer to wax as a medium and not to the way Johns has used it. Encaustic was a painting technique developed and practiced in Antiquity.[72] Pliny the Elder mentions two kinds of encaustic painting: one with wax and graver on wood; the other with wax and graver on ivory. To these Pliny adds a third method of using melted wax applied with a brush that was used for painting ships and which was 'not spoilt by the action of the sea nor by salt water or winds'. The most remarkable surviving examples of encaustic painting are mummy portraits from Hawara at Faiyum, Egypt, dating from the 1st century BC to the 3rd century AD. Over the centuries various attempts were made to reconstruct the process, but with little success, and the only certain thing about it is that it is extinct.[73] The use of encaustic for Romano-Egyptian funerary portraiture may permit certain deathly connotations to be attached to *Flag*, but Johns's use of wax is quite unlike that of wax painting in Antiquity. 'Encaustic' is of little use in understanding how *Flag* got made or to what effect. 'Wax' would be a more appropriate term.

The other problematic term is 'collage'. Although *Flag* can be regarded as a collage to the extent that it was made partly from bits of paper and cloth affixed to fabric, Johns's use of the technique is somewhat different from the paradigmatic Ur-collage developed and used by Braque and Picasso between 1912 and 1914, or collage as it was used by the Dadaists or by Matisse in his last years.

Collage, which for Braque and Picasso had been a way of emphasizing the *literal surface* to prevent it from fusing with *depicted flatness*, became for Johns a way of making sure that what he painted was kept apart from the American flag.[74] The affixed material that helps make *Flag* intervenes between representation and illusion (the depicted flatness of the Stars and Stripes) and literal flatness (the actual flatness of the fabric ground) and prevents factitiousness coinciding with flagness. Or does it intervene? Whereas in Braque's and Picasso's

collages the affixed material was obviously different from and extraneous to the literal flatness of the paper or cloth support and from the depicted flatness drawn or painted on top of it or under it, the affixed stuff of *Flag* is neither obviously different from nor extraneous to literal flatness or depicted flatness. Rather, it functions as another literal surface, a kind of new-ground that both asserts the actual flatness of the fabric to which it is affixed and puts it *sous rature*, uses it while simultaneously putting it in doubt, keeps it present while absenting it. Given that, to what extent can the affixed stuff of *Flag* be regarded as collage? And if it is collage, *where* is it collage?

All I am doing now is renovating some of the early writings on how *Flag*'s surface is built up. Here, for instance, is Kozloff describing *White Flag* (illus. 42), 'a reverie on surface and illusion, the relation of the parts to the whole', but most of what he says about it applies to *Flag* also:[75]

> Its façade is composed of newsprint scraps dipped into wax mixed with white pigment and affixed to the canvas. In addition, the medium, coming through the paper, has been augmented by more wax, brushed sometimes in simulation of, sometimes in opposition to, a flag's stripes. Physically speaking (there is yet no technical term), this would be a *hidden* collage. But one is entitled to ask whether, pictorially, the 'paint' is not itself the collage element, affirming the newsprint ground (although concealed behind this layer is still another surface, the actual canvas). If it is true that Johns has reversed the normal constituents of the collage process, then surely he has done the same with its play on reality. The 'real' is whatever is underneath, partially withheld from sight. Art reticently covers up or shields life, instead of assimilating and triumphing over it as in traditional collage. This sense of veiled experience, however, is countermanded by the external traces or wax impression of a real artifact.[76]

I have my quibbles with some of this, but to my mind Kozloff's is the best of the early attempts to characterize technically what kind of surface Johns made for *Flag*. If it is 'collage', he says, it is 'hidden' collage. But he doubts even this. Maybe the 'collage' is not the newsprint scraps mixed with pigment: maybe it is the 'paint'. And from this hiding or reversal there

develop other veilings or reversals of unreal and real, artefact and actual fact, art and life. With this in mind it is useful to restate and extend what I said a moment ago about the way *Flag* was made from cut and torn bits of material that were laid side by side and over each other and stuck in place by hot coloured wax, and point out how, in this process, the bits of material, adhesive and oil paint become one and the same thing. The process might better be characterized not as a way of fixing extraneous material to the surface of a painting but as a way of constructing surface. Collage and painting become one while retaining their individual characteristics. What Johns does works both ways. The writings on Johns are littered with references to 'the brushstrokes of *Flag*' as if it is a painting, or as if brushstrokes are all that there is, or as if they are all that obvious. Brushstrokes there are, but they do not dominate *Flag*'s surface nor are they more obvious than anything else that makes it what it is. Some areas are marked by the use of coloured wax applied with a palette knife or a brush. Like the depicted flatnesses of Braque's and Picasso's collages, these might go under the wax-coloured-affixed-bits of stuff. Other areas are marked by brushed flecks of oil paint. These, too, work like the depicted flatness of Braque's and Picasso's collages. But all these ways of applying paint, unconventionally and conventionally, have equal value and follow no particular sequence.

It seems that we should abandon 'collage' just as we abandoned 'encaustic' and do as Johns did and stick with wax, pieces of paper and cloth, and oil paint. As Ben Heller pointed out in 1959, though it derives from 'the same free and adventurous concept', what Johns does with newspaper and wax is not 'collage'.[77] Even now, as Kozloff pointed out in 1969, there is still no technical term to describe it. Maybe what we should do, as Johns did, is use it and deny it. Whatever *Flag*'s technique is, it is and is not 'collage'. We should do the same with 'painting'. Whatever the technique is, it is and is not 'painting'. Which is to say that *Flag* makes sense – albeit an uncertain sense – if we understand it as made of something that is neither collage nor painting but simultaneously both collage and painting. These are not just matters of recognition and vocabulary. Realizing how *Flag*'s surface was made, knowing how it was done and being able to speak and write it, enables us to understand how and why it effected and effects

Detail of illus.
Flag.

the range of responses it did and does, and how it might be taken to represent Johns and his experience of the world – it is, after all, as much *of* him as it is *of* the Stars and Stripes.

Whatever *Flag* is as surface, Johns has taken hold of it, dealt with it or managed it, by manipulating its homogeneous elements into place, here and there, and so on, all over the fabric. It offers, as Johns seems to have wanted it to offer, all sorts of 'possibilities for the changing focus of the eye', lots of bits and pieces to attract the beholder's glancing gaze.[78] Wherever one looks there is some depicted or literal flatness; variegation or valuation; a texture, stuff or granulation; a text, writing- or reading-matter (illus. 40). Each bit of stuff, each dab – which stays on the canvas a moment too long to be a proper dab – or patch of wax, with or without newsprint scrap, is distinct in accent and texture from those adjacent to it or under or over it. Just as Cézanne articulated, mapped or negotiated a surface by applying his paint in pronounced touches or brushstrokes, relatively equivalent in size and suggesting a uniformity of interest or detail over the whole picture, so Johns's use of trailing or sliding dabs or patches of

wax, paper scrap and oil paint enabled him to handle the entire surface in the same way. Johns acknowledged his interest in the paintings of Cézanne early on, and may even have appropriated and adapted from them when he made *Flag* and gave it the texture he did.[79] From here and there to all over, as with a painting by Cézanne, the more you look at the surface the more you come to dwell on its details. It is impossible to miss the gob of stuff that takes the shape of the southern states and the Gulf of Mexico (illus. 40) and, next to it, white on white, the horizontal overstroke, impasto to begin with, trailing off to scumbly bristle-marks. Or the generously oleaginous bit at the left of the lowest white stripe. There a light florid stroke, here a heavier one; opaque and transparent; wax and paint and oil paint; flat-brushed and rounded; flicks and flecks, always from the wrist or the fingers. Even when they contain textual matter, these are details of touch. After Cézanne, Johns is the most touching of artists.

Handling: touch and texture. Richard Shiff has written about the way in which 'Cézanne's paintings exhibit a visuality that seems to retain a thoroughly localized tactile order [which] can be appreciated by imagining a hand's rhythmic movements as responses to both the given materiality of surface and the pattern of marks the hand itself is creating', and how Johns's art, like Cézanne's, 'operates in the mode of touch, continually reorienting whatever localized physical connection to his works the viewer may succeed in establishing'.[80] Touch is significant. It is 'the gesture that deposits the painter's mark' and it is the mark seen and understood as 'the indexical sign of the gesture'; iconically it establishes relations 'to things of similar form seen both outside and inside paintings'; and it is 'the tactile sensation the painter actually experiences or the viewer imagines to be associated with making such a mark'.[81] With this in mind we can see how it is that the marks that make *Flag* come to mean more than what they are as material or texture; they imply something about how they got to be what and where they are, and more than that they imply 'experiences'. The marks are a kind of handwriting, they demonstrate a personal touch, and they provide Johns and then us with the experience of an authoring subjectivity – an absent controlling presence, physical and mental, that best begins with *Flag* and remains consistent through a body of work.

Touch and double-touch. Looking. But what kind of touch-ing can Johns's touch be seen as? What did it, and what does it, add up to on and as the surface of *Flag*? What experiences does the viewer imagine to be associated with it? And what kind of subjectivity might be indexed by it? The most interest-ing and useful information with which to make an answer to these questions is found in the writings of some of those who first considered Johns's work worthy of serious attention. Here is a sampling presented in chronological sequence. Robert Rosenblum, the first person to write about the 'fasci-nation' of Johns's work, pointed to the 'sensuous presence' of its imagery and the 'elegant craftsmanship (in general, a finely nuanced encaustic), which lends to these pictures the added poignancy of a beloved, handmade transcription of unloved, machine-made images'.[82] Two years later he wrote much the same thing, only changing that reference to 'elegant crafts-manship' into 'fastidious technique'.[83] Ben Heller wrote about 'the superbly worked surface, the quiet or bold color, the enjoyment of detail and a sense of the artist having lavished care, patience, and love upon his work'.[84] 'It is', he continued, 'gentle, exquisite, intimate, most personal. It is an art of shading not shouting, of conscious control not spontaneity'.[85] So Heller went further than Rosenblum had done in his characterization of Johns's touch, but also found love there. William Rubin wrote that 'Johns' genius is essentially minia-turist, and the finesse of his hand compares with the finest in the French tradition (with which tradition he has a basic affinity of "facture")'.[86] Leo Steinberg told a story about a 'young woman' who had written to him in June 1960 saying ' "When I saw Jasper Johns's paintings I wondered why he wasted those beautiful Chardin-like whites and greys on flags and numbers." It was', he says, 'the classic feminine disap-proval – like the familiar "I-don't-know-what-he-sees-in-her!" – of a man's love that seems misdirected. And yet, so far only Rosenblum has remarked that there is a factor of love in the way Johns works with his subjects.'[87] Steinberg, who over-looked that Heller had also found love in Johns's touch, tells this story against the 'young woman'. As far as he is con-cerned, she can't see what is going on. But maybe she can. And maybe Steinberg does also, and that is why he put her down. Max Kozloff, in his review of the retrospective in 1964, wrote about Johns's paint that he 'deposits it so caressingly as

to make one think that the canvas was once some vast erogenous zone'.[88] Four years and several articles on Johns later, he wrote about the 'lambent textures and caressing strokes' of *White Flag*; Johns's use of wax was 'fluent and corpulent' and he had 'fleshed the larger part of production' with it.[89] In those seven fragments we can locate a lexicon of touching experiences that the beholder imagines and, maybe, imagines Johns imaging. Johns's touch is caressing and gentle; concerned; controlled; elegant, delicate and refined; fastidious; fluent; patient; intimate; most personal; sensual and sensuous, beloved and loving, of and affecting that feeling of attachment that is based on sex. The range of adjectives is narrow and specific. It would be easy to claim that the qualities associated with Johns's touch are gendered in the feminine. But that claim would not be wholly convincing. It would be more accurate to understand them as not securely gendered as masculine.

Abstract Expressionism makes a context for *Flag* and those who first put adjectives to Johns's practice, his handling and touch, did so in relation to it, or that bit of it, which was associated with the paintings of Pollock, de Kooning and Kline, paintings informed by and written in terms of what T.J. Clark has referred to as 'a whole metaphorics of masculinity'.[90] To understand what the adjectives add up to that are used to describe Johns's touch we need to understand how they were contextualized by what their writers said of its relation to Abstract Expressionism. This means rereading the literature on texture, handling and touch.

In 1958 Rosenblum wrote that Johns's work had 'the rudimentary, irreducible potency of Abstract Expressionism': it evidenced the basic, masculine – there can be no doubt about 'rudimentary, irreducible potency' being gendered in the masculine – strength and power of that mode. However, that 'potency' was immediately moderated in Rosenblum's account by reference to the 'poignancy' and 'beloved'-ness of Johns's handling.[91] This moderation prevailed when next he wrote about Johns, in 1960. Johns, he noted, might like Pollock, Kline or Rothko reduce his art to 'sensuous primary facts', but those facts are not 'an athletic tangle of paint, a jagged black scrawl, a tinted and glowing rectangle'.[92] Moreover, Johns avoided 'a revolutionary vocabulary of vehement, molten brushwork'.[93] Heller, in his essay of 1959, also

removed Johns from the machismotific potency of Abstract Expressionism but not with reference to his handling about which, as we have seen, he wrote some interesting things. For Heller, Johns, by contemplating subjects like the American flag, ran 'counter to the current expressionistic sense of self' even while he treated 'the painting as an object of poetic expression'.[94] Rubin wrote about Johns's work in the course of considering the influence of de Kooning on the painters who were shown at the Museum of Modern Art's 'Sixteen Americans' in 1961. He related Johns to de Kooning indirectly, and I guess unintentionally, by way of what he wrote about Joan Mitchell. For Rubin, Mitchell was someone who worked 'in the de Kooning tradition in terms of slashing attack and a "salting" of the work with drip'.[95] But this was not what made her 'the only really refreshing painter in this vein'.[96] No. Mitchell had lived in Paris for some years, had maybe looked at Cézanne, Cubism and Mondrian, and 'As a woman painter . . . untainted by the usual cosmeticism . . . she is able to endow her work with real finesse and refinement – a welcome contrast to the blustering, heavy-handed stance of much Abstract-Expressionism.'[97] The move away from de Kooning's Abstract Expressionism is by way of a practice gendered in the feminine but not so completely gendered as to be corrupted by 'the usual cosmeticism'. What saves Mitchell's work from cosmeticism is her ability to give it 'real finesse and refinement'. Although Rubin does not discuss Johns's work in relation to de Kooning or Abstract Expressionism, he finds much the same qualities in it as he did in Mitchell's: 'richness, refinement in surface textures' and 'the finesse of his hand'.[98] Clement Greenberg saw Johns's work definitely in relation to de Kooning's: he counted Johns among those painters in New York who had 'begun to put de Kooning's manner to the uses of outright representational art', and it was this that prompted Michael Fried's contradiction, a contradiction that turns on matters of touch.[99] Against Greenberg, Fried writes: 'To begin with, in Johns' early paintings (the first targets, flags and numbers) the most relevant influences in point of *touch* – to my eye at any rate – appear to be perhaps Tworkov and almost certainly Philip Guston rather than de Kooning. Right from the start there is a resolute smallness and fussiness about Johns' brushwork that declares, within a more general accord of idiom, its opposition to de Kooning's. . . .'[100] The need to

describe a difference from de Kooning leads to the description of a sexual difference. 'Fussiness' must be read as gendered in the feminine. Maybe it's not surprising that Fried concludes his dispute with Greenberg in matrimony. 'A formal problem', he writes, 'inherent in abstract expressionist practice but raised most forcibly in de Kooning's work: namely, given one's predilection for "painterly" brushwork, how to organize the surface of the canvas so as not to yield a cubist space . . .' is solved 'by wedding a Guston-type handling of paint to organizational schema whose explicit two-dimensionality is intended to preclude reading the brushwork in terms of cubist space.'[101] What was it Cage wrote in 'Jasper Johns: Stories and Ideas'? 'Stupidly we think of abstract expressionism. But here we are free of struggle, gesture, and personal image.'[102] And then: 'Looking closely helps, though the paint is applied so sensually that there is the danger of falling in love.'[103]

The strategy, inaugurated by Rosenblum in his review of the Castelli show in 1958, became fixed very quickly: Johns had to be written in relation to Abstract Expressionism and then removed, distanced or differenced from it. By 1964 it had become a paradigmatic operation. So Solomon would write in his essay in the catalogue of the Jewish Museum's retrospective: 'Despite the fact that the painted surface in the early pictures . . . shows him to be a direct descendant of the preceding generation of abstract painters, it must be understood that Johns' attitude represents a radical departure from the expressionist projections of the "action" painters . . . he accepts the animated expressive surface of Pollock, de Kooning and Kline as a given fact, and his own position depends on the opposition of "other possibilities" to this known quantity. . . .'[104] The 'other possibilities' – 'objects transformed in a variety of ways' – were implicitly possibilities of touch.[105] Solomon wrote that the way Johns used 'expressionistic brush strokes' – to bring together two disparate remarks – had 'something to do with his unwillingness to let his pictures function as a means to self-expression in the traditional way'.[106] Harold Rosenberg wrote much the same things in his review of the 1964 show: 'In Johns' hands the familiar Action Painting messiness, chance effects, "mistakes" and "accidents" discard expressiveness and enter into a planned disposition of esthetic elements.'[107] And then, 'the vision of difficulty and struggle announced by Action Painting finds its

antithesis as much in Johns' use of ready-at-hand painting techniques as in his universally available signs.'[108] And, as my final example, read this from Kozloff's review of the same exhibition: 'Once perceived, and it is impossible not to perceive them immediately, the paint marks wedge open the continuity between idea and execution, at least as normally exemplified in the creative process. They call attention to themselves, not as physical equivalents of gestures – as in the Abstract Expressionism from which Johns derives historically – but as calculated intrusions into alien territory.'[109] Since the Abstract Expressionist territory was one of masculinity, the 'alien territory' into which Johns's handling intrudes might well be considered to be that of femininity.

The literature is in agreement. Johns's practice has a relationship with Abstract Expressionism. He may even have appropriated some aspects of it as resources with which to make his own art, but he avoided the metaphorics of masculinity that were so much a part of it. Against Abstract Expressionism, with its machismotifics of the construction and destruction of self, of struggle, gesture and personal expression, Johns makes something different. But what kind of difference is it? You might expect it to be a difference gendered in femininity. After all, the masculine–feminine opposition serves to define all kinds of operations. The early writing about Johns's practice did utilize a metaphorics of femininity and concepts associated with it. Let me rehearse the list of adjectives associated with Johns's handling and touch: caressing and gentle; concerned; controlled; elegant, delicate, and refined; fastidious; fussy; fluent; patient; intimate; most personal; sensual and sensuous; loved and loving. Accumulated like that, the associations of touch, as we have seen, might be read as tending towards connotations of femininity, but individually their writers never described Johns's practice as thoroughly or emphatically gendered in the feminine. The writing on Johns's touch veered towards the feminine, but something – of it as much as of the world outside it – prevented it from being written as feminine. What seems to have stopped it was its perceived finesse and refinement. For Rubin these were the qualities possessed by Joan Mitchell's painting, which prevented it from lapsing into cosmeticism. Female though their connotations may be, finesse and refinement were what stopped Mitchell's painting from being

completely gendered in the feminine. Mitchell made paintings 'as a woman' which came up for the count as quality painting in the machismotific tradition of de Kooning. Johns's handling and touch may have been seen and written as veering towards the feminine, but its finesse and refinement prevented it from being compromised and written as that. It was too disciplined, conscious and controlled in the manipulation of its means and materials. A language of sexual difference was used to construct a knowledge of Johns's handling and touch, but it could not be resolved into either a masculine or a feminine handling and touching. Maybe it is neither. Or maybe it has associations of both masculinity and femininity.

Johns's touch disavows the conventional metaphorics of Abstract Expressionism, but it does so from within the very space of modernist practice that the Abstract Expressionists occupied. It is a kind of disavowal in the given, in the self as the self is conventionally associated with and indexed to the hand of the artist making the canvas. But it is not a complete disavowal, denial or rejection of the masculine. Nor could it be. The disavowal does not abolish masculinity. It recognizes it as a limit to be dealt with. Masculinity is there in Johns's touch, not as an established self but as a disavowed self. The surface of *Flag* can be thought of as marking a space for the situation of an other identity, one that could never be totally achieved. Never completely negated, the disavowed masculine metaphorics of touch remains residual in this space, making the possibility of an avowed other kind of touch that has to be understood as, or associated with, a kind of non-masculine masculinity.

Looked at in this way, the kind of physical and emotional intimacy associated with Johns's handling and touch surfaces as an allegory of homosexuality made at a moment when there was no space available in avant-garde art practice for its self-representation or identification. Though there was a well-organized homosexual world in New York, homosexuality could only be represented as a necessary self-definition by a fastidious disavowal. Of course, this is not the only meaning that could be read out of Johns's touch as it might be indexed to the way he put and pieced together the Stars and Stripes. But, it was one of the meanings that the early commentators went near to writing – simultaneously avowed and disavowed – for the surface of his art.

The foregoing must not be read as emphasizing texture and touch over the textuality – all the fragments cut and torn from *The New York Times*, the *Daily News* and the *Nation* – which contributes to the fascination of *Flag*'s surface and demands a certain pattern of observation and response. Some of *Flag*'s texts are very visible and must always have been so. Others have their places on its surface in such a way that they could only have been glimpsed. Others are completely hidden. However, at the moment of making *Flag* every bit of its printed matter must have been visible, legible, and read. Now as then, those texts that are visible invite the beholder to read them and encourage him or her to look for more bits that might become legible if only they are searched out (illus. 40).

Despite the prevalence of talk about the language of art, of gesture and touch, most persons who are interested in the visual image find it weak or confusing in respect of meaning. *Flag*'s textuality is where they might expect meaning to be straightforward and affirmed. It might be fragmented, dispersed and seemingly chaotic, but all you have to do is discover it and read it. *Flag*'s beholders do attend to its surface in this way. They do try to read its texts as part of the language of Johns's art, looking, no doubt, for any ideas and themes, criticisms and witticisms, personal revelations of the artist's response to contemporary events, to society, to the Stars and Stripes that might help them understand what *Flag* means or that might provide something with which to construct an authoring intentionality to place before the work. However, only a very few of those who have noted *Flag*'s textuality have made anything of it in their own publications.[110]

Two of the most obvious bits are almost tautologies of the Stars and Stripes. Part of what seems to be an embossed seal or franking-mark bearing the words 'United States [of America]' shows through white against the blue of the bottom-left corner of the canton. And the West coast of part of a map of the United States shows through at the left side of the lowest red stripe. In the stripes, where the texts are relatively easy to read, there are several frames from a 'Dondi' comic strip that was published in the *Daily News* on Wednesday, 15 February 1956: a repair to damage incurred during a studio party in that year (illus. 39).[111] Several texts were taken from this source, including a fragment of the title and author of the serialized

story '[AND DE]ATH CAM[E TOO b]y Anthony G[ill]' (illus. 38). Here is 'The story so far: After running through one wife's fortune and driving a second wife into an elopement, ANDREW GARSIDE, handsome, charming parasite, makes his daughter RUTH, a slavey [sic] while he lives on the legacy his sister left to her. On coming of age Ruth will be in control of her money. Her father breaks up her first romance, telling her suitor that Ruth inherited insanity from her mother'.[112] To the right of this is a black arrow, which in a not-too-clear photograph points to Elijah Smith as 'Policemen close in on [him] from both sides [of the bridge] about thirty-five feet above the treacherous waters of Little Hell Gate'.[113] And below, near the centre of the lowest red stripe, there is a bit of an ad with a photograph purportedly of Mrs Nellie Bloom who, according to the copy, is '[Married – with] pe[ace] of m[ind]', which 'only came . . . when she learned the importance of the proper method of douching with a fountain syringe, using a effective yet safe solution like ZONITE . . . an effective anticeptic-germicide that washes away germs and odor-causing waste and is harmless to tissues'.[114] Elsewhere there are bits of essays and articles, titles and authors from other places. 'The Inquiring Photographer by Jimmy Jemail'. 'A Famous Hollwood Figure Tells You How To Reduce' – what? Weight, I guess. Here is a recipe for apple sauce; there 'Radio Free Europe'; and elsewhere, 'Voice of the People'. There are several fragments from at least two chapters of a medical textbook, one with the title 'The Nervous System'. The *Nation* supplies a bit of an essay that mentions the 'Middle East' and the 'State Department'. Tracking across the stripes from top to bottom and back and forth, you can read 'Tubes 50% off [. . .] Free Tubes of [. . .] Special'; '[Al]lstate Insurance Protection'; 'The art of cooking [. . .] Helen Worth's Cooking School'; '[F]irmfit Creations'; 'Handbags 5.99'; a deal is offered on Oldsmobile cars, someone has 'chopped' the price of the '[. . .]na Travel-Writer', and there is 'Beneficial Finance'; there is something concerning Rodgers and Hammerstein's new musical *Pipe Dream* (illus. 37);[115] there is an endorsement for the Hammond chord organ; there are real-estate ads for manufacturing properties, buildings and factories; there are employment ads, including one for a 'secretary to [the] equipment manager of [a] national women's mag'; 'Stock Prices Ebbs As Market Idles', and 'Oats Declin[e]'

while something happens or does not happen 'In Soy Bean'; one fragment concerns Californian Water Works Bonds (illus. 37), another invites manuscripts for submission to a publisher. One or two texts – and there may be more – are metonymies of friends: the fragment, close to the map of the United States, in which is mentioned Port Arthur, Texas, is probably turned towards Rauschenberg, who grew up there; and an ad claiming that 'any one of these [. . .] agents can help you [. . .] on your fire insurance' may be indexed to Rachel Rosenthal, who had a fire in her loft in the winter of 1955.[116] There is more, but that will do as a fair sampling of *Flag*'s textuality.

What do these various bits and pieces of text offer those persons seeking some assurance as to *Flag*'s meaning? What sense can we make of them? And how might they be understood as representing Johns's response to the social events and processes of *Flag*'s determining moment?

Social and individual life is written on the surface of *Flag*, but it is not the kind of life that is usually found on the front pages of *The New York Times* or the *Daily News. Flag*'s textuality makes no reference to the kinds of stories that made the headlines in January 1955, for example, the State Department's decision to put 27 per cent of the United States out of bounds to Soviet citizens; or Eisenhower's State of the Union address; or the Senate's Permanent Sub-Committee on Investigations, once headed by McCarthy, formally coming under Democrat control; or the trip to China by the United Nations' Secretary-General seeking the release of UN prisoners of war, including eleven American aircrew imprisoned as spies by Communist China; or Eisenhower asking for, and receiving, authority to use armed force to defend Formosa from 'the Reds'; or the anti-Communist resolutions still being passed by the Senate. The closest *Flag* gets to representing these kinds of themes and motifs are the thoroughly concealed invitation from one newspaper to complete the phrase 'If I Were Ike' and fragments from articles on political parties and the 'New Deal' of the Thirties. We might take these to represent *Flag*'s politics. If so, only visible with infra-red photography, they are subterranean and out of date.[117] As for its economics, the stock-market awaits an upturn. Over and above these base regimes, the hierarchy of issues is signified by the 'burning, soreness, pain of simple piles'. We read *Flag*'s surface for statements of what it might mean, for some value

to add to it, and what we find is a recipe for apple sauce, hints on how to reduce something, and a few frames from 'Dondi'. Anyone looking for references to the Cold War or belated McCarthyism, nationalism and patriotism is bound to be disappointed. There is little or nothing of that order of high seriousness here.

Flag's texts are trivial and superficial, and often, in the way they have been torn or cut and placed, as jokes, make a kind of sense out of nonsense. We do not expect to find these kinds of texts brought into contact with the Stars and Stripes. That is part of their humour. However, it is a humour not occasioned at the expense of the American flag, whose meaning is not obviously devalued by their discovery. The Stars and Stripes provides the structure for the textuality to operate within, but that structure has a relatively autonomous existence apart from the textuality as reading-matter. It provides the all-over context for the texts-as-jokes, but these seem to be indexed more to their lost original contexts and Johns's reasons for choosing them than they are to the flag. Something or someone is being played with, caricatured and snubbed – including, perhaps, the artist himself – but the flag of the United States survives relatively in tact. Strongly prefigured, it seems not to be what is being made the figure of fun.

Having discovered *Flag*'s texts and read some of them, I now want to consider what point of view and what kind of authoring subjectivity they effect. The idea of the point of view is that it establishes a reciprocal relation between who sees and what has been selected to be seen. The former enables a knowledge of the latter and vice-versa. Subjectivity and history come together in the point of view. Just as there is no history outside of its subjective realization, so there is no subjectivity undetermined by the history to which it belongs and which it appropriates and uses. And what better place to locate *Flag*'s history and subjectivity than in the textualized remainders of history – of its 'context' – that Johns used to make its surface?

The texts Johns used to make *Flag* establish a point of view. It is a view, as we have seen, that was directed at certain pages of *The New York Times*, the *Daily News* and the *Nation*, but not to others. It chose to look past the big stories that made the front and back pages, beyond the feature articles, con- centrated on the inside-back pages, and generally found what

it wanted to look at in the small ads and the funnies. 'Rummaging' is a good term for describing the manner in which *Flag*'s texts were chosen.[118] Their point of view is that of the rummager. Whether in newspapers around the studio or in the trash-can, they were searched for and brought out of or up from other contents; *Flag*'s texts were examined minutely; and then reorganized in a certain disarrangement. Searched and then brought to the surface of *Flag* and situated between the Stars and Stripes, these seemingly trivial texts gain a value they never possessed in their original contexts. What Johns's rummaging seems to evidence is a subject who, though he knows himself to be contextualized by the big political, economic and social stories of the day, chooses to see himself in terms of other stories, superficial ones located elsewhere in small print and at some distance removed from what was generally regarded as important. Their disordered arrangement on the surface is also significant in the construction of a subject for the work of art. Like the handling and touch that puts them in place, their disorder also facilitates all sorts of 'possibilities for the changing focus of the eye'. Placed as they are, they might be understood to have been brought together by a shifting, always-looking-elsewhere point of view. But if so, it is one that is kept within the secure and rigid limits set by the Stars and Stripes. To my mind, all this implies an unfixed or changing subjectivity seeing itself otherwise than in the ways always already fixed by the lineaments of a dominant set of ideas and beliefs.

The Stars and Stripes, which has no precise class content or meaning, interpellates a popular–democratic subject. Even when it becomes the site of struggle, that struggle is rarely understood to be about class. Usually it is a struggle over what kinds of seemingly unclassed national or patriotic values it stands for. Once you have discovered *Flag*'s texts, you expect that in some way they will be read as appropriate responses to the Stars and Stripes, that they will either celebrate or criticize its nationalism and patriotism. As we have seen, except for a couple of texts that seem to signify as tautologies of the meanings of the Stars and Stripes, there is little that can be read as either celebration or criticism of it, or of anything. The textual matter is just too fragmentary and seemingly trivial to signify convincingly in those ways. Even when you try to pull *Flag*'s textuality into a discourse that is critical of its patriotic

significance, that reading, in the end, is always framed by and located within the very meanings it seeks to criticize. At most, what happens when you read *Flag*'s texts is that the vividness of the patriotic message goes out of focus as you get involved in their triviality. But you must come back to the Stars and Stripes. The patriotic message contains everything. It is more or less hegemonic. What I have in mind is this: when you start to read *Flag*'s texts, the Stars and Stripes, which controls their arrangement, becomes peripheral: you concentrate on what fills and colours the stars and stripes. And once discovered and read, the 'free tubes of' whatever, 'handbags 5.99', the 'pain of simple piles', 'Dondi' or *Pipe Dream* (the least successful of all Rodgers and Hammerstein's musicals) become almost as urgent as any need to pledge allegiance or as important as any front-page politics, economics or sociology that might be associated with it. To this extent *Flag*'s superficial textuality becomes more significant than the meanings invested in the Stars and Stripes; but overall, the Stars and Stripes does its work. The point of view is that of any citizen of the United States, but this Stars and Stripes to which he or she is subject contains something inappropriate; within the framework of a positive conception of ideology the viewer finds something not quite negative but odd and unexpected, trivial, humorous. *Flag* affects a subject who should identify with what the Stars and Stripes represents – and in Johns's case this is not merely, or simply, patriotism – but finds itself reading a kind of subversion of that identity. If only briefly, *Flag* makes a patriotic subject that contains within itself a sub-version of that self. It is a subjectivity that makes itself as a disavowal existing in an avowal, that represents what is important to itself in terms of the trivial and superficial, and which finds an unexpected value in an obscure object of desire. Pushed to name this point of view, its subjectivity and sexuality, I would call it 'camp'.[119] It was Christopher Isherwood who, in 1954, wrote that camp 'was a subjective matter of "expressing what's basically serious to you in terms of fun and artifice and elegance" '.[120]

Although my account of what *Flag*'s textuality might add up to is just one history to place next to any that could be narrated, it does make a certain sense alongside the meaning I teased out of the descriptions its first critics and historians wrote concerning handling and touch. Which brings me back

to my earlier remarks about the value of *Flag*'s texture in relation to its textuality. I want to impress that this discussion of its texts should not be read as valuing textuality over handling and touch. In the general economy of *Flag*'s surface both these aspects of its facture are held together in a non-hierarchical and non-synthesized tension.

> *Is it a flag, or is it a painting?* Alan R. Solomon, 'Jasper Johns', 1964[121]
>
> *The words 'flag, standard, colors or ensign', as used herein, shall include any flag, standard, colors, ensign, or any picture or representation of either, or of any part or parts of either, made of any substance or represented on any substance, of any size evidently purporting to be either of said flag, standard, colors, or ensign of the United States of America or a picture or a representation of either, upon which shall be shown the colors, the stars and the stripes, in any number of either thereof, or of any part or parts of either, by which the average person seeing the same without deliberation may believe the same to represent the flag, colors, standard, or ensign of the United States of America.* United States Statutes at Large, LXI, Chp 389, 1947, p. 642

When Johns dreamt he saw himself 'painting a large flag' did he see himself making a painting of a flag or was he making a flag with paint and canvas or whatever? There is a difference, of course. To make a painting of a flag is not the same as making one with paint. The former involves the artist in representation and illusion; the latter means dispensing with such things, the better to make the thing itself. Awake, and in the studio making the object that became *Flag*, Johns blurred the distinction between 'making a painting of a flag' and 'painting a flag'. It is of little importance whether he did so intentionally or otherwise. From the moment that he hit on the idea of having the Stars and Stripes provide the structure for the way he was to use the surface of his painting, the idea of making a painting of a large flag was compromised. It was further compromised, bearing in mind how a Stars and Stripes is made, by his decision to follow the usual pattern and use three separate panels, one canvas for the canton, one for the short stripes to its right, one for the long stripes below (illus. 37). For those who know the Stars and Stripes, and are punctilious, this is, and will be, important. What Johns was doing was more like making a Stars and Stripes than making a

painting of one. As we have seen, he even followed the pattern by making each star and each stripe as an individual unit, to be put together to make the whole flag. A major problem must have been how to make sure that what he painted did not fuse with the Stars and Stripes to such an extent that he made the American flag. With the change from enamel paints to wax and pieces of newsprint and cloth he hit on an admirable way of preventing this from happening. What prevents *Flag* from being a Stars and Stripes is, more than anything else, its strange, beguiling factitiousness. But this hardly secures its identity as a painting or, more broadly, as a work of art. It is not a painting in any conventional sense; and its effect is no more that of a painting than it is of a flag – it is *of* both.

Though this effect is best understood as thoroughly peculiar to *Flag*, it was initially regarded as one produced by more or less all the flag, target, number and letter paintings that were included in the Castelli exhibition in 1958. It is registered in the early, favourable writings on Johns as a failure to come to terms with the work. The critics valued it, but they had difficulty explaining it. Rosenblum, for example, found the visual and intellectual impact 'bewildering' and 'disarming . . . of customary esthetic and practical responses'.[122] Fairfield Porter, to give another example, wrote that the 'painting is neither about painting nor about the "art symbol": it has to do with looking'.[123] But 'looking' was problematized also: 'Not looking as sensation, nor about the visual world.'[124] And so on: 'nor is there a concern with myth (except indirectly perhaps – is a flag a mythical symbol?)'.[125] Steinberg, in his monographic essay written in 1961 and published the following year, wrote of 'a crisis of criticism'.[126] Critics write their own criticism, certainly, but they do not write it as they please; they do not write it under circumstances chosen by themselves but under given circumstances directly encountered and inherited from the past. Steinberg's own writing is inscribed as much by the crisis he is concerned to explain as it is by his effort to write beyond that crisis. After reviewing the critical reception of Johns's work he concludes:

> We thus have a critical situation in which some believe that the subjects were chosen to make them more visible, others, that they were chosen to become invisible. It is the sort of

contradiction that becomes a heuristic event. It sends you back to the paintings with a more potent question: What in the work, you ask, elicits contrariety? It then turns out that the work is such as to make both groups of critics – wrong as they were – right. For Johns's pictures are situations wherein the subjects are constantly found and lost, seen and ignored, submerged and recovered again. He has regained that perpetual oscillation which characterized our looking at pre-abstract art. But whereas, in traditional art, the oscillation was between painted surface and the subject in depth, Johns succeeds in making the pendulum swing within the post-Cubist flatland of modern art. But the habit of dissociating 'pure painting' from content is so ingrained, that almost no critic was able to see both together.[127]

This is puzzling going somewhere: the idea of 'contrariety' and of a 'perpetual oscillation between painted surface and subject in depth . . . within the post-Cubist flatland of modern art' are good attempts at a first description of the effect of *Flag*. But, given that the major problem for any artist concerned to make ambitious modern art and any critic or historian concerned to write its value or history is one of deciding between the requirements of subject and surface, how can one account for that 'perpetual oscillation' and avoid privileging either subject or surface? Steinberg glimpses that deciding or not deciding between surface and subject was part of the crisis. How could one write subject and surface together as they 'converge in a single-image meaning'?[128] Criticism found it practically impossible. The effect of the work was to frustrate the attempt to do so. Indeed, it could only be done by engaging in a critique of the two concerns as culturally contingent and necessary. No one was prepared to do this. Though in a sense that was what Johns's *Flag* did. Steinberg realizes this. He even tries to write it that way. But, in the end, his need to write against 'a half-century of formalistic indoctrination' ensures a privileged status for subject-matter.[129]

Subject matter is back not as adulteration, nor as concession, nor in some sort of partnership, but as the very condition of painting, whether in content and form, life and art, the paint and the message are so much one and the same, that the distinction is not yet, or no longer intelligible. This amazing result is largely a function of his original subjects.[130]

Clement Greenberg, a representative of the kind of art criticism and history that Steinberg was opposed to, and someone who later found it necessary to defend himself against charges of being an arch-formalist, did somewhat better in seeing and writing surface and subject together. For Greenberg, writing in 1962, the lasting interest of Johns's art was 'largely in the area of the formal or plastic.'[131] He is interested in surface-matter. He is not interested in 'the literary irony that results from *representing* flat and artificial configurations which in actuality can only be *reproduced*'.[132] In other words, he is not very interested in Johns's subject-matter. But we must be wary, because more than anything he is interested in the 'painterly paintedness of a Johns picture' and the way it 'sets off, and is set off by, the flatness of his number, letter, target, flag and map images'.[133] He is interested, then, in the relationship he sees between surface and subject, a relationship that he understands as dialectical and which accounts for the 'effectiveness' of Johns's painting. This is what he says:

> By means of this 'dialectic' the arrival of Abstract Expressionism at homeless representation is declared and spelled out. The original flatness of the canvas, with a few outlines stenciled on it, is shown as suficing to represent adequately all that a picture by Johns really does represent. The paint surface itself, with its de Kooning-esque play of lights and darks, is shown, on the other hand, as being completely superfluous to this end. Everything that usually serves representation and illusion is left to serve nothing but itself, that is abstraction; while everything that usually serves the abstract or the decorative – flatness, bare outlines, all-over symmetrical design – is put to the service of representation. And the more explicit this contradiction is made, the more effective in every sense the picture tends to be. When the image is too obscured the paint surface is liable to become less pointedly superfluous; conversely, when the image is left too prominent it is liable to reduce the whole picture to mere image . . .[134]

Greenberg thinks that Johns's painting marks a moment of development, mediation and transition in which one quality is about to be, but is not yet, negated by its opposite: 'he brings de Kooning's influence to a head by suspending it clearly, as it

were, between abstraction and representation'.[135] An effective Johns' painting holds image (subject) and surface in tension. If either is allowed to become predominant, the value, the pleasure, the effectiveness is lost. So, Greenberg is intrigued by Johns but, bound by his critical system – as Steinberg was bound by his different system – to value abstraction over representation, he finds the work diminished by an assumed influence of de Kooning's 'homeless representation' – 'a plastic and descriptive painterliness that is applied to abstract ends, but which continues to suggest representational ones'.[136]

Johns's painting: a perpetual oscillation between subject and surface with an emphasis on subject or a suspended moment in the dialectic between abstraction and representation with an emphasis on representation? In his book of 1969 on Johns, Kozloff, after discussing how the work resists or escapes explanation by non-formalist and formalist critics alike, points out that both accounts emphasize 'a paradox that has somehow to be exposed as a new intention'.[137] For whatever the persuasion of the critic, he perceives in the work of Johns, now weakly, now distinctly, 'a programmatic mating of opposites whose fusion is by no means settled or even determined'.[138] Johns, he writes, 'maneuvres himself into a position where any one of the possible ways in which his work can be interpreted is both valid and invalid in approximately equal measure'.[139]

In 1964 Solomon had written that Johns's pictures 'before everything else, have to do with the avoidance of specific meanings, with the necessity for keeping the associational and physical meaning of the image ambiguous and unfixed'.[140] This is how he described the effect of *Flag*:

Now that the point has been so firmly established, it is really quite difficult to reconstruct the circumstance and the state of mind in which we were first confronted by this painting, and to recall our astonishment at the boldness of the idea and our excitement over the questions it raised. To put the matter simply, we saw a flag, an object which offers none of the possibilities of formal manipulation, of the making of decisions about the disposition of shapes on the surface, a predisposition upon which all modern painting has depended since cubism. The formal situation, in other

words, was given, and the object quality of the image seemed to assert itself in a surprising new way, at the expense of everything we had taken for granted for fifty years. Yet, when we looked closer, we saw that it was after all a painting, since the flat areas of the red and white stripes and the blue field were worked, as paint, with an enormously authoritative facility and with a great deal of surface variety and interest. Once we had comprehended that *Flag* was after all a painting, and not a mechanical object, we were immediately forced back to the demands made by the image, particularly with respect to all of our previous associations with it, and most important of all, with respect to our visual over-exposure to the image; it was so familiar that we had no reason to look at it closely. And yet it was after all in a painting, commanding our notice just because the artist had put it there, which brought our attention back to the painting again and to the reasons for the presence of the flag in it. Plainly enough, the result is a continuing process which regenerates an unfathomable psychological tension; it can never be resolved because Johns insists on keeping the situation ambiguous and incapable of resolution.[141]

Solomon regarded Johns's work as asking 'rhetorical questions, unanswerable questions which keep us constantly off balance, particularly with respect to our smug acknowledgment of what all our previous experience has told us to be true'; questions like 'Is it a flag, or is it a painting?'[142] Looking at *Flag* we are offered a choise: an 'either' and an 'or'. But the situation is 'ambiguous and incapable of resolution'. Though *Flag* is not best thought of as ambiguous, its effect does seem irresolvable in an either/or way. Steinberg was almost right when he wrote about Johns's paintings 'eliciting a contrariety'. *Flag* is made of and effects a contrariety rather than an ambiguity. The point is not that it is made of or contains two or more meanings but that those meanings are antagonistic opposites. It is this that makes the situation 'incapable of resolution'. An easy reading off one side of the opposition is checked by the possibility of reading off the other side. This is part of the 'crisis of criticism'. Any privileging of one of *Flag*'s oppositions is frustrated by the possibility of privileging the other one. And yet the need is to

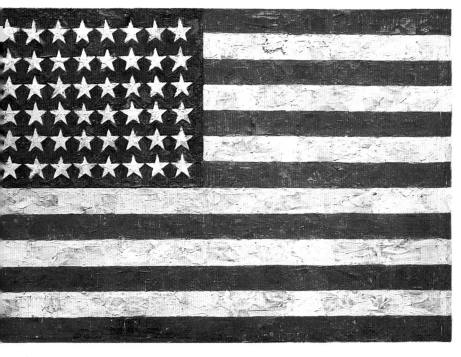

41 *Flag*, 1954–5, encaustic, oil and collage on fabric mounted on plywood, 107.3 × 153.8. The Museum of Modern Art, New York.

42 *White Flag*, 1955, encaustic and collage on canvas, 198.9 × 306.7.
Collection of the artist, on loan to the National Gallery of Art, Washington,
DC.

do precisely that, to fix its meaning and value as either surface or subject. Even Solomon tended to privilege subject-matter. 'There is no doubt that the predetermined nature of the flag image is the critical factor in the ambiguity. . . .'[143] This doesn't convince. *Flag*'s meaning and value has to be understood as a special kind of ambivalence. Solomon posed the question, 'Is it a flag, or is it a painting?' A year later Johns would answer, 'Say, the painting of a flag is always about a flag, but it is no more about a flag than it is about a brushstroke or about a colour or about the physicality of paint, I think.'[144] The early critics attempted to do away with this ambivalance by reducing it to two contradictory levels of signification – 'visual and intellectual'; 'painting and art symbol'; 'painted surface and subject in depth'; 'abstraction' and 'representation'; and so on. In doing so they established a pattern of error in explanation of Johns's art, and of *Flag* in particular.

Wittgenstein claimed in his *Tractatus Logico-Philosophicus* that 'A picture represents its subject from a position outside it. (Its standpoint is its representational form.) That is why a picture represents its subject correctly or incorrectly.'[145] Then he went on: 'A picture cannot, however, place itself outside its representational form.'[146] The point about Johns's *Flag* is that, as a work of art, it does not represent its subject from a position outside its representational form. It both represents its subject and is the subject represented. In managing to do this, it shifts the conditions of 'outside' and 'inside', referent and sign, flag and work of art.

The peculiar character of *Flag*, where the Stars and Stripes and the art object, flag and factitiousness, are so thoroughly congruent, is such that wherever one looks there is both flag and painting (or something that is neither painting nor collage, but painting and collage). *Flag* is neither flag nor painting (or something that is neither painting nor collage, but painting and collage) but flag and painting (or something that is neither painting nor collage, but painting and collage.) Neither the Stars and Stripes nor a painting (or something that is neither painting nor collage, but painting and collage) of the Stars and Stripes, it is simultaneously both the Stars and Stripes and a painting (or something that is neither painting nor collage, but painting and collage). The oppositions that organize *Flag* merge in a constant and provocative undecid-

able exchange of attributes. This causes problems for anyone who is concerned to fix its meaning.[147]

Let us assume that the Trustees of the Museum of Modern Art, New York, like Steinberg and Solomon and all those early commentators on Johns's art, were puzzled by *Flag*. Though not privy to the Minutes of their discussion, we can be pretty sure that they, too, were concerned as to whether it was a flag or a painting. We know, of course, that they were worried about whether it was patriotic or unpatriotic. These two concerns bear on each other.

> *Take Jasper Johns' work, which is easily described as an accurate painted replica of the American flag but which is as hard to explain in its unsettling power as the reasonable illogicalities of a Duchamp ready-made. Is it blasphemous or respectful, simple-minded or recondite? One suspects here a vital neo-Dada spirit.*
> Robert Rosenblum, 'Castelli Group', 1957[148]

> Emile de Antonio: *What about Dada?*
> Jasper Johns: *'What about Dada?' What kind of question is that? 'What about Dada?'*[149]

Johns's practice has been explained in terms of 'strategies for making and effacing art'.[150] The idea of effacing, however, is only of limited use for thinking about *Flag*'s effect because when Johns makes it he eliminates nothing. He causes nothing to disappear. Nothing is withdrawn from our attention. On the contrary, it is the way *Flag*'s flagness and factitiousness are made to refuse to disappear, and, not effaced, are allowed to affect each other, that causes its undecidability. We might better try to explain the peculiarities occasioned by simultaneously seeing flagness and factitiousness and the way that the former affects the latter, and vice-versa, not in terms of effacing art but of the interrupting of two messages, one of art, the other of life.

Flag is made of two main messages or two utterances. As a work of art it embodies a set of ideas and beliefs about art and aesthetics and as the American flag it embodies a set of ideas and beliefs about citizenship, nationalism and patriotism. When we try to concentrate on its message as a work of art, that message is interrupted by its message as the American flag. This interruption causes doubts about *Flag*'s ontology as a work of art but not about its patrioticness. Rather, this

interruption confirms the work of art's patriotic value. As Cage wrote, 'The flag is nothing but The Stars and Stripes Forever.'[151] But when we try to concentrate on *Flag*'s message as the American flag, the patriotic message is interrupted by the art message. As we have seen, *Flag*, an object that is manufactured neither of painting nor collage but painting and collage, is made of marks of its own contingency, problems and solutions, questions and answers of its own making. It is an interesting surface, made to be looked at, read and thought about. But how does the way it is made, and can be made meaningful as a work of art, relate to that which gives it structure, form and coloration – the Stars and Stripes? The meaning of *Flag*'s surface in art must somehow be at odds – this is the character of an interruption – with its meaning as the American flag if it is not to be understood – and it never has been understood in this way – purely and simply as the American flag. This is how *Flag* struck Ben Heller, the first person to write about it at any length, in 1959. Heller is in no doubt about it: 'Jasper Johns paints . . . the American flag'; but 'through the insistence of a flag rendered quite simply as a flag . . . Johns forces the viewer to actually *look* at the painting. This is a quiet forcing, a suggestive forcing, but an insistent one all the same. And it makes relevant the superbly worked surface, the quiet or bold color, the enjoyment of detail.'[152] For Heller, *Flag* is the American flag, but 'primarily' its importance is less as flag 'than as a means of forcing the viewer to focus upon the canvas itself . . . that in which he [Johns] is most interested'.[153] Though *Flag* is the American flag, its patriotic message is insistently forced into a state of less importance by 'the superbly worked surface', which is what interested and continues to interest Johns most. What Heller is writing here, as a critic tending to privilege surface over subject, is the extent to which *Flag*'s meaning in and as art interrupts its value and meaning as the national emblem of the United States of America. For persons of a patriotic persuasion, especially those not predisposed towards modern and Modernist painting, this was, and is, bound to be a problem. There would be nothing 'quiet' or 'suggestive' about this insistent 'forcing'. For them any 'interruption' of the patriotic message of the Stars and Stripes would have to be regarded as unpatriotic 'rowdyism'.[154]

Flag's 'rowdyism', its noisy or disreputable character, the

way its meanings in art and life interrupt each other, is hinted at in the term 'neo-Dada', which was used as the first published critical reflex to it when Johns showed it at the Castelli Gallery in 1957.[155] Dada had a low life in art history and criticism in the United States until 1951, when Robert Motherwell's *The Dada Painters and Poets: An Anthology* was published.[156] Exhibitions that included the work of Marcel Duchamp (in 1952) and Duchamp and Francis Picabia (in 1953), both accompanied by feature articles in the art press and *Life* magazine, contributed to, or can be taken as signs of, a renewed interest in Dada.[157] Then in 1957 there was a Jacques Villon, Raymond Duchamp and Marcel Duchamp retrospective at the Guggenheim Museum, New York, and another book appeared, *Dada: Monograph of a Movement*, again published by Wittenborn, Schultz, Inc.[158] It was in May this year, in Rosenblum's review of the 'New Work' show at the Castelli Gallery, that *Flag* first entered published discourse.[159] And entered it referenced to Duchamp and Dada. *Flag* was 'as hard to explain in its unsettling power as the reasonable illogicalities of a Duchamp ready-made'. Was it 'blasphemous or respectful [unpatriotic or patriotic], simple-minded or recondite?' Rosenblum suspected that here was 'a vital neo-Dada spirit'. The following year 'neo-Dada' was used to label Johns's *Target with Four Faces* (illus. 34) on the cover of the January issue of *Art News*.[160] Inside, above the table of contents, Johns was placed as 'the newest member of a movement among young American artists to turn to a sort of neo-Dada – pyrotechnic or lyric, earnest but slyly unaggressive ideologically but covered with esthetic spikes. Johns's first one-man show places him with such better known colleagues as Rauschenberg, Twombly, Kaprow and Ray Johnson.'[161] For the unacknowledged author of this copy, Johns's 'neo-Dada' was of a serious and cunning but not very hostile kind, directed more at art than life, at aesthetics rather than ideology broadly conceived. (Further inside *Art News* Fairfield Porter managed to review the exhibition at Castelli's without recourse to 'neo-Dada'.[162]) Thereafter, 'neo-Dada' was taken up by *Newsweek*, 31 March 1958, where, in an essay titled 'Trend to the "Anti-Art" ', the Johns show and exhibitions of work by Rauschenberg and Alan Kaprow were taken as evidence of a 'trend . . . in the direction of . . . neo-Dadaism, a throw-back to an old movement which shocked

Europe 40 years ago.'[163] The anonymous author provided this little bit of art history, which may well have been derived from Barr's Museum of Modern Art catalogue of 1936, *Fantastic Art, Dada and Surrealism*:

The original Dada movement grew out of the revulsion which many artists felt toward the bloody madness of World War I. Some of them – painters and writers – decided to create an 'anti-art', which they felt would be in keeping with the nature of an irrational world. Even the name Dada, was picked at random. One of the founders stuck a knife into a French dictionary, and the point hit the word Dada meaning hobbyhorse. Digging in the spur with a mad humor, the Dadaists rode their esthetic charger to exhaustion, trampling the neat scruples of everyone, who treated art more 'seriously' than they did.[164]

'Trend to the "Anti-Art" ' ends with a discussion of Johns's work – this is where we learn that he 'intuitively like[s] to paint flags' – and concludes:

At his recent first show almost all of Johns' pictures were bought – at from $150 to $2,000 – two reportedly by the Museum of Modern Art. Both he and Rauschenberg now live on their sales. Dada, it seems, rides again.[165]

It is difficult to know what to make of this. No doubt its significance should not be exaggerated. But it is significant that Hilton Kramer, writing a year later in *Arts*, deliberately represented that significance as insignificance. Indeed, he got quite hot under the collar about it, and about Johns – and Rauschenberg. For him, writing in February 1959, Johns's work was 'mock-naive . . . a kind of Grandma Moses version of Dada'. Whereas 'Dada sought to repudiate and criticize bourgeois values . . . Johns, like Rauschenberg, aims to please and confirm the decadent periphery of bourgeois taste.'[166] We can assume that issues of bourgeois value and bourgeois taste, issues necessarily unavoidable in any discussion of Dada, were raised by Barr's Committee when it met in February 1958 to consider purchasing *Flag* in the knowledge that, outside the Museum of Modern Art, Johns's work was understood as almost occasioning a revival of Dada. Surely it took the art-talk of 'neo-Dada' seriously. It knew that as Dada Johns's work might be seen as 'wantonly outrageous and iconoclastic', as

'advocating anti-rational values . . . almost to have declared war on the conventions and standards of respectable society'.[167] But it also knew that the original Dadaists held 'respectable society responsible for the War, the Treaty of Versailles, post-War inflation, rearmament and a variety of social, political and economic follies that have made the *realities* of modern Christendom in their eyes a spectacle of madness just as shocking as their most outrageous *super-realities* seem to the ordinary world which believes itself sane and normal'.[168] In other words, inside the Museum of Modern Art, Dada's anti-rational, outrageous iconoclasm and opposition to respectable, sane society might have been understood as a rational response to an irrational society. This was Barr's view as he had recorded it in *Fantastic Art, Dada and Surrealism* in 1936. He seems not to have changed his mind about it. By 1958 the catalogue was in its third edition. Of course, Barr and the Museum were well able to deal with these issues with regard to Johns's work generally. They were quite prepared to exhibit *Target with Plaster Casts* (illus. 7) so long as the lid was down over its penis. But they would not have found it so easy to handle *Flag*, where nationalism and patriotism were involved and where 'bourgeois taste' or artistic or aesthetic intention or effect could not easily be distinguished from 'bourgeois values' or ideological or political intention or effect. Inside the Museum, and within its own discourse on Dada, *Flag* might well have been understood by some persons not as an irrational response to a rational society – which would have been problematic – but as a rational response to an irrational society, which would have been more problematic.[169]

Whatever the content of its deliberations – flag or painting? 'Neo-Dada' or not? – it seems that Barr had trouble reassuring his Committee of *Flag*'s positive, patriotic value. We know that he tried to do it by providing a character reference for Johns. Remember, he described Johns as 'an elegantly dressed Southerner' who had 'only the warmest feelings toward the American flag'. But that didn't work. It couldn't. Biography and intentionality were not the issues. Effect was. The decision on *Flag* was referred to the Trustees.[170] Who worried about it. According to one account, Ralph Colin was 'the motivating force' here.[171] He considered it 'as perhaps too cynical a portrayal of the flag, and of course without regard to the esthetic qualities of the work'.[172] As far as he was

concerned *Flag* disregarded normal standards. It mocked and sneered at the Stars and Stripes. And Colin's was the opinion that prevailed. My guess is that in coming to agree with him, the Trustees were collectively registering the effect that *Flag*'s undecidability had on them. In the Museum of Modern Art's boardroom, *Flag*'s doubtful quality, its aporetic effect, was articulated as a kind of cynicism that might be understood by certain groups of persons as an interruption of the patriotic message of the American flag, or even as a violation of flag law and the flag code. And that is why, fearful that it 'would offend patriotic sensibilities', the Trustees voted against acquiring it in 1958, not a year of hysterical patriotism or Cold War paranoia but still one in which art and politics could not escape one another.

Worry about *Flag*'s patriotic value may well have died down, but an internal memo reminds the Museum of Modern Art's curators that it should not be exhibited in the main lobby, and the question of whether it is a flag or a painting of a flag is still a vivid one.[173]

> *. . . it has been necessary to analyze, to set to work,* within *the text. . . , certain marks. . . , that* by analogy *. . . I have called undecidables, that is, 'false' verbal properties (nominal or semantic) that can no longer be included within philosophical (binary) opposition, but which, however, inhabit philosophical opposition, resisting and disorganizing it,* without ever *constituting a third term, without ever leaving room for a solution in the form of speculative dialectics.* Jacques Derrida, *Positions*[174]

As an 'undecidable' *Flag* is a kind of 'unity of simulacrum' that cannot be securely located within any of the oppositions or antimonies that make it and which are used in its accounting. It resists and disorganizes them, and effects a constant exchange of meanings, attributes, values and subjectivities. Neither beginning nor end, it is both beginning and ending; neither forgetting nor remembering, it is both forgetting and remembering; neither original nor unoriginal, it is both original and unoriginal; neither personal nor impersonal, it is both personal and impersonal; neither masculine nor not-masculine, it is both masculine and not-masculine; neither celebration nor criticism, it is both celebration and criticism;

neither rational nor irrational, it is both rational and irrational; neither simple-minded nor recondite, it is both simple-minded and recondite; neither patriotic nor unpatriotic, it is both patriotic and unpatriotic; neither ground nor figure, it is both ground and figure; neither collage nor painting, it is both collage and painting; neither texture nor textuality, it is both texture and textuality; neither subject nor surface, it is both subject and surface; neither content nor form, it is both content and form; neither representation nor abstraction, it is both representation and abstraction; neither life nor art, it is both life and art; neither inside nor outside, it is both inside and outside; neither sign nor referent, it is both sign and referent; neither flag (standard, colours or ensign) nor painting (or something that is neither painting nor collage, but both painting and collage), it is both flag (standard, colours or ensign) and painting (or something which is neither painting nor collage, but both painting and collage). Mute and eloquent, opaque and lucid, *Flag* works in the space of difference where it articulates well-rehearsed oppositions and disarticulates them. Neither positive nor negative, but both positive and negative, *Flag* cannot be resolved into a pure positivity or a pure negativity and seems always to force seeing and understanding, reading and writing to another time and place.

3 Figuring Jasper Johns

Brillat-Savarin . . . observes that champagne is stimulating in
its initial effects and stupefying in those which follow (I am not
so sure of this: for my part, I should say this was more likely to
be the case with whiskey). Here we find posited, apropos of a
trifle (but taste implies a philosophy of trifles), one of the most
important formal categories of modernity: that of the sequence
of phenomena. What we have is a form of time . . .
Roland Barthes, Preface to Jean-Anthelme Brillat-Savarin's
Physiologie du goût, 1975[1]

One thing working one way
Another thing working another way.
One thing working different ways
at different times. Jasper Johns, *Sketchbook* [1965][2]

In 1960 Jasper Johns took a Savarin coffee-can that he had been
using in the studio to hold turpentine and paintbrushes and
translated it and its contents into plaster. The plaster version
was then sent to the foundry and cast in bronze. Next, the
bronze components were cleansed and chased. There must be
at least nineteen or twenty individual elements that con-
tributed to this object coming to be what it is: the can, the now
metal turpentine in the can, and the seventeen paintbrushes.
Assembled and painted, it was then titled *Painted Bronze* (illus.
43, 47) though sometimes – and increasingly after its appear-
ance at the Johns retrospective held at the Whitney Museum
of American Art in 1977 – a parenthesis is added to make it
Painted Bronze (Savarin). This addition is made not only to
make clear in discourse its difference from *Painted Bronze (Ale*

Another view of
is. 47, *Painted*
onze, 1960,
inted bronze,
.3 × 20.3
meter.
ollection of the
ist, on loan to
e Philadelphia
useum of Art.

Cans) (illus. 48), a sculpture of related meaning and effect, but
also, I think, to register a subtle increase of value which
accrues to it over the years greater than that which accrues to
its close relative.

 Painted Bronze has been referred to as a replica, but it isn't;
the details of the label, for example, have been copied, but not
exactly; the brushes, as one commentator put it, 'seem so
perfect that it is hard to believe that they are not the originals',
but it is the very perfection of their painting as painting that

proves the lie of them.[3] It has also been described as a *trompe l'œil* work, which would mean it functioned in a kind of game in which the beholder is willingly deceived, but Johns is surely not playing that kind of game.[4] He once explained the situation he was aiming for like this:

> You have a model and you paint a thing to be very close to the model. Then you have the possibility of completely fooling the situation, making one exactly like the other, which doesn't particularly interest me. (In that case you lose the fact of what you have actually done.) . . . I like that there is the possibility that one might take one for the other, but I also like that with a little examination, it's very clear that one is not like the other.[5]

The label looks like the label; something looking like a turpentine and paint spill has run down and across it. The top and bottom rims have been painted with metallic silver paint to look like the aluminium of the original can. A high degree of illusion has been achieved by the way it has been painted. It is an illusion enhanced by allowing the object the freedom to occupy, without a base, any space it is placed in. The possibility is there that you might take it for a Savarin coffee-can with seventeen paintbrushes, but it becomes clear when you look at it that it is not a can with brushes in it. *Painted Bronze* does not deceive the eye, and it would not deceive the hand: it is small, but it is very heavy. Look at the label: you can see that it has been painted, and quite freely; look at the small print: the marks signifying individual letters do not become them; letters refuse to make words; words remain illegible. But things are not out of control. Look at the way the turpentine spill has been made or permitted to change direction as it partly obscures the first 'a' of 'Savarin' and the 'o' of 'COFFEE'; look at any individual paintbrush handle and notice how it has been painted and overpainted; look again at the label – see its relations of colour and hue. This is complex painting mindful of the medium and playing games with the illusion of shallow space. The fingerprints on the brushes make the illusion, but the ostentatious orange thumb-print on the can, wrinkling the red of the label and pushing the black band of 'COFFEE' into the ground, unmakes it. And not all of the can has been painted over: here and there the bronze of the cast metal breaks the illusion created by the aluminium

paint. Also, Johns's touch is everywhere apparent as style and as a kind of subjectivity. Each mark is treated as *of* the can, the label, and the brushes, and as *of* Johns himself and his identity as an artist concerned with the intimate tactility of pictorial things. In this respect the fingerprints and thumb-print are tautologies. There are no accidents here, just a lot of highly selfconscious, self-reflexive hand-of-the-artist facticity of the kind associated with Modernist painting. It may seem like a sculpture, but, if so, it is a sculpture that has been painted not so much to look like a Savarin coffee-can with paintbrushes in it as one that has had painted onto it – so as to be congruent with it – a thoroughly Modernist painting of a Savarin coffee-can with brushes in it. It is very delicately done, but there is no doubt that this is painting stressing the properties of the medium and the flatness of the surface in ways that are supposed to guarantee painting's independence of and resist-ance to the sculptural. Yet this is Modernist painting that has been added to the very three-dimensionality that is the province of sculpture. Without a base, however, its three-dimensional value as sculpture is depreciated. But it is not negated. *Painted Bronze* does not go as far as *Flag* in problem-atizing the ontological difference between art and life, art and non-art, but it does problematize, in a related way, the difference – and in the discourse of art around 1960 it was for some persons a crucial difference – between painting and sculpture. As its title suggests, *Painted Bronze* is an object that is neither a painting nor a sculpture, but both a painting and a sculpture.

Conversing in a room that had both painting and sculpture in it and knowing as he does that there is a difference between them, he suddenly laughed for he heard what he had just said (I am not a sculptor). I felt suddenly lost, and then speaking to me as though I were a jury he said: But I am *a sculptor, am I not? This remark let me find myself, but what I found myself in was an impenetrable jungle.* John Cage, 'Jasper Johns: Stories and Ideas', 1964[6]

This is the wandring wood, this Errours den . . . Edmund Spenser, *The Faerie Queene*[7]

Johns is best known for his paintings, drawings and prints, and most commentary on his art has tended to forego

extended discussion of his sculpture. Examples of his work in three dimensions have been included in the retrospective exhibitions and are mentioned in the monographs, but the lack of attention paid to it is worth commenting on. Of course, Johns has produced very little sculpture – only twenty or so pieces – most of which was made between 1958 and 1960 and several of which, for example *Flashlight* (illus. 44), *Light Bulb* (illus. 45) *Painted Bronze (Ale Cans)* or *Painted Bronze*, problematize their condition as sculpture.[8] So, Johns may well be a sculptor, but making sculpture seems never to have occupied him to the extent that painting, drawing or printmaking have, and when he has made work in three dimensions, that work has tended to make seeing and understanding it as sculpture difficult. Alan Solomon, in his catalogue essay for the Jewish Museum retrospective of 1964, wrote of how he experienced 'a genuine confusion about the identity of these objects'.[9] His reaction was typical. Furthermore, most of Johns's sculptures are small in size and, despite their complexity of effect, seem, somehow, no more than playful diversions. Yet, as Freud and Wittgenstein have reminded us, some things can only be said, or can only be said effectively, playfully or in the margins, as jokes or asides.[10] Maybe this is how we ought to respond to Johns's sculptures. In which case, *Painted Bronze* might best be understood as a joke or an aside that developed – to an extent greater than *Painted Bronze (Ale Cans)* or any other individual piece did – a centrality and importance that transcended the seriousness of its initial wittiness.

Rereading the literature of 'Jasper Johns', particularly the monographs and monographic essays, it becomes apparent that the usual strategy for writing about Johns's sculpture is to tell us how a piece was made, then note how puzzling it is, and then relate it to what one has to say about the paintings, drawings and prints. (In this respect, what you are reading now might strike you as conventional.) However, the monographs by Max Kozloff and Richard Francis provide us with two interesting exceptions to the general rule. They are exceptional because they begin with a discussion of the issues raised by an individual sculpture, and that discussion then determines – orders, clarifies and defines – what each author has to say about 'Jasper Johns' and Johns's art-practice generally. Francis chose to attend to *Painted Bronze*.[11] It makes a good beginning. Kozloff went to another sculpture, *The Critic Sees*.[12]

44 *Flashlight I*, 1958, sculpmetal over flashlight and wood, 13.3 × 23. × 9.8 Private collection, New York.

45 *Light Bulb II*, 1958, sculpmetal, 7.9 × 20.3 × 10.6 Collection of the artist, on loan to the Philadelphia Museum of Art.

What Kozloff says about *The Critic Sees* (illus. 46) is especially interesting and useful and I want to consider it here. Before I do so, it is worth taking note of the epigraph that Kozloff appended to his text:

46 *The Critic Sees*, 1961, sculpmetal over plaster with glass, 8.3 × 15.9 × 5.4. Present location unknown.

> All the arts live by words. Each work of art demands its response; and the urge that drives man to create – like the creations that result from this strange instinct – is inseparable from a form of 'literature', whether written or not, whether immediate or premeditated. May not the prime motive of any work be the wish to give rise to discussion, if only between the mind and itself? PAUL VALERY: *Degas, Manet, Morisot*[13]

Kozloff believes that works of art can affect the way we see and understand the world. Whether they are relatively clear and specific or relatively unclear and unspecific with regard to their intentions and audience, in each case, seeing them can lead to new knowledge. Paintings and sculptures usually effect this knowledge by guiding the eye, leading or directing it to this or that meaning. They do not usually, he says, 'interrogate the whole operation of looking'.[14] Unless, that is, they have been made by Johns, whose intention is to have them do precisely this. Johns's paintings and sculptures 'set out to trip up the beholder with his own prejudices'; they 'call attention to the experiences of the viewer, even as they provide that experience'; they 'provoke the spectator about

the spectator's provocation'; and they have as their 'content' not 'the thing seen' but 'seeing' it.[15]

According to Kozloff, Johns has developed a practice based on the supposition that ' "things" have no intrinsic value', that there is no equivalence between a thing and what it represents.[16] A work by Johns must, therefore, be understood not as having a 'message' in its own right or a literal meaning, but as presenting several possible meanings from among which the beholder, provoked or lured into curiosity, has to choose. 'But to choose among these alternatives, or even to judge what they might be, becomes an experience of imaginative self-discovery which Johns' creations are designed to test.'[17] Often the ability to choose is frustrated by a work's initial aesthetic appearance; that is, by its obvious or emphatic fascination as facture, colour, composition, and so on. The locus of meaning will be the beholder, but in front of any work by Johns the beholder's usual ways of making sense of what is being looked at, experienced and named, are threatened or examined to such an extent that the work turns out to be 'a species of menacing pleasures'.[18]

It is here that Kozloff refers us to *The Critic Sees* as 'an illustration, or almost a paradigm' of the situation he is concerned to describe.[19] *The Critic Sees* is a brick of plaster with, on its façade, a cast of spectacles, behind the lenses of which are set casts of human mouths, one with the teeth together, the other with the teeth apart; and everything is covered with a layer – brushed, smoothed, and scratched – of grey plastic-metal of the kind used by model-makers. *The Critic Sees* makes a joke about art critics and art criticism: critics are blind, they see with their mouths. Kozloff notes this obvious inference and then goes on to point out that

> the piece is figuratively endowed with a sensory capacity of its own. Not only does it have an inner and outer structure, but it also carries the suggestion that human senses – insofar as they are referred to by facial fragments – are contained by the work, which thereby confronts the spectator in an almost animate guise. Or, rather, it should be said that faculties, rather than the senses, indicate the point at issue. For verbal activity, or possibly that from which it derives, conceptual thinking, is juxtaposed to the process of vision. . . . Taken in itself the object would imply, not that

sight is more important than speaking, but that they are peers, brought together in an unnatural situation (with the further discrimination that the speech element might be seen as active or passive).[20]

Seeing, and thinking and speaking. Kozloff's conclusion:

Overall, then, *The Critic Sees* is a presentation of two activities concerned not only with works of art, of course, but with the human reception of the visual world: sight and verbal articulation. Within their context here it is impossible to tell whether speech has usurped vision, or vision has capped speech. The probability remains that they are necessarily mutual reinforcements, components of an integrated function. But it is just as reasonable to suppose that they are displacements rather than extensions of each other, with all that that suggests of resistance and disorientation. That either interpretation is possible is merely one attribute of the muteness of visual art – which can be literal and tangible, but not explicit, in its meaning. Johns accentuates this muteness in an effort to underline the spectator's dilemma. If his 'statement' is open-ended and unresolved, so too, he seems to be saying, is our relation to art. His is a reverie on the potentialities of and the obstruction to what can be learned. Without at least an initial intimation of this uncertainty, and the pressure it exerts, no viewer fully experiences a work of art which sidetracks all categories. (Is *The Critic Sees*, for instance, a life cast, a still life, an object, or a sculpture – and if a sculpture, is it a bas-relief?) For one moment in his career the artist externalises, perhaps even allegorizes, the dialogue in which 'the prime motive of any work is the wish to give rise to discussion, if only between the mind and itself'.[21]

At the end of his analysis Kozloff is, of course, using and following a part of the epigraph he has taken from Valéry's text *Degas, Manet, Morisot*. With that in mind, it is not difficult to understand why he regarded *The Critic Sees* as a puzzling object determined by an 'urge', 'drive', 'prime motive', 'wish' or desire for 'an experience of imaginative self-discovery' that necessarily came to have 'a form of literature'.[22] It is this desire that Kozloff believes Johns 'for one moment in his career . . . externalises, perhaps even allegorises'. But this is a desire that

47 *Painted Bronze*, 1960, painted bronze, 34.3 × 20.3 diameter. Collection of the artist, on loan to the Philadelphia Museum of Art.

48 *Painted Bronze (Ale Cans)*, 1960, painted bronze, 14 × 20.3 × 12.1.
Museum Ludwig, Cologne.

could only be externalized – represented – allegorically, and *The Critic Sees* is hardly an isolated instance of its coming into being. Johns's dominant mode of seeing, thinking and speaking 'the visual world' and forming 'works of art' is allegorical. That is what I claim in this essay. And what is interesting and useful in Kozloff's discussion of *The Critic Sees* – in the way he begins his book on Johns – is that, although all the early commentaries on Johns's work registered the uncertainty effected by it, his was the only text to glimpse that Johns might be worth serious consideration as an allegorical artist and that the value of his work, especially in the late 1950s and 1960s, might be as allegory.[23]

> *The subject of allegory can only be called a grammatical subject.* Hegel, *Lectures on Aesthetics.*[24]
>
> *The language of allegory speaks to another.* Maureen Quilligan, *The Language of Allegory*[25]

Allegoria – the word first appears in the Hellenistic period, perhaps around 270 BC, with reference to the grammatical and rhetorical tradition in which it had the restricted sense of a trope.[26] It is a Greek word made of two parts. The first part comes from *allos*, which means 'other'. The second part comes from the verb *agoreuein*, which originally meant 'to speak in the open assembly'. However, the 'open assembly' or *agora* that is contained within the verb has historically specific connections with two different places and two different ways of speaking. *Agoreuein* has in it the idea of speaking in the Athenian legislative assembly and in the open market-place, of speaking in the manner of official political address and in everyday common speech. When *agoreuein* is combined with *allos*, the composite *allegoria* connotes both that which is said in secret and that which is unworthy of the crowd. *Allegoria* is a private, guarded way of speaking: the 'mob' may hear it, but it is most intended for the 'few'; what is spoken is spoken publicly but, at the same time, privately.

Allegoria: 'other-speaking', to speak otherwise or to signify other than that which is said. As the components come together they give rise to two distinct but related traditions of allegory. If the emphasis is placed on 'speaking' or 'saying' other than what seems to be spoken or said, then allegory is

largely a grammatical and rhetorical matter concerned with compositional techniques, practices, protocols and procedures. But if emphasis is laid on the 'other' and allegory is taken to be a matter of saying or speaking on or about 'an other text', then it is a philosophical or exegetical matter concerned with explicating or interpreting something already spoken or written. This is *allegoresis*. As allegory developed, the two traditions of grammatical and rhetorical practice and critical commentary came together as a mode that is present in more or less any kind of representation, verbal or visual. Any allegory of the Middle Ages, Renaissance or modern epoch will evidence a highly developed, selfconscious use of language and a highly developed, selfconscious concern with using, incorporating and commenting on another text.

It is a defining characteristic of allegory that it has an antecedent text – some verbal or visual representation external and prior to it – that it echoes and alludes to. This antecedent text will have a religious, historical, philosophical or aesthetic authority that is remade, cast or re-imaged by the allegorist. It is given a new context, structure and meaning to supplement that which it had before. The relationship that pertains between the allegory and its antecedent text is a complex one. Edwin Honig explained it in terms of a 'twice-told tale'; Maureen Quilligan, following him, described the antecedent text as the 'pretext'.[27] This is Quilligan on allegory's special relationship with its pretext:

> By pretext I mean the source that always stands outside the narrative (unlike the threshold text, which stands within it at the beginning); the pretext is the text that the narrative comments on by reenacting, as well as the claim the narrative makes to be a fiction *not* built on another text. The pretext thus names that slippery relationship between the source of the work and the work itself; this relationship deserves a special term, for it is more complicated than the usual connection between a work and its sources, which are often no more than places where the author found stimulating ideas for fictional treatment of a given subject. Even when an allusion is meant to be used as a guide to interpreting the specific passage in which it occurs, this nexus of texts does not approach the connection between an allegory and the pretext. The pretext is not merely a

repository of ideas, it is the original treasure house of truth, and even if that treasure house has been plundered and is assumed to be empty, it still retains its privileged status in guiding not only interpretation but the possibilities of the allegory. And it is primarily the status of language in the pretext which determines the development of allegory; if its language can name truth, then the language of the allegorical narrative will be able to. If its language is not felt to have special powers for revealing reality, then the language of the allegory will have a corresponding difficulty in articulating the truth of the human condition.[28]

What Quilligan is driving at is that the pretext is more than merely one resource among the many available in a culture with which to make another text, story or image. It is a resource chosen because it is rich enough to enable a work that, when it is made, seems new. The new work seems original but the pretext provides its 'truth', and even guides our attention to that 'truth'. What gives the pretext its special value, however, is not only the truth or ideal it contains but also its way with language. It is the pretext's semantics or syntax or vocabulary or imagery or any combinations of these that the allegorist appropriates for the allegory along with something of its truth or ideal. In the Middle Ages and the Renaissance, the Bible or one of its Covenants or Books or chapters or verses would have been the pretext for allegory. This is less likely to be the case in the modern epoch. Though the problem of recreating authority as a critical re-examination of the ideal is almost certainly part of the same endeavour. The pretext for modern allegory, and here, of course, I have Johns's practice as an allegorist in mind, might well be something of the art of Magritte or Picasso. However, as it was with the Bible, so is the pretext with Magritte and Picasso. Which brings me to comment on the idea of the 'threshold text' that is referred to parenthetically by Quilligan in the extract given above.[29] This is what establishes the pretext's presence and authority as 'source' within the allegory. The threshold text begins and starts the direction of the new work formally and ideally and provides the signal for the reader or beholder to scan and understand the work as allegory. In Johns's art, for example in *Harlem Light* (illus. 1) and *Untitled*, 1972 (illus. 6), the flagstones and the crosshatchings function

as threshold texts or threshold images that refer the beholder to the pretextual authority of Magritte and Picasso, and establish new beginnings in and for work – albeit beginnings already well-established – both in terms of form and ideal.

So to the meaning of allegory in rhetoric. One of the earliest definitions of allegory in English is in Thomas Elyot's *Bibliotheca Eliotae: Eliotes Dictionarie* of 1559: '*Allegoria* – a figure called inversion, where it is one in woordes, and another in a sentence or meaning.'[30] Over 400 years later, Angus Fletcher in his *Allegory: The Theory of a Symbolic Mode* defined it in much the same way: 'In the simplest terms, allegory says one thing and means another.'[31] This is the conventional wisdom. And it is fine, so long as we keep in mind where the otherness of allegory is located. The other thing, sense or meaning that allegory says is a property of, or a possibility present in, the words of a text or the forms of a visual image, in the material signifiers of an utterance made visual.[32] Remember, Walter Benjamin insisted that allegory always laid claim to being written, not spoken, words, and recognized in the literary and visual emblem books of the Baroque 'authentic documents of the modern allegorical way of looking at things'.[33] As Quilligan has pointed out, 'All allegories are texts, that is, words printed or hand-painted on a page. They are texts first and last: webs of words woven in such away as constantly to call attention to themselves as texts. Unlike epics, which can be oral, allegories are always written.'[34] In allegory the material signifiers are signifying several signifieds simultaneously. The *allegoria* is in the words written on the page or in the visual images, in their continuous interplays as they effect meanings, and not in the meaning that the reader or beholder makes for them or gives them by way of commenting on them – that is *allegoresis*. The 'inversion' that defines allegory is effected by the play of its material signifiers, by what can be seen and understood; the other 'sentence' or 'meaning' is not added by the allegory's readers or beholders because it is absent and needs to be put in place; it is present as a kind of polysemous potential in the way the materials have been formed or figured. Allegory acknowledges – plays with – and uses the polysemic capability of signifiers to turn an open and direct, a relatively public, statement towards other less open and less direct, relatively private, meanings. It means what it says, but it also signifies otherwise. It is a critically selfcon-

scious way of writing or visual imaging that effects several meanings simultaneously. Most of the persons addressed by allegory are cognitively and emotionally satisfied with what it says literally, but other persons, sharing the allegorist's attitude to language and stimulated by his self-reflexive use of it, are predisposed, in skills and competence, to take another meaning, or several other meanings, from it.

As Fletcher pointed out with reference to Elyot's definition of allegory, the term 'inversion' or '*inversio*' should be taken in its original sense of 'translation', while 'translation' is but the Latin equivalent of the Greek *metaphor*.[35] It was Cicero who first used *allegoria* in the sense of 'a continuous stream of metaphors' ('cum fluxerunt continuae plures tralationes [translationes]'). And this is the sense that Quintilian, in the first century AD, gave it when he wrote 'A continuous metaphor makes an allegory' ('*allegorian* facit continua *metaphora*').[36] Allegory: a figure called inversion, translation or metaphor – this is formally correct but, following Fletcher for a moment, the definition only 'holds true as long as the term "metaphor" is understood loosely. If metaphor is to be the name for any and all "transfers" of meaning it will necessarily include allegory.'[37] As Fletcher goes on to point out, the difficulty here is that taking metaphor as the name for all transfers of meaning obscures the complications that make allegory interesting. He recalls the classic distinction between trope and figure. We need to hang onto it. A trope is a word used in a way that effects a conspicuous change of its meaning. A figure is a change of meaning effected across a group of words, sentences or paragraphs. Allegory must be a figure.[38] Fletcher then notes and inverts Quintilian's belief that in the same way that 'a continued metaphor develops into allegory, so a sustained series of tropes (e.g., ironic tropes) develops into this figure' also.[39] Quintilian was considering irony – where the whole discourse is permeated by doubt and double meaning – as the best example of truly figured speech. Irony, which was traditionally classified as one of the tropes, is a statement that involves the explicit expression of one attitude or evaluation but means the opposite attitude or evaluation. Irony, unlike allegory, says one thing and means its opposite. But what Quintilian says about irony and allegory suggests an approach to allegory with regard to the tropes. 'Perhaps', says Fletcher, 'instead of considering how the

parts, the particular tropes of irony and double meaning, have the power to produce a total allegorical figure, we might ask whether the total figure . . . does not give particular symbolic force to the part. The whole may determine the sense of parts, and the parts be governed by the intention of the whole. This would yield a concept of a teleologically ordered speech.'[40] In other words, instead of thinking of allegory as determined by the development of its parts we should really consider the selection and combination of the parts as determined by the allegory or by the allegory's 'truth' or 'ideal'. Allegory governs the systematic use of the tropes. It determines the crafted functionality of its way of speaking. And the two kinds of teleologically controlled tropes that, for Fletcher, come immediately to mind are, of course, synecdoche and metonymy. We are not far from Johns at this point, and synecdoche and metonymy will return us to him very soon. As we have seen, with metonymy the literal meaning for one thing is applied to another with which it becomes closely but contiguously or concomitantly – and perhaps only briefly – associated; it establishes a cause/effect relation. With synecdoche a part comes in place of a whole, and so on. In the end Fletcher has no doubt about it: 'taken together synecdoche and metonymy appear to contain the full range of allegorical part-whole relationships'.[41] As far as he is concerned, we can now settle on the generic term for the sustained use of synecdoche and metonymy, namely allegory. In that case allegory, which begins in and contains metaphor, is the generic term for a figure made of opposed, antagonistic tropes.

> Heretofore the naming of names has gone on either literally or as metaphor. But now . . . a new mode of expression takes over. It can only be called a kind of ritual reluctance. Certain things, it is made clear, will not be spoken aloud; certain events will not be shown onstage; though it is difficult to imagine, given the excesses of the preceding acts, what these things could possibly be. Thomas Pynchon, The Crying of Lot 49[42]

> The plane's edge beckons. Susan Sontag, 'In Memory of their Feelings'[43]

What I take to be Johns's way of working with the controlled use of synecdoche and metonymy can be tracked across the surface of a number of paintings that he made in the late 1970s

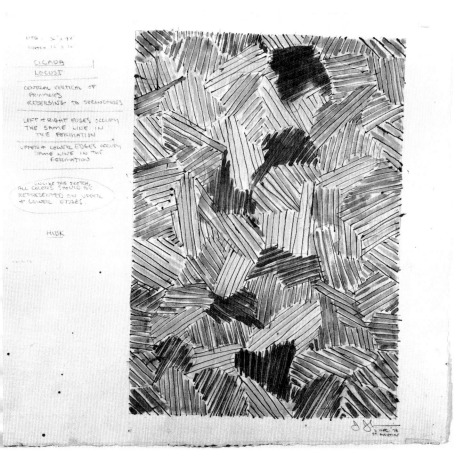

Untitled, 1978,
watercolour, pencil
and ink on paper,
55 × 45.7. Private
collection.

and early 1980s. The order and progress of these paintings is clearly established, and they permit us to see the inauguration of certain synecdoches and metonymies and to follow the manner of their convergence and divergence, association and displacement. The paintings I have in mind had their beginning in aspects of two watercolour drawings. The first drawing, which is dated 2 December 1978 and catalogued as *Untitled* (illus. 49), works out a new variation on the cross-hatched surface: the colours change from a centred vertical row of primaries to secondaries at the edges, and the pattern is such that if the surface was scrolled horizontally and vertically it would make a *torus* (a ring-doughnut form).[44] In the wide margin at the left Johns has noted how the pattern works and, as if they were possible titles, he has also noted the words 'HUSK', 'LOCUST', and 'CICADA' in underlined capitals. Six

months later, in June 1979, 'Cicada' was taken over as the title of the other drawing that concerns me (illus. 51). This large drawing sets the word 'Cicada' in place at its lower edge in this fashion: a bit of an 'o' and then 'HNS1979CICADAJASPERJ' and then the other bit of the 'o' that began the syntagm and which returns us to it. Since *Painting with Two Balls* of 1960 (illus. 57) it had been Johns's practice sometimes to stencil his name or initials and the title and date of the picture at its lower edge, but here they are used, as they were for the first time in *Fool's House* of 1962 (Collection of Jean Christophe Castelli), as a trope on the way that *Cicada*'s surface could be rolled to form a cylinder. We might see the painting of the label on *Painted Bronze* as establishing this 'rotational trope' in Johns's art.[45] However, the turning effects of this surface are of less interest here than the marginalia associated with it.

It is difficult to identify or describe everything drawn, painted and written in the margin of the *Cicada* drawing. There are several hatching strokes in red, yellow and blue watercolour, some of them outlined with their complementaries. These could be test-marks where Johns estimated the amount of paint in his brush and its rate of flow. But why are some of them given wavy outlines? And while much can be estimated by pressing a round-pointed brush onto the sheet so that it makes a tear or droplet shape, why trail off that shape with a tail like a tadpole or a spermatozoon – unless you wanted it to look like a tadpole or a spermatozoon? There are four drawings of cicada: two views from above and two from the side; two painted green, and two in monochrome wash; three with wings and one of the insect at larval stage. There are drawings of hands; eyes; a turtle made with a continuous spiral; a triangle with a circle in its centre made with a fine brush and red paint, and another made with a pencil and outlined with violet wash; a fire; other more or less unidentifiable things; schematized, diagrammatic representations of sexual couplings and quadruplings; penises and scrotums, with and without hairs; skulls – single skulls and lots of skulls – full face and profile; a skull and crossbones (this skull is drawn in profile also); it is here that Johns works out the arrangement for the stencilled letters (or seems to): 'OHNS 1979 CICADA JAS' bisected by a vertical line after 'CIC' and, marked above it, 'MID'; and last, in this incomplete listing, 'POPE PRAYS AT AUSCHWITZ/''ONLY PEACE!'' '.

What are we supposed to make of all this? Does it signify? Or is it a non-signifying diversion? Is it a kind of imagistic game? Or is it more like an accidental narrative that Johns produced while making the hatched surface that came to be associated with it? Not that there seems anything surrealistically automatic about this marginalia. I certainly do not think that Johns was trying to map his unconscious. It is more material than that. There must be reasons for these images to be there beside the hatched surface. But it seems that the reason they are there is not that they were what was in his mind when, over a pencil grid, he began to paint in the hatchings. They seem to have been contingent or concomitant references. The first 'cicada' is a marginal reference alongside 'locust' and 'husk' – a 'cicada' that came to intrigue him as he worked on the surface. Sign or referent? The name of an insect or the actual insect? The name of an insect or a picture of the insect? Two different kinds of signifier, but maybe not ones where the specific reference rather than a contingent or concomitant reference should be taken. The hatched surface and 'cicada' and then the hatched surface and *Cicada*'s marginalia in this account come together in much the same manner that the target and plaster casts came together to make *Target with Plaster Casts* (illus. 7). They were in the same space and were brought together fortuitously, if not accidentally, to make a work of art. The same structuring logic at work in both pieces would explain why they have more or less the same form. Indeed, *Cicada* can be scanned and understood as one more refinement of whatever it was that *Target with Plaster Casts* was articulating, if only on the level of tropic endeavour, that is to say, in terms of its figurative mode. And, if so, given the progression of the pictures that follow, it is clear that whatever Johns was trying to represent with *Cicada* had to be displaced onto other, as yet (in June 1979) unmade paintings.

Presumably the four drawings of the cicada – almost a sequence illustrating the stages of its growth and maturation – were copied from plates in an entomological text-book. Johns probably did some research to confirm *Cicada*'s associations. Perhaps he went to the library and looked them up. Some commentators have made much of seeing the surface mechanism – the way the primary colours in the centre can be seen as if emerging from the complementaries at either side – as a metaphor for the way in which the wingless larva of the cicada

periodically sheds its outer skin until it finally emerges as a winged adult.[46] If this is so, it is not just so. Johns's concern with 'skin' goes back to the *Studies for Skin* of 1962 (illus. 25) and *Skin with O'Hara Poem* of 1963–5 (illus. 26).

'POPE PRAYS AT AUSCHWITZ/''ONLY PEACE!'' ' and the skull and crossbones were notes taken from a press photograph of an incident during Pope John Paul II's visit to the concentration camp (Johns has a clipping of the photo in one of his sketchbooks; the skull and crossbones appear on a sign in the background).[47] The smaller skulls and the scrotum sacks were taken from an illustration of a seventeenth-century Nepalese painting of the Devatā Samvara with his female wisdom,

50 Nepalese, 17▮ century, *The Terrible Devatā Samvara, who has seventy-four arms, with his female wisdom (shakti) w twelve arms,* gouache on clotḥ 71.1 × 48.3. Ex- collection Ajit Mookerjee; pres� location unknow▮

which Johns came across in Ajit Mookerjee's book *Tantra Art* (illus. 51).[48] If the drawings in the margin of *Cicada* are anything to go by, Johns was particularly struck by the necklace of skulls and by the way sexual penetration is represented – the hairy scrotum comes directly from the terrible Samvara. Some of the other marginalia were also taken from Tantra art: the drawing of fire is an almost direct copy of a page from a seventeenth-century manuscript titled 'The Principle of Fire', which illustrates a cremation pyre: a signifier of the spirit moving onto a fresh birth. The way the flames are drawn in this illustration also accounts for the wavy, inverted v shapes in red paint and pencil. The triangle with a circle in its centre is taken from a yoni (vulva); the triangle signifies the vulva and the circle signifies the nuclear seed. The spigot shape in violet wash below Johns's version of 'The Principle of Fire' seems to have been taken from one of the four gated sides of the enclosure of a Yantra; next to the fire it might be understood as a damper's spigot, but now it makes more sense to see it as a synecdoche of that which it surrounds in the yantra – the yoni and bindu (seed). And, finally, to the left of 'POPE PRAYS AT AUSCHWITZ' the seemingly arbitrary configuration of red lines should be understood not only as marks made by Johns cleaning or proving his brush but also as a very free, schematic copy of an illustration of a lingam set in a yoni – the standard emblem of the double-sexed deity – with pūjā (worship) offerings laid on it.[49]

What seems to have happened – this is how I make sense of it – is that while Johns was making the hatched surface that was afterwards named and thought about as *Cicada*, he came across and became fascinated by some of the plates in Mookerjee's *Tantra Art* and the press photograph of Pope Paul II at Auschwitz. These things 'cropped up' while he was making the hatched surface, and certain details in them seemed to mean – or could be made to seem to mean – something in a relation of association with it. There is a connection established here between Johns's thinking and painting the crosshatchings named *Cicada*, what they meant to him at the time, the moment of becoming engaged with the photograph of the Pope, Mookerjee's book and Tantra art, the holocaust and cremation, the tantric imagery of cremation, the Auschwitz skull and the Devatā Samvara's skulls, metaphors of death and sexual penetration . . . what these signifiers

might have meant in their original contexts and what they might have meant for him, and so on and so forth. The mechanism that connects these specific synecdoches to each other and to the hatched surface is metonymy. *Cicada*'s margin is the site of their entry into Johns's art, their appropriation and connection to his allegorical purpose.

This is Michael Rosenthal's description of the painting (illus. 52) that Johns made after the *Cicada* drawing and paintings:

> The finely tuned composition of *Dancers on a Plane*, 1979, consists of mirrored vertical halves, each of which is divided horizontally into four sub-sections. Johns always makes certain to show the bundle of hatches of one color surrounded by the other two primary colors; at the crucial horizontal borders, he continues the hatch lines in some fashion, as in the game exquisite corpse, but alters either the color or the direction of the mark or both. Although these rules prevail, there is much freedom for idiosyncracy.
>
> The rhythmic character of the crosshatch pattern is complemented on the vertical borders where white-painted metal eating utensils provide a counter-point or base line. There is a clear repeating pattern in which the knives are mirrored and a fork is aways opposite a spoon. A corollary system can be discerned as well, starting at each upper corner, reading down, and continuing upward to the opposite corner. Knife, spoon, fork, and so forth, is one; knife, fork, spoon is the other.
>
> The letters of the title, in primary colors, and of the painter's name and date of the work, in white, are interwoven across the bottom. Divided into the same number of red, white, blue, and yellow elements on each side, the arrangement of the letters is highlighted by the symmetrical *A* in the middle. Cut off at each end, the row suggests the familiar cylindrical composition that the whole painting assumes.
>
> The only imperfect, or completely unaccounted for, element is the black sash at the far right, accompanied by bits of the same color nearby, which are not precisely duplicated on the left. As in *Corpse and Mirror* the right side is thus distinguished as being the mirrored one.[50]

This is a fascinating surface, which, as Rosenthal's text shows,

interpellates a puzzled and puzzling beholder. We are expected to think about what kind of surface it is and what kind of painting we are looking at. We are supposed to work it out and see a solution in its mirrored vertical halves and its horizontally divided subsections. And we are supposed to take delight in its ritualistic, even obsessive, technical complexity. Look closely. There is a lot of painting to see: overpainting and underpainting. The surface is built up in layers: there are traces of the secondary colours visible below the primaries; and black and white. Some of the crosshatching was brushed on; some of it was pressed on by means of harder implements; some of it looks like finger-painting. The stencilled words along the lower edge contribute to the effect. Fragmented and made disjunctive, they make evident the materiality of writing. So we attend to them as surface-matter, as a pattern of elements. Of course, we puzzle them out and make them read 'DANCERS ON A PLANE, JASPER JOHNS, 1979', and quite likely we realize that they are troped, as they were in *Cicada*, towards – Rosenthal points this out – a cylindrical possibility for the surface. In other words, they are arranged like that not only to name and authorize the surface but also, as they were in *Cicada*, to generate their bit of it in ways compatible with the rest of it.

But what is the meaning of the crosshatched surface in its relation of association with the idea of dancers on a plane, and with whatever is signified by the cutlery painted white and fixed to the verticals of the white frame? This is a different kind of puzzle. Given what we know about its beginning in Johns's art, surely we are not expected to understand the crosshatching as a metaphor for the kinds of movements that dancers make. (Though it would be possible to see it as a reference to that moment early in the twentieth century when painters such as Duchamp and Francis Picabia were interested in, and sought to provide, representations of movement. That possibility should be sufficient to make us sceptical of the idea that the hatching pattern is a metaphor for dancing or for dancers.) However, this is not to say that the surface is not turned towards some dancers or an individual dancer – this is a 'mirrored' surface and the plural might refer to a single dancer doubled. Nor is *Dancers on a Plane* about cutlery, where cutlery is understood to be a metaphor for 'consuming' painting or dance. What is happening on and as the surface mediates that

kind of purely projective assumption. We have to start thinking with a degree of historical specificity about the kinds of contiguity that might exist between what is there and the ideas we are generating about it. We know that connotation is at the edge. And we know, because we have glimpsed some of the meanings that might be associated with cutlery as it has been used in Johns's art, that what is connoted by it is unlikely to be peripheral. Johns had wanted to incorporate the testicles and penis from the Tantra painting but had not been able to do so successfully.[51] Maybe that failure helps explain the presence of the cutlery. Interviewed in 1989, he was asked if the cutlery was associated with Tantric imagery of 'mating', with the Devatā Samvara and his wisdom, copulating and dancing. He replied, 'No. I associated it with the many-handedness of Shiva and his Shakti.'[52] However, as we have seen, both in the Tantra painting and in the margin of *Cicada*, signifiers of sexual penetration are placed in a relation of association with signifiers of death, while signifiers of death, since *In Memory of My Feelings – Frank O'Hara* (illus. 8), have often signified in a relation of association with cutlery. In this chain of contiguity, the cutlery at the edge of *Dancers on a Plane* has to be understood as a displaced signifier of other, more conventional, signifiers of sex and death. Interestingly, in the same interview Johns was also asked: 'What is the function of the knife and spoon in the much earlier set of drawings that relate to Frank O'Hara?' He replied: 'My associations, if you want them, are cutting, measuring, mixing, blending, con-suming – creation and destruction moderated by ritualized manners.'[53] The move that Johns makes, or the ideological distance that he travels, in giving these associations seems immense. He begins with precise, intimate physical actions and ends with nouns identifying highly abstract notions. Cutting, measuring, mixing, blending, consuming are easily understood as actions associated with preparing and eating food and with producing and consuming art. It is not so easy to grasp how cutlery might be associated with making the violence and extremeness of originating and ending some-thing more acceptable as social behaviour or as a way of life. Except, perhaps, as and via metonymy. Given what we know about Johns's characteristic protocols and procedures when it comes to making art, it is possible to glimpse the way he might be using cutlery to refer to sex and death – or even 'creation

and destruction' – in ways that make the reference, and even the actual events, less painful, violent or extreme, if only for himself. The signifiers are mundane, as are the first associations, but the chain ends with grand metaphysical themes – creation and destruction. These are the themes signified by the union of Samvara and his Shakti. They are, in a sense, the Tantra painting's ideal: the 'creative process and absolute cessation' as a single principle wherein there is neither affirmation nor denial, neither purity nor impurity, neither form nor formlessness but a bringing together of all these dualities.[54] And it is this ideal along with some of the Tantra painting's pictorial language that Johns appropriates to the crosshatched pattern and its associated thematics that become *Dancers on a Plane*. The appropriation is, however, to an ideal already established and critically reviewed in Johns's art, which makes the moderating use of cutlery appropriate at the plane's edge.

Johns made another *Dancers on a Plane* in 1980 using much the same crosshatched pattern but changing the colouration (illus. 53). It is a darker painting – 'the ominous sequel', as one commentator put it.[55] Johns also replaced his own name with that of Merce Cunningham, breaking it and interspersing the letters with the now mirrored or reversed letters of the title: NANᗡIƎNИGAH⅃AꟼMAMИEORꙄCЯEƧCƆUИ. The trope here directs us not only to the possibility of a cylindrical surface but also to one that seems as if it could be read from the back as well as the front – a trope set by *Flag*.[56] More to the point for my analysis are the signifiers of sexual penetration that Johns has managed to incorporate in the bronze frame along with the knives, forks and spoons now also cast in bronze. The scrotum is there at the bottom below the central 'A'; the penile shaft is above it, across the surface, in the triangle at the centre of the top framing edge. These signifiers have been taken indirectly from the yoni triangle and directly from the Nepalese painting of the Samvara. The vertical line which divides the Samvara's scrotum into its blue and green halves is there in Johns's picture scraped through the grey paint, as are the hairs growing out of it. The skulls are represented by the row of white dots that, equal to half the width of the canvas, travel almost half way across the centre of the surface; this has been taken from the white dots of Samvara's necklace of skulls, or its danglers.

Dancers. Sex and death. Creation and destruction. Cutlery. Whatever the historically specific references are that might be associated with *Dancers on a Plane* they undoubtedly have a contiguous relation of association with those themes associated with *In Memory of My Feelings – Frank O'Hara*: unseen but present dead men, and a skull; abstract surface significance, and cutlery; memories and feelings; the scene of a self or selves. You could take *Dancers on a Plane* as another version of *In Memory of My Feelings – Frank O'Hara* – its main themes dealt with this time not by reference to O'Hara but to Merce Cunningham, another close friend, a choreographer with a distinct philosophy and style, a whole company of dancers, and, a name to be troped.[57]

Johns's next paintings, the three *Tantric Detail* pictures of 1980–1 (illus. 54, 55, 56), have their pretext as much in *Painting with Two Balls* (illus. 57) as in Tantra art. The penis is stopped short; the penile shaft cut off by the top division of the canvas. It has been pointed out how, 'after two decades, Johns makes the slang expression "two balls" explicit'.[58] The skull has also been cut off at the cranium by the bottom division of the canvas. In these paintings Johns brought the signifiers of sex and death clearly into view. At the same time he seems to have been less concerned with making the crosshatched surface in his usual dense manner. As a ground on and against which to place the male genitals and the skull it has less actual, material density than it had in the *Dancers on a Plane* and *Cicada* paintings. It also has more of the look of metaphorically expressive painting than any of its immediate predecessors, *as if* Johns was less in control of his means and materials or *as if* making it occasioned greater risk taking, more accidents and less moderation than was usually the case. I am sure that it is intended as a practical fiction. Sex and death are rarely as obviously on display in Johns's art as they are here. The scrotum and penile shaft (taken from Tantra painting) and the skull – associated with the Tantra painting and the photograph of the Pope at Auschwitz, traced and painted in the manner of the print in *Arrive/Depart* of 1963–4 (illus. 23) and the lithograph *Untitled (Skull)* of 1973 (illus. 24) – are set in place *as if* in quotation marks. They are so ostensive that, in view of their previous marginal and euphemistic significance, you are led to question their value as subject-matter.

The surface pattern and facture continue to effect their

51 *Cicada*, 1979, watercolour, crayon and pencil on paper, 109.2 × 73.
Collection of the artist.

52 *Dancers on a Plane*, 1979, oil on canvas with objects, 197.5 × 162.5.
Collection of the artist.

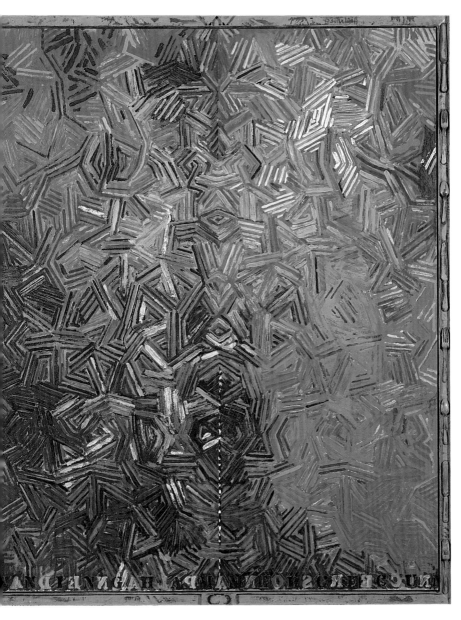

53 *Dancers on a Plane*, 1980, oil and acrylic on canvas with painted bronze frame and objects, 200 × 161.9. The Tate Gallery, London.

54 *Tantric Detail I*, 1980, oil on canvas, 127.3 × 86.5. Collection of the artist.

55 *Tantric Detail II*, 1981, oil on canvas, 127.3 × 86.5. Collection of the artist.

56 *Tantric Detail III*, 1981, oil on canvas, 127.3 × 86.5. Collection of the artist.

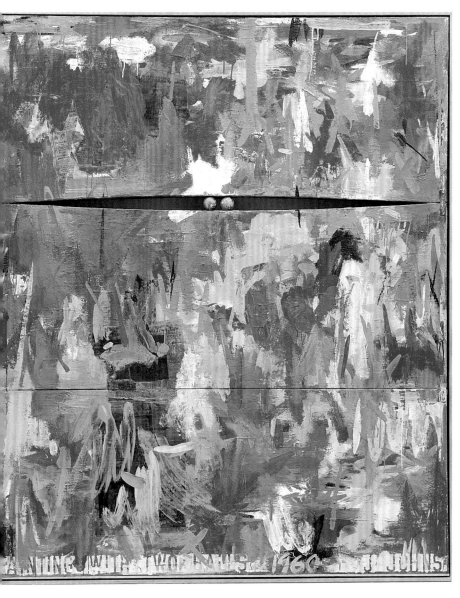

57 *Painting with Two Balls*, 1960, encaustic and collage on canvas with objects, 167.6 × 137. Collection of the artist, on loan to the Philadelphia Museum of Art.

58 *Savarin (Whitney Museum)*, 1977, lithograph, 121.9 × 81.3. Published by ULAE.

59 *Between the Clock and the Bed*, 1981, oil on canvas, 183 × 321. Collection of the artist, on loan to the National Gallery of Art, Washington, DC.

fascination. You can still take delight in scanning and understanding Johns's protocols and procedures. Your attention captured, you notice how *Tantric Detail I* is divided into three horizontal bands and how the hatchings shift direction at the junction of each section, and how *Tantric Detail II* and *Tantric Detail III* reverse the hatching pattern. There are also other reversals to note: the skull in *Tantric Detail I* is underpainted in black and overpainted with grey; in *Tantric Detail II* it is underpainted in grey and overpainted with black; and in *Tantric Detail III* it is underpainted in black and overpainted with white. In *Tantric Detail I* the scrotum is underpainted on the left in blue and on the right in green – following the colour scheme of the Tantra painting, which also sets the pattern of the red bisecting line – and overpainted with grey; in *Tantric Detail II* the scrotum is underpainted blue on the right and green on the left and then overpainted with grey; there is no underpainting in *Tantric Detail III*. There is even more of this kind of matter, but that is sufficient to give you some idea of the kinds of rules and formalities controlling the production of these surfaces. The narrative they illustrate is one of 'ritualized manners' transgressed and breaking down. Or, rather, it looks like that. Evidence of ritual there is, but it is creating the illusion of a surface in the process of disappearing. In *Tantric Detail III* there is only one layer of crosshatchings – well, maybe there is, here and there, a hint of another layer, but we cannot be certain – and it does not travel all over the surface.

I am puzzled by the relation of subject and surface in the *Tantric Detail* pictures, by how, at the moment the male genitals and the skull come so emphatically onto the surface as subject-matter, that surface is painted *as if* it is disappearing. Sex and Death. Given the signifying character of Johns's art, it can't be that obvious – can it? Johns's practice, even in the early 1980s, has to be understood as effecting an oscillation between subject and surface – as still holding them in a dialectical tension. Maybe here we should keep in mind the idea of subject-matter as surface and surface as subject-matter. Seeing the *Tantric Detail* pictures in this way then allows us to understand how the genitals and skulls that made their appearance in the margin of *Cicada* as synecdoches with a metonymic significance in relation to a specific surface, to the rest of Johns's art, and to a particular moment have turned

into conventional signifiers, dead metaphors, and as such might have a value not as emphatic subject-matter but as not very significant – though not insignificant – stuff with which to make a surface. We might then look to the surface-matter in its moment of disappearance and understand it as turned, once again, towards some difficult and less open subject-matter. In other words, the relative values which seem to have been added to subject and surface are working thoroughly allegorically. The row of dots below the genitals and the skull which can be and has been easily misunderstood as mere surface-matter indicates that this might be the case. In the context of so much subject-matter turned towards surface-matter, here the row of dots works not only as surface-matter, as a surface-mechanism, but also otherwise, as a threshold image or subject hinting at its pretext in the Nepalese Tantra painting. At which moment Johns abandons the skull (temporarily) and the genitals as signifiers in his paintings – but not his concern with using signifiers of sex and death as surface devices or as themes to be worked with and out – and restarts making paintings with all-over crosshatched surfaces.

Whatever meanings I have written or might be read in my text, it is assumed that the 'few' persons who were personally close to Johns between 1979 and 1981 were able to scan and understand the *Cicada*, *Dancers on a Plane* and *Tantric Detail* paintings in much the same way that they would have seen, thought and talked about *In Memory of My Feelings – Frank O'Hara* – that is to say, in terms of synecdoche and metonymy as enabling and diverting mechanisms of surface and subject. Which is to say, as allegory.[59]

> . . . *in the big* Savarin *print, which began because a poster was needed for my show at the Whitney Museum, I drew one of my sculptures much larger than life; but that was a deliberate attempt at advertising on my part.* Jasper Johns to Christian Geelhaar, 1978[60]

As yet I have said nothing about personification, one of the most reliable indicators of allegory. Consideration of personification will return us to *Painted Bronze* (illus. 43, 47) and, before that, to the other sculpture closely related to it in meaning and effect, *Painted Bronze (Ale Cans)* (illus. 48).

'Personification' corresponds to the original Greek word *prosōpopoiia* or, as it was translated into Latin by Quintilian, *prosopopoeia*.[61] In its Greek form it is a composite of *prosōpon*, meaning the face or countenance of a person or a façade in general, and *poiein*, the verb 'to make'. By the time of Greek tragedy, *prosōpon* had come to refer explicitly to the mask worn by a character on stage and later to the character itself, the 'person'. The composite *prosōpo-poiein* means to compose by means of *prosōpa*, while *prosōpo-poiia* means 'the composing of speeches for characters'. By the first century BC *prosōpopoiia* was used to refer to the rhetorical practice of either making a presence for a person who is absent or giving form and speech to that which is mute, formless or inanimate. Quintilian presented it as fictitious speech of the kind an advocate might put in the mouth of his client, as making conversations between ourselves and others, and as giving speech to the dead, to cities or to abstractions. It is a figure in which either an inanimate object or an abstract concept is spoken as if it were endowed with life or human attributes; it gives an actual personality to an abstraction or, more often, it gives a con-sciously fictional personality to an abstraction.

The Critic Sees (illus. 46) and *Painted Bronze* provide me with examples of two different kinds of personification, the former clear and straightforward, the latter more complex. As we have seen, *The Critic Sees* is no more than a brick of plaster that has been given a mask with obvious, if displaced, signifiers of seeing, and thinking and speaking. Johns has given a façade to a senseless lump and turned it into an object that, as Kozloff put it, 'confronts the spectator in an almost animate guise'; it has 'its own faculties'; and it is 'able to survey and scrutinise the observer'.[62] It reverses the usual terms of viewing so that the beholder becomes the vivid object of what he is looking at. This is the effect of personification. As a personification, *The Critic Sees* presupposes a beholding subject for 'itself' that it seems to take over even as, in the figural space of chiasmic interpretation, it is taken over by the subject who beholds it. The beholder who comes across it and attends to it is 'interrogated' by it as if by a person.[63] In this situation the beholder tries to make sense of – so as to get free of – what and how the personified object is seeing, thinking and saying what it is seeing, thinking and saying – which, of course, in part at least, is what and how the beholder is seeing, thinking and saying it.[64]

So to *Painted Bronze*. Though it was occasionally personified in critical and historical writing about it, Johns does not seem to have regarded it or taken it as a personification of anything until the late 1970s, when he used it to represent himself in a thoroughly autobiographical context. Its personification in the literature of art and Johns's use of it as a personification of himself might not be unrelated (the latter may have been partly determined by the former), but it is Johns's use of it that most interests me here. In order to explain why and how it came in place of Johns, I have to consider the circumstances of its production and its relation to its immediate predecessor, *Painted Bronze (Ale Cans)*, and then track certain aspects of its repeated use as a special kind of signifier in Johns's art.

Like the flagstones, crosshatchings, and Tantric details, *Painted Bronze (Ale Cans)* and *Painted Bronze* also have a pretext. Here is the story as Johns tells it.

> I was doing at the time sculptures of small objects – flashlights and lightbulbs. Then I heard a story about Willem De Kooning. He was annoyed with my dealer Leo Castelli for some reason and said something like, 'That son of a bitch you could give him two beer cans and he could sell them.' I heard this and thought, 'What a sculpture – two beer cans.' It seemed to fit in perfectly with what I was doing, so I did them and Leo sold them.[65]

And thereafter:

> The idea for the ale cans was like a present. I felt I should already have known to do it as a sculpture: it had the right scale, it was already there – all I had to do was look over and see it, and then do it. Doing the ale cans made me see other things around me, so I did the Savarin Can. I think what interested me was the coffee can used to hold turpentine for the brushes – the idea of one thing mixed with another for a purpose.[66]

Painted Bronze (Ale Cans) – two cans of Ballantine Ale and a base to put them on were constructed out of an assortment of found and moulded objects. The base was thumb-printed; everything was cast in bronze; and then the labels were painted onto the cans. The smaller can has been opened; there is a three-ring trade-mark on its top; it is a Southern can from

Florida. The larger can has been left unopened; its top lacks the three-ring sign; it is a Northern can from New York. One is heavy; the other is not so heavy. And so on. This is usually taken as fascinating stuff, but more important for understanding what *Painted Bronze (Ale Cans)* might mean is the fact that its beginnings were in a remark made by de Kooning about Castelli. De Kooning was in 1960 the most important action-painting Abstract Expressionist. Johns's dealer did not sell Abstract Expressionism – indeed, his gallery was set up to market something else.[67] To my mind *Painted Bronze (Ale Cans)* is a sculpture – we recognize it as a sculpture because it has a base – that comments on an individual artist, his ideas on art and his attitude to the art market, and on the whole ethos of Abstract Expressionism, which by 1960 was firmly established in the New York art community as *the* 'New American Painting'. Abstract Expressionism was there in place as the latest moment in the history of modern art, historicized as the result of a 'long struggle' with the artists 'themselves even more than with the public'.[68] Each day Johns and the other ambitious avant-garde artists who desired a productive novelty for their work had to establish their relations with it and differ their art from it.[69] It was a resource available to Johns but there was a lot in it he could not use and did not want. He was, for example, not interested in appropriating the metaphorics of masculinity that were an essential part of a lot of Abstract Expressionist painting, or the machismotifics of social behaviour that went with its supposedly 'stubborn, difficult, even desperate effort to discover the self'.[70] Abstract Expressionism involved, in one way or another, the dramatization of a performance of the exposure of feeling – 'an effort to which the whole personality should be recklessly committed', as one critic put it – and for some artists – such as de Kooning – that also meant living an aggressively heterosexual life and getting drunk both in and out of the Cedar Street Tavern – the favourite bar of the Abstract Expressionist painters and their friends.[71] By picking up on de Kooning's jibe about Castelli and using it to make a sculpture, Johns differs himself and his practice from Abstract Expressionism.

What painting there is on *Painted Bronze (Ale Cans)* is confined to the labels where, unlike the painting of *Painted Bronze*, it is not obviously Modernist painting; it does not effect a maximum presence as a painted surface; the brush-

strokes show; but it is punctilious painting – this is the label that Kozloff saw Johns copying as if it was a 'life' model.[72] Nor is it obviously expressionist painting – a personality may well have been committed to the task of making it what it is, but certainly not 'recklessly'. We are not supposed to see it as an 'exposure of feeling'. And though Johns was drinking beer at the time, there is nothing in *Painted Bronze (Ale Cans)* that could be taken as signifying that he was reckless in his drinking habits. He may have been – but one of the cans remains unopened. A commentator who got close to him tells us that 'Johns used Ballantine Ale cans, most likely because the brand was a personal favorite'. (She also points out that 'the simplicity of the can's label design and its bronze colour' made it a suitable model.)[73] I wonder what de Kooning's favourite brand was? Different communities have different drinking habits and prefer different bars and brands. Habits, places and labels become the intriguing aspects of 'mythologies'. Johns avoided the Cedar Bar and liked Ballantine Ale.[74]

Painted Bronze (Ale Cans) – Johns takes over a story about something de Kooning said, uses it to make a joke at de Kooning's expense – the sculpture is always explained in this way – and ends up with a twice-told tale about the pictorial metaphorics of masculine expression and the machismotics of masculine identity. The point, of course – and this is why it isn't usually explained like this – is that it signifies these things otherwise. De Kooning's comment and Johns's twice-told tale were then displaced onto *Painted Bronze*, with its obvious metonymic association of can and paintbrushes (cause) with the practice of painting and paintings (effect).[75]

Painted Bronze (Ale Cans) and *Painted Bronze* recur in Johns's art as either indexical or iconic signs. When Johns uses the base of a can to mark or imprint the surface, then the trace left behind on the surface has the value of an indexical sign – it is a synecdoche of the whole thing that printed it and has a metonymic relation with Johns as the person who did the printing. When Johns makes a graphic equivalent of the can or uses a photograph of it, recreates or reinterprets the original with a pictorial image resembling it, then the sign has the value of an icon. *Painted Bronze (Ale Cans)* and *Painted Bronze* first appeared as indexical signs in *Field Painting* of 1963–4 (illus. 60) – a Ballantine Ale can and a Savarin coffee-can and brushes also appear in this picture attracted by the magnets

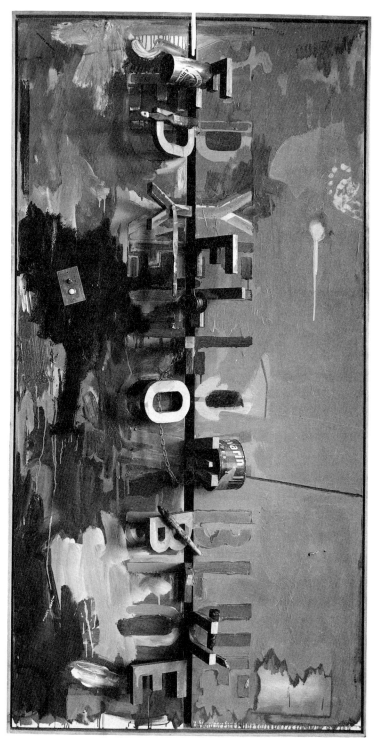

60 *Field Painting*,
1963–4, oil on
canvas with
objects, 183 × 93.
Collection of the
artist, on loan to
the National
Gallery of Art,
Washington, DC.

attached to the three-dimensional letters of the colour names RED, YELLOW, BLUE, which divide the surface in two. Thereafter, in 1964, *Painted Bronze (Ale Cans)* was used to provide the image for *Ale Cans*, a lithograph published by Universal Limited Art Editions (ULAE); and three years later *Painted Bronze (Ale Cans)* and *Painted Bronze* were used to provide images for the portfolio *First Etchings* also published by ULAE.

61 *In the Studio*, 1982, oil on canvas with objects, 183 : 192. Collection of the artist, on loan to the Philadelphia Museum of Art.

Arrive/Depart of 1963–4 (illus. 23), *Eddingsville* of 1965 (illus. 5), *Passage II* of 1966 (Harry N. Abrams Family Collection), *Harlem Light* of 1967 (illus. 1), *Decoy* of 1971 (Collection of Mrs Victor W. Ganz), *Untitled*, 1972 (illus. 6), *Corpse and Mirror II* of 1974–5 (illus. 64) and *Dutch Wives* of 1975 (private collection and Collection of the artist), *Weeping Women* of 1975 (illus. 30), *Usuyuki* of 1977–8 (Collection of the artist), *Between the Clock and the Bed* of 1981 (illus. 59), *In the Studio* of 1982 (illus. 61) – this is an incomplete listing of the surfaces that carry the indexical traces of a beer-can and/or a coffee-can. I take it that in each case the circle has a value in excess of that which it has as a reflexive formal device marking and making the surface. The indexical trace comes in place of an object closely associated with Johns – *Painted Bronze (Ale Cans)* or *Painted Bronze* or a Ballantine Ale can or a Savarin coffee-can – and in place of him and his consciousness as author of the surfaces it appears on and in. The can circles are talismanic marks that not only print the surface in quite contingent ways but also have a value to strengthen, sustain, measure and stamp that surface as *of* Johns. But neither they nor the surface they mark creates or develops the semblance of personality that is a feature of personification.

It is interesting to note which of his paintings and sculptures Johns keeps for his own collection. It has been said that the best collection of 'Jasper Johns' is owned by Johns himself.[76] Some pieces, such as *White Flag* from the Castelli show of 1958, were kept because they failed to sell, but there cannot have been many items that failed to find buyers after that. He sold *Painted Bronze (Ale Cans)*, but that was partly the point of making it – so that Castelli could sell it. He did make another cast of it for himself in 1964. And he has kept the unopened can that was one of the 'models' for the piece.[77] But *Painted Bronze* was never sold or made into an edition – even of two. This strikes me as probably significant. My guess is that it means more to him than *Painted Bronze (Ale Cans)*. Though

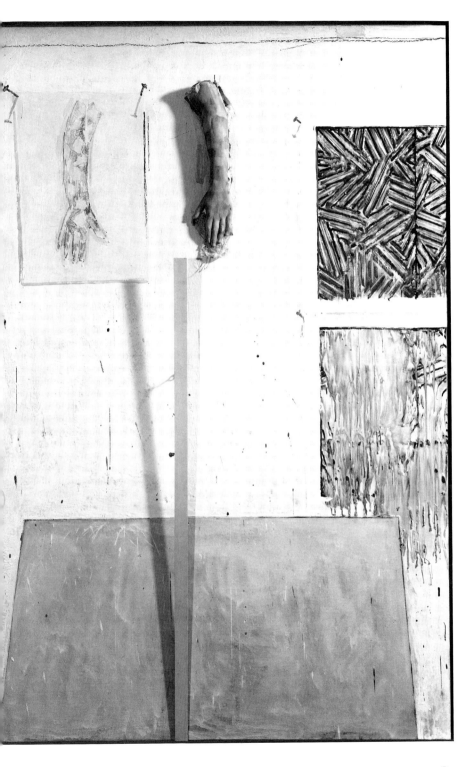

189

both sculptures have had a use value in his art as repeatable –
but not exchangeable – signifiers, the sculpture that usually
came in place of Johns when something was required to do so
was not *Painted Bronze (Ale Cans)* but *Painted Bronze*.

A photograph of *Painted Bronze* was used on the plain white
cover of the catalogue produced for the retrospective exhibi-
tion that the Jewish Museum gave Johns in 1964. (What
written information there is is all on the back cover.) The year
before, a photograph of *Painted Bronze (Ale Cans)* against a
black background had been used for the front cover of Leo
Steinberg's *Metro* monograph. It is to the point that whatever
value it had for illustrating or representing 'Jasper Johns' was
quickly displaced onto *Painted Bronze*. As an iconic sign *Painted
Bronze* is here *anchoring* 'Jasper Johns' as *author-function* and
relaying or encouraging the beholder around the exhibition
and through the catalogue.[78] The cover brings 'Jasper Johns'
and 'Savarin' into a reciprocal relation. 'Savarin' on the can
refers us to 'Jasper Johns'. Or, to put that another way, 'Jasper
Johns' is here displaced onto 'Savarin'. The name of the
philosopher of the kitchen as a brand-name of a vacuum-
packed ground coffee is turned towards the name of the artist

62 *Untitled*, 1977,
lithograph, 69.9 ×
101.6. Published
ULAE.

190

63 *Savarin*, 1977, lithograph, 114.3 × 88.9. Published by ULAE.

who the catalogue constructs as something of a philosopher of the studio – and a good cook also. The retrospective exhibition gives *Painted Bronze* a context of use on the catalogue's cover but, placed against the plain white background, it is presented as contextless. Thus isolated, the photograph of *Painted Bronze* effects some of the uncertainty of seeing and thinking and saying that the actual *Painted Bronze*, and Johns's work generally, achieves – an uncertainty commented on in the essays in the catalogue. It turns us towards an *œuvre* and to 'Jasper Johns' as author of that *œuvre*. But thus isolated, that is all it can do.

In 1977 *Painted Bronze* provided one of the images used for the cover of the catalogue and the poster for the retrospective exhibition held at the Whitney Museum of American Art. Two different lithographs were used to make and transfer the images. The one used for the catalogue meant that it appeared on the back cover (illus. 62). The one used for the poster was 'larger than life', but, as Johns said, 'that was a deliberate attempt at advertising' on his part (illus. 58, 63).[79] In each case, for those who know it, the image effects some of the uncertainty with regard to painting and sculpture that *Painted Bronze* effected. But the image is sufficiently different from

Painted Bronze – the turpentine spill has been cleaned away, the fingerprint has gone, and the brushes have been made more pristine – to encourage the suspicion that what is recreated here may actually be a Savarin can with paintbrushes in it. As the main pictorial signifier on the poster, something which is neither *Painted Bronze* nor a Savarin can with paintbrushes in it but both *Painted Bronze* and a Savarin can with paintbrushes in it is represented on a wooden surface in front of *Corpse and Mirror II* (illus. 64). The wood-grain becomes the background for information about what is being advertised. There is no mistaking the product for Savarin coffee – though it is important, of course, that the can is a Savarin can and that there are paintbrushes in it. The product is clearly stated in corporate identity stencilled capitals: 'JASPER JOHNS'. The poster has the material significance of a page from an emblem book whose words and images have been brought together and creatively developed into what we now recognize as a personification of 'Jasper Johns'.

64 *Corpse and Mirror II*, 1974–5, oil on canvas with painted frame, 145.3 × 173. Private collection

One week after the opening of the Whitney retrospective, *Newsweek* magazine (27 October) published a long feature article titled 'Super Artist: Jasper Johns, Today's Master'.[80] The *Newsweek* cover is worth noting, with its colour photograph of Johns and caption 'Jasper Johns Super Artist' (illus. 65). Seen and understood as a kind of parallel text, this is just a photo-equivalent of the exhibition poster – another conscious attempt at advertising – which makes obvious what the poster represents obliquely.[81] A photograph of Johns has to be there on the *Newsweek* cover. The aim is to introduce him, the look of him, to a wider and more general public than the gallery-going community. And for some persons, let's face it, Johns's

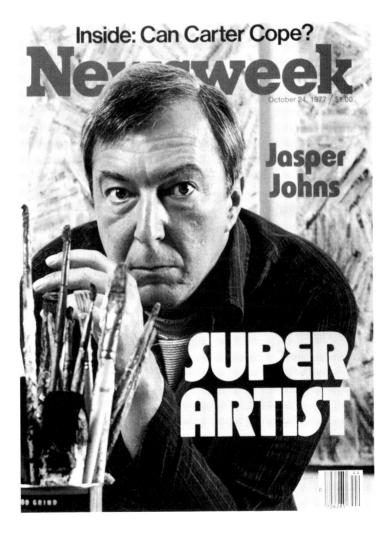

193

portrait-likeness has to be there because *Painted Bronze* isn't. What is there is a bit of a coffee-can with some paintbrushes in it whose meaning for those who know about Johns and his art is turned towards *Painted Bronze* but for those who do not know about Johns and his art is just a can with paintbrushes in it signifying all kinds of super artistry – which, after all, is what the painted bronze had come to signify by this time.

But look at the brushes in the can: clean and unclean; bristles up and ready for use. Brought next to it like this, they make clear a certain strangeness about the brushes in *Painted Bronze*. It is not that they should not be like that in *Painted Bronze* because that is how Johns kept and presumably still keeps his brushes whilst working – bristles down, soaking in the turpentine. That is part of his, and most artists', studio practice. But they do seem strangely packed together. Perhaps the brushes in the photograph on the *Newsweek* cover were Johns's attempt to make *restitution* to the brushes in *Painted Bronze*.[82] Perhaps that is why he made sure that we see them placed upright again, returned to their proper condition and use value as paintbrushes. Also, they would have been very difficult to cast with the bristles up. And once cast that way, they would have been more easily and quickly recognized as casts of brushes – hair rarely convinces when rendered in bronze – and the uncertainty that *Painted Bronze* was intended to effect would have been greatly diminished. That being the case, there must have been good technical and conceptual reasons for keeping the bristles of the brushes pointing down in the can.

This is how Kozloff in his second monograph on Johns, published in 1974, described *Painted Bronze* along with *Study for 'Skin I'* (illus. 25):

As for the content of *Painted Bronze* and *Study for 'Skin I'* . . . they go further in being studies of imprisonment. Into that lovingly rendered bronze replica of his Savarin paint can, Johns wedges his brushes, which, so far from being cleansed by turpentine, stew eternally in metal. It is as if matter has taken the bristles into its own, sealed in the 'soil' of art without any hope of that lifting away which restores freshness to the remembering mind. Even more extreme is the sightless image of the artist pressing cheeks and hands against the blank caging surface of the paper. Like the

sculpture, the drawing appears as a frightful dream that will never relinquish its grip. Doubtless it was intended that the impasse envisioned in these two works brings time to a standstill. Without the potentiality for, or allusion to, change, Johns's art takes on a memorial character. It becomes a relic of triumphant memory, closed to all further experience because paralyzed.[83]

Whatever else it might be, for Kozloff *Painted Bronze* is a special kind of aporia: a memorial to and a relic of memory beyond which Johns could not pass.[84] And this is the object that Johns chose to come in place of himself.

As the personification of 'Jasper Johns', *Painted Bronze* comes in place at a moment and site of retrospection as memorial and relic of memory associated with signifiers of death. The choice of *Corpse and Mirror II* for the background surface of the poster cannot have been accidental. While the row of 'morning coffee' biscuits imprinted along the lower edge of the ink, watercolour and crayon drawing of the Savarin can and paintbrushes, *Untitled*, 24 March 1977 (illus. 66), makes an obvious pun on – and so moderates – the deep sorrow that, for whatever reason, might be associated with *Painted Bronze*. In this drawing Johns's handprints substitute for the crosshatchings of *Corpse and Mirror II*. Another association was made somewhat later when, in 1981, Johns returned to the lithograph used for the Whitney poster and added to it (illus. 67). 'Savarin' comes in place of Johns again as the name of his 'larger than life' Other. But it means more than that here because the wooden pattern below the can was marked with an impression of the artist's hand and forearm and the initials 'E.M.' to establish a relation of association not only with Savarin but also with Edvard Munch and his *Self-portrait* lithograph of 1895. The Savarin can and brushes against the background of *Corpse and Mirror II* and Johns's hand- and arm-print are turned towards Munch's self-portrait, pale against a black background, with a skeletal hand and arm set horizontal across the page below it.[85]

As it appears in 1977 in the Whitney poster, *Painted Bronze* returns to classify new work and old work – painting, sculpture and graphic work – as *of* 'Jasper Johns'. As an iconic sign it recreates the original's play with the distinction between something that is neither a painting nor a sculpture

66 *Untitled*, 1977, ink, watercolour and crayon on plastic, 48.3 × 30.5. Private collection.

67 *Savarin*, 1977–81, lithograph, 127 × 96.5. The Museum of Modern Art, New York.

but both a painting and a sculpture, and between a painted bronze of a coffee-can with paintbrushes in it and coffee-can with paintbrushes in it. And it also functions as a personification of 'Jasper Johns' in what can now be seen and understood as an extended allegory of ideas about memory and the impossibility of transcending it, about remembering and the impossibility of forgetting, about retrospection as the basis of going on or beginning, where going on and beginning can only mean repetition and return or an attempt at restitution, about sexual difference and self-identity, about sex and death.

> I am concerned with a thing's not being what it was, with its becoming something other than what it is, with any moment in which one identifies a thing precisely and with the slipping away of that moment, with at any moment seeing or saying and letting it go at that. Jasper Johns to G.R. Swenson, 1964[86]
>
> . . . my work is in part concerned with the possibility of things being taken for one thing or another – with questionable areas of identification and usage and procedure – with thought rather than with secure things. Jasper Johns to Vivien Raynor, 1973[87]

The main trouble we have to contend with when reading or beholding allegory is our own psychological and linguistic uncertainty as to what is signified when, selfconsciously, language is used figuratively. The allegorist begins and ends with language as if it is his first and ultimate subject. It is of little consequence whether it is predominantly verbal or predominantly visual, the allegorist's way with language manipulates, beguiles or fascinates the reader or beholder into a position of self-defining selfconsciousness. I take it that this was what Kozloff was driving at in his commentary on *The Critic Sees*. Allegory provides the provocation to and experience of reading or scanning and understanding even as it calls attention to our emotional and intellectual experience of reading or scanning and understanding it. The process of interpretation can go on indefinitely. It is a problem knowing when to stop. The reader or beholder has to put an immense amount of energy into reading or scanning and understanding an allegory, and might feel that the effort is not necessarily always repaid. What, then, is the value of allegory and of Johns's work – especially *No, In Memory of My Feelings – Frank O'Hara, Untitled, 1972, Target with Plaster Casts, Flag, Painted*

Bronze, *Dancers on a Plane*, the works that have been my objects of study – when considered as allegory?

Scanning and understanding Johns's work, attentive to the ways it represents or signifies otherwise, is a bit like listening to a conversation between someone and his or her psychotherapist or reading a text harping on – neither publicly nor privately, but both publicly and privately – about a few themes. I mentioned some of them a moment ago: remembering and the impossibility of forgetting; sexual difference and self-identity; sex and death. There is nothing unique or profound about these themes or their obsessive return and reprise. Though they add to its interest, they are not what makes Johns's work valuable. At its best, Johns's way with allegory works with and against, reinforces and subverts, confirms and questions the language appropriated to its project. The protocols and procedures of ambitious Modernist painting are selfconsciously and critically used to deal with pressing pictorial issues and make accentuated surfaces – this is the aesthetic value of Johns's work – which represent an experience and knowledge of subjectivity and of the world in ways that disrupt, disperse and make discontinuous the kinds of experience and knowledge that is supposed to be effected by those surfaces – this is its historical value. But there is still more to it than that.

> *Within the series of oppositions that [Michael] Fried develops in this text ['Art and Objecthood'] it is, of course, art that works in contradistinction to objecthood. And what this means is that art is ineluctably involved in the domain not of the literal but of the virtual: the seeming, the as-if. Within high modernism the major form this virtuality took was to create the illusion that the physical existence of the work of art was entirely a function of the sensory experience to which it was addressed, so that if high modernism's drive was, in Clement Greenberg's words, 'to render substance entirely optical,' that was in order to create 'the illusion of modalities: namely, that matter is incorporeal, weightless, and exists only optically, like a mirage.' If 'Art and Objecthood' quotes this passage from Greenberg with approval this is because it organizes the model of virtuality that Fried wants to contrast with literalness. And that model is that of the impossible suspension of the work in space as if it were nothing but pure optical glitter, without weight and without density, a condition that establishes the corresponding illusion that its viewer is similarly bodiless, hovering before it as a kind of*

decorporealized, optical consciousness. And this in turn becomes
the dimension within which a further illusion can occur, namely,
that there can be an instantaneously but forever complete
experience of knowing, within which this object and this subject
can be utterly transparent to one another. This is the opening, or
clearing, onto meaning/being that 'Art and Objecthood' takes as
the exalted possibility of art: art as it eshews presence and
achieves that presentness which as its author says, 'is grace'.
Rosalind Krauss, 'Using Language to do Business as
Usual'[88]

In the copious literature on allegory, reference is usually made
to some seminal passages in Goethe's *Maxims and Reflections*
published in 1824 (the result of striving for a language to
describe poetic activity that had concerned him since the
1790s), or to F.W.J. Schelling's *The Philosophy of Art* published
in 1854 (but written in 1802), or to Coleridge's *The Statesman's
Manual* of 1816.[89] This is Coleridge:

> Now an allegory is but a translation of abstract notions into a
> picture-language, which is itself nothing but an abstraction
> from objects of the senses; the principal being more worth-
> less even than its phantom proxy, both alike unsubstantial
> and the former shapeless to boot. On the other hand a
> symbol [. . .] is characterised by a translucence of the
> special in the individual or of the general in the special or of
> the universal in the general; above all by the translucence of
> the eternal through and in the temporal. It always partakes
> of the reality which it renders intelligible; and while it
> enunciates the whole, abides itself as a living part in that
> unity, of which it is the representative. The other are but
> empty echoes which the fancy arbitrarily associates with
> apparitions of matter, less beautiful but not less shadowy
> than the sloping orchard or hill-side pasture-field seen in
> the transparent lake below.[90]

Coleridge stresses that allegory is a translation of rarified ideas
about things into arbitrary illustrations or decorative images.
It is associated with the working of understanding and fancy;
it is the result of an empirical process; and it provides an image
of that process as well as the generalizations produced by it.
The symbol is unique and provides its own significance; it is
an image alone; it is part of the whole which animates it; it is
characterized by transparency or near-transparency and it

makes intelligible immediately or almost immediately what shines through it – that which is essentially unchanging, the Eternal.

Coleridge's discussion of allegory and symbol occurs in connection with an argument advocating the Bible as a practical handbook for statesmen. Coleridge thinks of the Bible as 'a system of symbols, harmonious in themselves, and consubstantial with the truths, of which they are the *conductors*'.[91] Later commentators took his remarks to define the general nature of the symbol in literature and the plastic arts. It must have been easy to do so. He writes about the Bible as if he is discussing poetry. What this writing – Goethe's, Schelling's and Coleridge's – marks is that moment in the general process of secularization when the theological symbol is secularized and the 'unity of the material and transcendental object' that constitutes it is given a meaning in a burgeoning aesthetics as the indivisibility of form and content, appearance and essence achieved in works of and by genius.[92] At which moment, allegory is reconstituted as the symbol's 'speculative counterpart'.[93]

Although in Christian theology the symbol is taken to be a unity, in aesthetics as it develops in the Neoclassicist and Romantic eras it is not quite that. Rather, it is a necessary connection or relation between two things: what it is as a sensuous thing and what it comes in place of. For Coleridge, a symbol was a consubstantation of the truth it conducted. In the modern epoch it becomes a work of art that carries feeling or a state of mind from its creator to its reader or beholder. The Modernist or dominant theory of modern art is a variation on the theory of the symbol and the Romantic ideology of art as the manifestation of genius, of creative powers that lie beyond the reach of mere craft, learning or applied technique. Clement Greenberg is Modernism's Coleridge.

In 1940, in one of his earliest critical essays, 'Towards a Newer Laocoon', Greenberg considered what he saw and felt as the history of avant-garde painting.[94] He discussed the project of the avant-garde since its inception in the nineteenth century and identified two emphases within it. The first emphasis – he had discussed it the year before in 'Avant-Garde and Kitsch' – was the inversion of the relative importance of subject-matter and surface-matter. The avant-garde concentrated on and emphasized the problems and character

of the medium. Its painters attended to the flatness of the canvas and the means and materials of painting as an art, so as to 'get at the very essence of painting as well as of visual experience'.[95] The second emphasis was a tendency to investigate the medium for its expressive effects. Greenberg identified 'a common effort in each of the arts to expand the expressive resources of the medium, not in order to express ideas and notions, but to express with greater immediacy sensations, the irreducible elements of experience'.[96] When he wrote that, he was making a distinction between subject-matter and content: 'every work of art must have content', he wrote, 'but . . . subject matter is something the artist does or does not have in mind when he is actually at work'.[97] Content is what the work of art does to the beholder; it is an emotion derived from the work of art. Painters had to make paintings that affected the beholder not with ideas about things but with 'immediate and more powerful sensations'.[98] Greenberg advised them to look to the example of music to learn how this might be done:

> Only by accepting the example of music and defining each of the other arts solely in terms of the sense or faculty which perceived its effect and by excluding from each art whatever is intelligible in terms of any other sense or faculty would the non-musical arts attain the 'purity' and self-sufficiency that they desired: which they desired, that is, in so far as they were avant-garde arts. The emphasis, therefore, was to be on the physical, the sensorial.[99]

The painter, taking his example from music, had to make a sensuous object that would affect the beholder in terms of the sense appropriate to painting – in terms of sight. In this way, wrote Greenberg, 'painting and sculpture can become more completely nothing but what they do'; they become more thoroughly an optical effect:

> they *look* what they *do*. The picture or statue exhausts itself in the visual sensation it produces. There is nothing to identify, connect or think about, but everything to feel.[100]

Twenty-seven years later when, in 'Complaints of an Art Critic' (1967), Greenberg defended himself against accusations of being an 'arch-"formalist" ', he did so by reiterating and clarifying what he had written about 'content' in 1940 and

by emphasizing that his reputed formalism was primarily addressed to the idea of art as expression.[101]

> . . . the quality of a work of art inheres in its 'content', and vice-versa. Quality is 'content'. You know that a work of art has content because of its effect. The more direct denotation of effect is 'quality'. Why bother to say that a Velasquez has 'more content' than a Salvador Rosa when you can say more simply, and with directer reference to the experience you are talking about, that the Velasquez is 'better' than the Salvador Rosa? You cannot say anything truly relevant about the content of either picture, but you can be specific and relevant about the difference in their effect on you. 'Effect' like 'quality', is 'content', and the closer reference to actual experience of the first two terms makes 'content' virtually useless for criticism.[102]

In those fragments from 'Complaints of an Art Critic' and 'Towards a Newer Laocoon' Greenberg is telling us that in seeing works of art he experiences something he calls 'content'. The content of a work of art is more or less unspecific or unspecifiable. Content is 'quality', and vice versa. He knows that a work has content because of its 'effect' – its effect on him. Content is what Greenberg feels. And what he feels is located not in the subject-matter or ideas that are being communicated by the artist but in the medium as it has been used to make the surface – but not in the medium used metaphorically because that would be to make content, effect or quality a translation of something, and it isn't that for there is 'nothing to identify' and 'everything to feel'. Critical judgement, which is a matter of taste, measures content, effect or quality. It is what makes or breaks a painting. This is Greenberg writing about the work of some of the Modernist painters he came to value after Abstract Expressionism:

> Louis is not interested in veils or stripes as such, but in verticality and colour. Noland is not interested in circles as such, but in concentricity and colour. Olitski is not interested in openings and spots as such, but in interlocking and colour. And yet the colour, the verticality, the concentricity, and the interlocking are not there for their own sakes. They are there, first and foremost, for the sake of feeling, and as

vehicles of feeling. And if these paintings fail as vehicles and expressions of feeling, they fail entirely.[103]

Clearly there is a difference between experiencing a painting as a vehicle of feeling and experiencing an artist's feelings, but surely that is what is conjoined in the content, effect and quality that Greenberg so eloquently writes about.[104] The dominant theory of modern art establishes an adequation between the emotion felt by the beholder and the use of the surface of the painting and the artist's psyche or self. Greenberg holds to the theory – in his writing it becomes a powerful and exclusive approach. As I read his criticism, the kind of painting that he values effects in him an identification with something that, and someone who, is not him. That is why he values it. And how long does it take for this kind of painting to achieve its effect? 'Esthetic judgments' (this is what Greenberg writes in 'Complaints of an Art Critic') 'are given and contained in the immediate experience of art. They coincide with it; they are not arrived at afterwards through reflection or thought.'[105] Modernist painting, and especially the American-type painting that Greenberg valued – work by Morris Louis, Kenneth Noland (illus. 68), Jules Olitski, and by some of the Abstract Expressionists, for example, Pollock – is an art of radical purity that, according to him, developed in pursuit of the immediacy of effect. Time hardly comes into it, you see. It is in a moment of autonomy and self-sufficiency, spontaneity and transcendence of all commonplace limits of perception and thought that Modernist painting understood as symbolic asserts its content, effect and quality.

It was more difficult for Greenberg to see, feel and write about sculpture in the way that he did painting. However in 1948 he glimpsed the possibility that in the future sculpture and not painting might be the art most able to provide the kind of experience he valued. This is what he wrote in his 'Art Chronicle: The New Sculpture', published in 1949:[106]

> Painting of a kind that identifies itself exclusively with its surface cannot help developing toward decoration and suffering a certain narrowing of its range of expression. It may compensate for this by a greater intensity and concreteness – contemporary abstract art has done so with signal success – but a loss is still felt in so far as the unity and dynamics of the easel picture are weakened, as they must be

by any absolutely flat painting. The fact is, I fear, that easel painting in the literally two-dimensional mode of our age, with its positiveness, forces upon it may soon be unable to say enough about what we feel to satisfy us quite, and that we shall no longer be able to rely upon painting as largely as we used to for a visual ordering of our experience.[107]

When in 1958 he came to revise and rewrite 'The New Sculpture' ready for inclusion in *Art and Culture*, the anthologized selection of his critical essays that was published in 1961, he had become even more convinced that sculpture had begun 'to make itself felt as the most *representative*, even if not the most fertile, visual art of our time'.[108] Painting continued 'as the leading and most adventurous as well as the most expressive of the visual arts', but sculpture 'immersed in its means' in a desire for purity had been able 'to put an ever more higher premium on sheer visibility and an ever lower one on the tactile and its associations' so that, like painting, it could now 'render substance entirely optical'.[109] In 1958

sculpture seemed about to offer Modernist art a way beyond the narrow range of painting's 'field of possibilities'.[110]

When Greenberg rewrote 'The New Sculpture' he gave as examples some of David Smith's sculptures.[111] However, by the time the essay appeared in *Art and Culture*, the new sculpture in mind was more likely to have been the recent moves into abstraction that Anthony Caro had made with *Twenty-four Hours* (Tate Gallery, London) and *Midday* (illus. 69).[112] This was sculpture that derived its ideological resources from what Greenberg had written about the problems and concerns of Modernist painting, and which he would value for its abstractness and the autonomy and clarity of its construction, for its 'necessity' and because it was 'compelled by a vision unable to make itself known except by changing art'.[113] It was at this moment when sculpture seemed about to become the practice in which and with which to come to grips with the conditions of artistic modernism that Johns made most of his work in three dimensions, including, of course, *Painted Bronze (Ale Cans)* and *Painted Bronze*.

We are led, in conclusion, to a historical scheme that differs entirely from the customary picture. The dialectical relationship between subject and object is no longer the central statement of romantic thought, but this dialectic is now located entirely in the

temporal relationships that exist within a system of allegorical signs. It becomes a conflict between a conception of the self seen in its authentically temporal predicament and a defensive strategy that tries to hide from this negative self-knowledge. On the level of language the asserted superiority of the symbol over allegory, so frequent during the nineteenth century, is one of the forms taken by this tenacious self-mystification. Wide areas of European literature of the nineteenth and twentieth centuries appear as regressive with regard to the truths that came to light in the last quarter of the eighteenth century. For the lucidity of the pre-romantic writers does not persist. It does not take long for a symbolic conception of metaphorical language to establish itself everywhere, despite the ambiguities that persist in aesthetic theory and poetic practice. But this symbolical style will never be allowed to exist in serenity; since it is a veil thrown over a light one no longer wishes to perceive, it will never be able to gain an entirely good poetic conscience. Paul de Man, 'The Rhetoric of Temporality'[114]

I have attempted to develop my thinking in such a way that the work I've done is not me – not to confuse my feelings with what I produced. I didn't want my work to be an exposure of my feelings. Abstract-Expressionism was so lively – personal identity and painting were more or less the same, and I tried to operate the same way. But I found I couldn't do anything that would be identical with my feelings. So I worked in such a way that I could say that it's not me. That accounts for the separation. Jasper Johns to Vivien Raynor, 1973[115]

The valorization of the symbol over allegory in the modern epoch, which begins with Coleridge, among others, was most usefully reconsidered by Paul de Man in his essay of 1969, 'The Rhetoric of Temporality'. Here the Romantic and post-Romantic symbol appears more and more a special case of figurative language in general, a trope or figure integrated with other tropes or figures. In order to disclose how the symbol was falsely set in dominant opposition to allegory, de Man analyses that passage in *The Statesman's Manual* where Coleridge asserts that the symbol is characterized by 'translucence' and allegory is referred to as a 'translation', a 'phantom proxy' or a reflection.[116] De Man points out that the distinction as Coleridge has written it disappears when read attentively: allegory as a 'phantom proxy' or reflection is 'unsubstantial' and 'shapeless', but the symbol understood as something translucent must also be unsubstantial and shapeless; both allegory and symbol have the same relation to a transcendental origin 'beyond the world of matter'.[117] And it is this

transcendental source that the critics of Romanticism concentrate on and not the material substantiality of the symbol that effects it. 'Starting out from the assumed superiority of the symbol in terms of organic substantiality, we end up', de Man writes, 'with a description of figural language as translucence, a description in which the distinction between allegory and symbol has become of secondary importance'.[118] Having pointed this out, he then attends to the materiality of the symbolic text and how it effects its seemingly transcendent vision. Rousseau's *La Nouvelle Héloïse* and Wordsworth's sonnets on the River Duddon, the passages on crossing the Alps and the ascent of Snowdon in Books VI and XIV of *The Prelude*, provide de Man with examples of prose and poetry that literary criticism has continually misread as unifying the antimonies of inner and outer experience, mind and nature, subject and object, time and eternity. De Man demonstrates that these texts are as much allegorical as they are symbolical. Rousseau is shown to have used his knowledge of the *jardins anglais*, Defoe's *Robinson Crusoe* and the *Roman de la Rose* to make his description of the natural,[119] while Wordsworth's highly valued direct perception and unmediated creative expression depended not on the specific locale but on the control exercised by 'a traditional and inherited typology'.[120] In each case the author has tried to communicate a moment of purified perception, but can only be claimed to have done so by not acknowledging the operations that make his text what it is as writing. The symbol tries to deny its material mediating character as language. But for de Man a symbolic text always turns back into what it is and what makes it what it is – allegory. The allegorical mode of the texts de Man studies always disrupts their symbolic form, and these disruptive moments are valued because they disclose a knowledge that the texts veil, or try to conceal. The generally existing allegorical mode provides the symbol with its own ideology critique:

In the world of the symbol it would be possible for the image to coincide with the substance, since the substance and its representation do not differ in their being but only in their extension: they are part and whole of the same set of categories. Their relationship is one of simultaneity, which, in truth, is spatial in kind, and in which the intervention of time is merely a matter of contingency, whereas, in the

world of allegory, time is the originary constitutive cate-
gory. The relationship between the allegorical sign and its
meaning (*signifié*) is not decreed by dogma; in the instances
we have seen in Rousseau and in Wordsworth, this is not at
all the case. We have, instead, a relationship between signs
in which the reference to their respective meanings has
become of secondary importance. But this relationship
between signs necessarily contains a constitutive temporal
element; it remains necessary, if there is to be allegory, that
the allegorical sign refer to another sign that precedes it. The
meaning constituted by the allegorical sign can then consist
only in the *repetition* (in the Kierkegaardian sense of the
term) of a previous sign with which it can never coincide,
since it is of the essence of this previous sign to be pure
anteriority. The secularized allegory of the early romantics
thus necessarily contains the negative moment which in
Rousseau is that of renunciation, in Wordsworth that loss of
self in death or in error.[121]

The prevalence of allegory works against the symbolic effect of
the text and the claims made in virtue of its transcendence by
forcing to mind the constitutive gap that there is in language
between words or visual images and the reality or experience
of reality that they try to evoke.

De Man's critical writings – the work he produced in the
United States at the time of and subsequent to his engagement
with New Criticism – continually return to focus on analysing
the relation between the experience of a consciousness, the
working out of a logos of that experience, and the communi-
cation of it or response to it by another mind. What he writes
about poetry and prose applies almost as well to the seemingly
less wordy visual forms of fine art and the ways they are seen
and understood to communicate experience. An interesting
appropriation of the work of de Man to an extended critique of
the belief that visual art can unmediatedly communicate or
vehicle feeling from one mind to another was made by Hal
Foster in his 1983 essay 'The Expressive Fallacy'.[122] Foster was
primarily concerned with German Expressionism and
Abstract Expressionism, but if we take 'expressionist' to
mean, as Greenberg did in 1939 and 1940, 'avant-garde' and
'modern' – that is to say, 'Modernist' – what he writes can be
read as referring to all Modernist art, including that which is

not explicitly expressionist in its gestuary character. Expressionist art, says Foster, following the drift of some of what de Man wrote in his essay of 1974 on Nietzsche's theory of rhetoric, is not so much the form that directly comes from and to 'the freed marks and colours that signal self-expression' as it is a 'specific *language*' that 'denies its own status as language'.[123] It is, he says, a language that persuades or encourages the beholder to see it as originating in the artist's self and which seems neither socially nor historically mediated but whose ' "immediacy" . . . is an effect – of a twofold mediation'.[124] Because the stretched canvas 'already exists as a picture', the artist must deny or supersede the representational paradigm in and with which he works.[125] In other words, the artist must deny or supersede the fact that when he or she makes a work of art it is done under a certain description of what it is that is being made. And the artist must then substitute marks and colours for once directly felt feelings, as if those marks and colours were not substitutions for, but vehicles of, those feelings. As Foster points out, for the original Expressionists, 'expressionism was an art of "inner necessity" (Kandinsky) and "abstraction" (Worringer) that operated by a formula such as this: via abstraction the viewer is compelled by the inner necessity of the artist'.[126] It is here that Foster uses de Man's examination of a passage from Nietzsche's *The Will to Power* to pack his punch with reference to German Expressionism and Abstract Expressionism:

> Yet this notion of self-expression, which governs the common idea of modern art in general, derives, as Paul de Man noted, 'from a binary polarity of classical banality in the history of metaphysics: the opposition of subject to object based on the spatial model of an "inside" to an "outside" world' – with the inside privileged as prior. Expressionism not only conforms to this metaphysics of presence, it celebrates it. . . . Indeed, the old metaphysical opposition of inside versus outside, soul versus body, is the very basis of expressionism – and of all its oppositions: nature versus culture. . . ; individual versus society. . . ; artist versus convention – all of which return, in an existentialist register, in abstract expressionism.[127]

Following the way that de Man located the key to Nietzsche's critique of metaphysics in what he reminds us about language

as the medium within which the play of reversals and substitutions (such as before for after, early for late, outside for inside, cause for effect) takes place without regard for the truth value of these structures and about the figurality of all language, Foster picks up on the fact that 'Nietzsche, who is often (mis)cast as the philosophic precursor of expressionism, effectively deconstructed it before the fact.'[128] He points out that for Nietzsche this 'inner necessity' is 'based on a linguistic reversal', and then quotes part of the fragment examined by de Man to emphasize and develop his own critique of expressionism:

> 'The whole notion of an "inner experience" enters our consciousness only after it has found a language that the individual *understands* – i.e., a translation of a situation into a familiar situation. . . .' This 'translation' precedes, indeed constitutes any formed expression so that between it and the self a rhetorical figure intervenes (in linguistic terms, the subject of the *énoncé* and the subject of the enonciation are discontinuous). The adequation of self and expression is thus blocked – by the very sign of expression. Such is the pathos of the expressionist self: alienated, it would be made whole through expression, only to find there another sign of its alienation. For in this sign the subject confronts not its desire but its deferral, not its presence but the recognition that it can never be primary, transcendent, whole.[129]

At some stage on his way to becoming an artist Johns tried to make paintings that were to be seen and understood – like Abstract Expressionist paintings were seen and understood – as identified with the artist and the expression of his feelings, but he failed to do so and decided not to continue trying to make paintings like that.[130] However, it seems that he did not want to make that kind of painting anyway; he did not want his picture-making to express his feelings, or what he has referred to as his 'flawed nature' and his 'self'.[131] The first decision would have been based in a practical failure or in the insight gained that the expression of feeling via art is so fraught with difficulties as to be practically impossible. The second decision would have been based in Johns's biographical historicity, in the determined need not to communicate a knowledge of himself. He 'wanted to have an idea, or an image, or whatever you please, that was not I'[132] Perhaps

learning something from the theoretical discourse and works of Cage, Cunningham, and Rauschenberg, whose critique of self-expression was already established by the time he met them in 1953 or 1954, Johns developed a way of making art that drew attention to its rhetorical structure and blocked the adequation of self and expression and about which he could say that it was 'not me'.[133] The 'I' of Johns's work is not the transcendental 'I' of expressionism, Modernist painting and sculpture or the symbol, but another seemingly negative 'I' or a not-in-place 'I'. From the moment of its beginnings in the discourses of modern art and Modernism Johns's art resisted being seen and understood as the expression or communication of feelings or an originary 'I'. Nevertheless, his art can be seen and understood as representing an 'I' – not for the 'mob' but for the 'few'. Seen and understood as allegory the 'not I' or negative self-knowledge that is represented in and by Johns's work turns into a vivid, positive 'not I' that represents a biographical historicity, even illustrates stories of a life, and, if psychoanalysis and the theory of allegory are correct, constitutes truth. As an allegorical representation of a 'not I', Johns's work signifies not only what it is as a 'not I' but otherwise as the only self-identity available to its creator – and its beholder. Seen and understood like this, the painting or sculpture appears – it draws attention to 'itself' – as but one moment in the continuous process of desiring a self-identity wherein polysemic signifiers of that identity are simultaneously found and lost, created and destroyed, placed and displaced. Against the claims made on behalf of Modernist painting and sculpture, Johns's art makes obvious the perpetual slippage between signifier and signified, sign and meaning or referent, and the lack of correspondence between seemingly self-possessed experience and the communication or representation of that experience.

Realizing that the modern world is a space in which things and meanings disengage – that the world is a configuration of things that designates not a single universal meaning but a plurality of distinct and isolated meanings – the allegorist directs the reader's or beholder's attention to the arbitrary character of his text or visual form.[134] The allegorist realizes that the fabric of modern culture is a space whose truth can only be located in and represented by a disavowal of the symbolic. The language of allegory works to show us that

meaning is always elsewhere and other, never coincident with intent, or self-possessed. Whatever meanings might be read or seen in the work, they will not close down on the need for further description and interpretation. Allegory and symbol are alike not as orders of language but as strategies of figuration. But the former has the power to interrupt the effect of the latter and demonstrate that it is not what you think it is rather than what you think it is. Allegory has the power to effect the knowledge that you are not what you think you are rather than what you think you are, that the idea of the self or the 'I' can never be an integral subject or object of knowledge. This is the value and ethical purport of allegory as de Man explained it in 'The Rhetoric of Temporality':

> Whereas the symbol postulates the possibility of an identity or identification, allegory designates primarily a distance in relation to its own origin, and, renouncing the nostalgia and the desire to coincide, it establishes its language in the void of this temporal difference. In so doing, it prevents the self from an illusory identification with the non-self, which is now fully, though painfully, recognized as a non-self. It is this painful knowledge that we perceive at the moments when early romantic literature finds its true voice.[135]

Following de Man, we could say that this 'painful knowledge' is what is represented in and by the art of 'Jasper Johns' signifying otherwise in the market-place, challenging our usual habits of seeing and understanding, and effecting doubts in any discourse that tries to appropriate and value it. Johns's work favours and effects a vivid self-engendered paradox, a kind of knowledge about the self, the world and practical consciousness that is difficult to accept and impossible to transcend. However, it is worthwhile reminding ourselves that this is a claim made in virtue not only of pictures such as *Untitled*, 1972, *No*, *In Memory of My Feelings – Frank O'Hara*, *Target with Plaster Casts*, *Flag*, and *Dancers on a Plane*, but also of *The Critic Sees*, *Painted Bronze (Ale Cans)* and, especially, *Painted Bronze*, sculptures made as jokes or asides.

Evidently these bronzes are here in the guise of works of art, but as we look at them we go out of our minds, transformed with respect to being. John Cage, 'Jasper Johns: Stories and Ideas', 1964[136]

Peter Fuller: *Were you exaggerating the 'objectivity' of your work, its separateness from your feelings, then, say twenty years ago?*
Jasper Johns: *What can you say? Obviously, the idea of objectivity itself exaggerates the absence of subjectivity so that, at best, one can say that one's intention is so and so, and obviously one does not do exactly what one intends. One does more, usually, and often less, also. Or you could just say one does other.*[137]

References

Beginnings

1 John Milton, *Paradise Lost*, ed. A. Fowler (London, 1968, corrected 1971), VIII, 251.

2 J.E.Young, 'Jasper Johns: An Appraisal', *Art International* (September 1969), p. 51.

3 Charles Harrison and Fred Orton, 'Jasper Johns: "Meaning What You See" ', *Art History*, VII/1 (1984), pp. 78–101.

4 On Art & Language see Charles Harrison and Fred Orton, *A Provisional History of Art & Language* (Paris, 1982) and Charles Harrison, *Essays on Art & Language* (Oxford, 1991).

5 Art & Language's *Portrait of V.I. Lenin with Cap, in the Style of Jackson Pollock I*, 1979, and *Joseph Stalin Gazing Enigmatically at the Body of V.I. Lenin as it Lies in State in Moscow*, 1979, were exhibited at the University Gallery, University of Leeds, in January 1980. On the *Portrait of V.I. Lenin in the Style of Jackson Pollock* pictures see Charles Harrison and Fred Orton, *A Provisional History of Art & Language*, pp. 62–6 and Charles Harrison, *Essays on Art & Language*, pp. 141–9. In some other Art & Language paintings made between 1982 and 1983, each one a different *Index: The Studio at 3 Wesley Place*, and especially versions *II–VIII*, I also saw something of the ways the Modernist priority of surface over subject could be worked with and against to produce a kind of meta-discourse on Modernist art practice by using descriptive detail or subject-matter to make a seemingly self-sufficient surface. On Art & Language's *Index: The Studio at 3 Wesley Place. . . , I–VIII*, 1982–3, see Harrison, *Essays on Art & Language*, pp. 150–74.

6 See Art & Language, 'Portrait of V.I. Lenin', *Art-Language*, IV/4 (1980) and 'Abstract Expression', *Art-Language*, V/1 (1982) reprinted in Charles Harrison and Fred Orton, *Modernism, Criticism, Realism: Alternative Contexts for Art* (London, 1984), pp. 145–69 and 191–204 respectively.

7 Art & Language's notion of *of* was developed from David Kaplan's essay 'Quantifying In', *Words and Objections: Essays on the Work of W.V. Quine*, ed. D. Davidson and J. Hintikka (Dordrecht, 1969) and its discussion of the relations between names, their objects and the uses of those names. A name, Kaplan suggests, may be of its object (for someone) by virtue of a relation of resemblance, or descriptiveness, or iconicness (x is like its object for p); or it may be of its object (for someone) by virtue of a causal or genetic connection (x can be traced to its objects by p); a name may also be vivid for someone by virtue of some interest on that person's part and can be so independently of either descriptive or genetic considerations. Kaplan illustrates his argument by analogy with pictures. The Art & Language text 'Portrait of V.I. Lenin' (see n. 6 above) follows up the implications of this analogy and extends them in pursuit of a concept of realism in representation that is sufficiently sophisticated to cover the practice of art and not just those types of pictures that are 'philosophers' objects'. As regards any claim that a picture is *of* something, Art & Language assert that 'it is an

implicit condition of any realistic criticism that genesis be recognized in general as a more powerfully explanatory concept than resemblance'. The argument is generally addressed against those cultural tendencies which suggest that the *how* of the production of pictures should be inferred from assumptions about the *what*; for example, the tendency to allow the application of empiricist or stylistic categories to define the grounds of causal enquiry. In 'Portrait of V.I. Lenin', Art & Language suggest that 'there may be a way to regard realistic pictures as, among other things, pictures whose genetic systems contain a "closed", or rather partially closed system. We may be able to regard a realistic picture as a picture whose termini are that picture and that which it is *of*. Such as a system is not really closed, rather . . . it is limited or restricted in some way that is historically or *cognitively significant*, and not just structurally or because of an investment in dominance.'

8 Fred Orton, 'Present, the Scene of . . . Selves, the Occasion of . . . Ruses', *Foirades/Fizzles: Echo and Allusion in the Art of Jasper Johns*, exh. cat. ed. James Cuno; Grunwald Centre for the Graphic Arts, Wight Art Gallery, University of California, (Los Angeles 1987), pp. 167–92.

9 Jakobson, 'Aphasia as a Linguistic Topic' (1953) reprinted in *Selected Writings II: Word and Language* (The Hague, 1971), pp. 229–38, and 'Two Aspects of Language and Two Types of Aphasic Disturbances' (1954) published as Part II of *Fundamentals of Language* (The Hague, 1956), reprinted in *Selected Writings II: Word and Language*, pp. 239–59.

10 Jakobson, 'Two Aspects of Language and Two Types of Aphasic Disturbances', p. 258.

11 Jakobson, 'Aphasia as a Linguistic Topic', p. 236.

12 Jakobson, 'Two Aspects of Language and Two Types of Aphasic Disturbances', p. 259.

13 Christopher Norris, *Paul de Man: Deconstruction and the Critique of Aesthetic Ideology* (London, 1988), pp. 49–50.

14 Ibid., p. 50.

15 Ibid.

16 See Max Kozloff, *Jasper Johns* (New York, 1969), esp. pp. 9–10; Andrew Bush, 'The Expanding Eye: The Allegory of Forgetting in Johns and Beckett', *Foirades/Fizzles: Echo and Allusion in the Art of Jasper Johns*, pp. 127–46, and Richard Shiff, 'Anamorphosis: Jasper Johns', pp. 147–66. David Shapiro, in his Introduction to *Jasper Johns Drawings, 1954–1984* (New York, 1984), moves towards seeing and understanding Johns's work as allegory, but, in the end, does not go far enough: 'Everything is a metaphor, even the word *metaphor*, and even the word *literal*, as in the art of Jasper Johns.'

17 Edwin Honig, *Dark Conceit: The Making of Allegory* (1959; New York, 1966); Angus Fletcher, *Allegory: The Theory of a Symbolic Mode* (Ithaca, NY, 1964); and Maureen Quilligan, *The Language of Allegory* (Ithaca, NY, 1979).

18 Especially the essays collected in Paul de Man, *Allegories of Reading: Figural Language in Rousseau, Nietzsche, Rilke and Proust* (New York, 1979); *Blindness & Insight: Essays in the Rhetoric of Contemporary Criticism*, 2nd edn (London, 1983); *The Rhetoric of Romanticism* (New York, 1984); and *The Resistance to Theory* (Manchester, 1986).

19 The interest of Post-Modernist criticism in allegory can be read in a series of essays published in *October*: Douglas Crimp, 'Pictures', *October*, 8 (Spring 1979), pp. 75–88; Joel Fineman, 'The Structure of Allegorical Desire', *October*, 12 (Spring 1980), pp. 47–66; Craig Owens, 'The Allegorical Impulse: Toward a Theory of Postmodernism', *October*, 12 (Spring 1980), pp. 67–86; Douglas Crimp, 'On the Museum's Ruins', *October*, 13 (Summer 1980), pp. 41–57; Craig Owens, 'The Allegorical

Impulse: Toward a Theory of Postmodernism', Part 2, *October*, 13 (Summer 1980), pp. 59–80; and Stephen Melville, 'Notes on the Re-emergence of Allegory, the Forgetting of Modernism, the Necessity of Rhetoric, and the Conditions of Publicity in Art and Criticism', *October*, 19 (Winter 1981), pp. 55–92, which is distinct from the others in quality and kind. Here I have in mind, specifically, Owens's excellent conclusion to Part 2 of 'The Allegorical Impulse: Toward a Theory of Postmodernism' and, generally, but much less excellently, how he explains allegory's central place in Post-Modern art and art criticism.

20 Craig Owens, 'The Allegorical Impulse: Toward a Theory of Postmodernism', *October*, 12, p. 75 and 77–9.

21 Craig Owens, 'The Allegorical Impulse: Toward a Theory of Postmodernism', Part 2, *October*, 13, p. 64, and 'The Allegorical Impulse: Toward a Theory of Postmodernism', *October*, 12, p. 75.

22 For an account of Post-Modernism understood as a form of consciousness determined by a 'hypothetical break' in the development and character of capitalism, see Frederic Jameson, *Postmodernism or, The Cultural Logic of Late Capitalism* (London, 1991).

23 This is not the place for a critical review of the way Craig Owens appropriated the work of Jacques Derrida to his claims for a Post-Modernist subversion of the nature/culture opposition, the privileging of the reader in the reader/spectator opposition, the move from history to discourse, etc. For a useful glimpse of how and why Owens 'never quite got Derrida and company right', see Stephen Melville, 'Contemporary Theory and Criticism', *Art in America* (July 1993), pp. 30–31.

24 See Jacques Derrida, trans. Alan Bass, *Positions* (London, 1987), pp. 41–43, for a brief introduction to 'certain marks . . . that *by analogy*' he has called 'undecidables'.

25 Jacques Derrida, trans. Alan Bass, '*Différance*' (1968) in *Margins of Philosophy* (Brighton, 1982), pp. 1–27. As a neologism that Derrida brings into discourse, '*différance*' is made of two words – *différence* and *différance*: 'difference' and, from the verb 'to defer', *différer*, a 'deferred thing'. *Différance* seems to overturn the privilege accorded speech in linguistic theory and the philosophy of language because the crucial *a* that marks the difference between *différence* and *différance* is only present in writing. However, this difference can only function within the system of phonetic writing and its language and grammar, and since there is no completely phonetic writing, even in this context the *a* that marks the difference tends to disappear as something available to sensibility and intelligibility. *Différance* is not only made of two words, it holds within it two meanings, one spatial, the other temporal: (from Ferdinand de Saussure) that in language there are only differences, phonetic and conceptual differences that issue from the system and which, as signifiers and signifieds, are set in certain relations as meaningful signs; and (from Derrida himself) that meaning is nowhere present in language because the differential play within it prevents the sign from coinciding with itself in a kind of perfect moment. The meaning of *différance* is neither differential nor deferred but both differential and deferred.

26 G.R. Swenson, 'What is Pop Art?', Part 2, *Art News* (February 1964), reprinted in *Pop Art Redefined*, ed. John Russell and Suzi Gablik (London, 1969), p. 83.

27 'Interview with Jasper Johns' in Christian Geelhaar, *Jasper Johns: Working Proofs* (London, 1980), p. 48.

1 *Present, the Scene of My Selves, the Occasion of these Ruses*

 1 'Interview with Jasper Johns' in Christian Geelhaar, *Jasper Johns: Working Proofs* (London, 1980), p. 55.
 2 Roberta Bernstein, 'An Interview with Jasper Johns', *Fragments: Incompletion and Discontinuity*, ed. Lawrence D. Kritzman (New York, 1981), p. 284.
 3 Paul de Man, 'Shelley Disfigured' in *The Rhetoric of Romanticism* (New York, 1984), pp. 120–21.
 4 Michael Crichton, *Jasper Johns* (New York, 1977), p. 59.
 5 Ibid., pp. 54–5.
 6 Ibid., p. 60.
 7 Richard Shiff, 'Anamorphosis: Jasper Johns' in *Foirades/Fizzles: Echo and Allusion in the Art of Jasper Johns*, exh. cat. ed. James Cuno; Grunwald Centre for the Graphic Arts, Wight Art Gallery, University of California, Los Angeles (1987), p. 154.
 8 Ibid., pp. 154–5.
 9 For the 'several distinct changes' this panel went through between March and August 1972, see Roberta Bernstein, *Jasper Johns' Paintings and Sculptures 1954–1974: 'The Changing Focus of the Eye'* (Ann Arbor, 1985), p. 237 n. 30.
10 Shiff, 'Anamorphosis: Jasper Johns', p. 154.
11 James Cuno, 'Voices and Mirrors/Echoes and Allusions: Jasper Johns's "Untitled", 1972' in *Foirades/Fizzles*, p. 204.
12 Richard S. Field makes this point in *Jasper Johns: Prints 1970–1977* (London, 1978), p. 23.
13 Thomas B. Hess, 'Polypolyptychality', *New York Magazine* (19 February 1973), p. 73.
14 On studio paintings, and paintings as moral and technical or practical studios, see Art & Language, 'A Cultural Drama: The Artist's Studio' in *Art and Language*, exh. cat.; Los Angeles Institute of Contemporary Art (1983), pp. 17–19.
15 Hess, 'Polypolyptychality', *New York Magazine*, p. 73.
16 Bernstein, 'An Interview with Jasper Johns', *Fragments: Incompletion and Discontinuity*, p. 282.
17 Richard Francis, *Jasper Johns* (New York, 1984), p. 17.
18 Jacques Lacan, 'The Agency of the Letter in the Unconscious or Reason since Freud' in *Ecrits: A Selection*, trans. Alan Sheridan (London, 1977), pp. 155–6.
19 Friedrich Nietzsche, *Gesammelte Werke* (Munich, 1922), v, p. 300, trans. and cited by Paul de Man, 'Rhetoric of Tropes (Nietzsche)' in *Allegories of Reading: Figural Language in Rousseau, Nietzsche, Rilke and Proust* (New York, 1979), p. 105.
20 The literature on metaphor is enormous. *Critical Inquiry* 5 (Autumn 1978), which consists of contributions delivered in earlier versions at a conference on metaphor sponsored by the University of Chicago Extension in February 1978, provides a good sampling of some of the issues involved.
21 Roman Jakobson, 'Aphasia as a Linguistic Topic' (1953) in *Selected Writings II: Word and Language* (The Hague 1971), p. 236. It is in this essay that Jakobson starts to attend to aphasia as either a 'contiguity disorder' or a 'similarity disorder' understood in terms of metonymy and metaphor; see his conclusion, p. 238: 'The opposition of the two types of verbal behaviour – the metonymical, concerned with external relations and the metaphorical, involving internal relations – underlies the alternative syndromes of aphasic disturbances –

similarly disorder and contiguity disorder. While each of these two types of aphasia tends toward unipolarity, normal verbal behaviour is bipolar. But any individual use of language, any verbal style, and trend in verbal art displays a clear predilection either for the metonymical or for the metaphorical device.'

22 Quintilian, trans. H.E. Butler, *The Institutes of Oratory*, VII, 6, sec. 19, (London, 1953), cited in Angus Fletcher, *Allegory: The Theory of a Symbolic Mode* (Ithaca, NY, 1965), p. 85.

23 The metaphor-metonymy dyad that Jakobson introduced in 'Aphasia as a Linguistic Topic' (see note 21 above) was developed in his essay of 1954, 'The Two Aspects of Language and Two Types of Aphasic Disturbances', and published as Part II of *Fundamentals of Language* (The Hague, 1956) and in a somewhat different version in *Language: an Enquiry into its Meaning and Function*, ed. by R.N. Ashen (New York, 1971), pp. 155–73 and in Roman Jakobson, *Selected Writings II: Word and Language*, pp. 239–59. On Jakobson's use of Ferdinand de Saussure's linguistics, see David E. Cooper, *Metaphor* (Oxford, 1986), pp. 34–9.

24 Roman Jakobson, 'Two Aspects of Language and Two Types of Aphasic Disturbances', *Selected Writings II: Word and Language*, pp. 241–4.

25 Ibid., pp. 254–9.

26 Ibid., p. 254.

27 Ibid., p. 255.

28 Ibid., pp. 255–6.

29 Jacques Lacan's appropriation of Jakobson to Freud can be read in 'The Agency of the Letter in the Unconscious or Reason since Freud', in Lacan, *Ecrits: A Selection*, pp. 146–78.

30 The following texts provided seemingly reliable guides to the language and lore of Jacques Lacan: Bice Benvenuto and Roger Kennedy, *The Works of Jacques Lacan. An Introduction* (London, 1986); Juliet Flower MacCannell, *Figuring Lacan: Criticism and the Cultural Unconscious* (Lincoln, NB, 1986); Jonathan Scott Lee, *Jacques Lacan* (Amherst, 1991); and Samuel Weber, trans. Michael Levine, *Return to Freud: Jacques Lacan's Dislocation of Psychoanalysis* (Cambridge, 1991). David Macey's *Lacan in Contexts* (London, 1988), pp. 121–76, contains a useful critical discussion of the common view that Lacan was a psychoanalyst whose work was informed by a serious interest in linguistics. Macey shows that though Lacan took speech and language as the field and medium of psychoanalysis, his use of linguistics was idiosyncratic and based on highly unstable, uncertain definitions.

31 Lacan, 'The Agency of the Letter in the Unconscious or Reason since Freud', p. 160.

32 Leo Strauss, *Persecution and the Art of Writing* (Glencoe, IL, 1952). Strauss regarded his book as a contribution to the sociology of knowledge or the sociology of philosophy, but Lacan read it as it was also intended to be read, as a work of Cold War political philosophy. See Lacan, 'The Agency of the Letter in the Unconscious or Reason since Freud', *Ecrits: A Selection*, p. 158 and p. 177 n. 23. Lacan found especially useful Strauss's chapter 2, 'Persecution and the Art of Writing', with its opening paragraph: 'In a considerable number of countries which, for about a hundred years, have enjoyed a practically complete freedom of public discussion, that freedom is now suppressed and replaced by a compulsion to coordinate speech with such views as the government believes to be expedient, or holds in all seriousness. It may be worth our while to consider briefly the effect of that compulsion, or persecution, on thoughts as well as actions.'

33 See Lacan, 'The Agency of the Letter in the Unconscious or Reason

since Freud', p. 155, where Lacan introduces the idea, taken from Strauss's *Persecution and the Art of Writing*, of *'between-the-lines'* censures; see Strauss's argument in *Persecution and the Art of Writing*, pp. 22–7, that 'Persecution . . . gives rise to a peculiar type of literature, in which truth about all crucial things is presented exclusively between the lines.'

34 Lacan, 'The Agency of the Letter in the Unconscious or Reason since Freud', p. 158.

35 Jacques Lacan, 'The Direction of the Treatment and the Principles of its Power', *Ecrits: A Selection*, pp. 227–80.

36 Ibid., pp. 259, 274.

37 Lacan, 'The Agency of the Letter in the Unconscious or Reason since Freud', p. 147.

38 Joel Fineman, 'The Structure of Allegorical Desire', *October* 12 (Spring 1980), p. 50.

39 The causal, determined or genetic *of* comes into my text from Art & Language's essay on what is meant by claiming what a painting is *of*; see Art & Language, 'Portrait of V.I. Lenin', *Art-Language*, iv/4 (June 1980), pp. 26–61, reprinted in *Modernism, Criticism, Realism: Alternative Contexts for Art*, ed. Charles Harrison and Fred Orton (London, 1984), pp. 145–69.

40 For the way surface and subject can occasion a kind of crisis of evaluation for Modernist art criticism and history, see Fred Orton, 'Reactions to Renoir keep changing', *Oxford Art Journal*, viii/2 (1985), pp. 31–2.

41 Clement Greenberg, 'Towards a Newer Laocoon', *Partisan Review* (July–August 1940), reprinted in *Clement Greenberg. The Collected Essays and Criticism, Vol. 1: Perceptions and Judgments, 1939–1944*, ed. John O'Brian (London, 1986), pp. 23–38; see esp. p. 30.

42 On the priority of the possession of the surface of a painting for an artist's 'expressive purpose', see Richard Wollheim, 'The Work of Art as Object', *Studio International* (December 1980), reprinted in Wollheim, *On Art and the Mind* (London, 1973), pp. 122–7, and Harrison and Orton, *Modernism, Criticism, Realism*, pp. 10–17.

43 For a discussion of some of the restrictions that Modernist art criticism and history imposes on seeing and understanding, see Harrison and Orton, 'Introduction: Modernism, Explanation and Knowledge' in *Modernism, Criticism, Realism*, pp. xi–xviii, xxiii–xxv.

44 Jasper Johns's sketchbook note published in Alan R. Solomon's essay 'Jasper Johns', *Jasper Johns*, exh. cat.; The Jewish Museum, New York, p. 15; Whitechapel Gallery, London, p. 19 (1964).

45 Richard Francis, *Jasper Johns* (New York, 1984), p. 50.

46 Noam Chomsky, *Reflections on Language* (London, 1976), pp. 3–12, reprinted in Harrison and Orton, *Modernism, Criticism, Realism*, pp. 94–9.

47 The idea of 'cognitive style' is taken from Michael Baxandall, *Painting and Experience in Fifteenth-century Italy* (Oxford, 1972), pp. 36–40, reprinted in Harrison and Orton, *Modernism, Criticism, Realism*, pp. 140–43.

48 Roberta Bernstein, 'An Interview with Jasper Johns', *Fragments: Incompletion and Discontinuity*, p. 286.

49 Ibid., p. 288.

50 Leo Steinberg, 'Jasper Johns', *Metro*, 4/5 (1962); revised and published as *Jasper Johns*, (New York, 1963); further revised and reprinted as 'Jasper Johns: The First Seven Years of His Art' in *Other Criteria: Confrontations with Twentieth-century Art* (New York and Oxford, 1972), pp. 17–57. See 'Jasper Johns: The First Seven Years of His Art', *Other Criteria*, p. 37.

51 See, for example, Alan R. Solomon, 'Jasper Johns', *Jasper Johns* (New York, 1964), p. 6; (London, 1964), p. 7.

52 Ibid.

53 Michael Crichton, *Jasper Johns*, p. 30; Roberta Bernstein, 'An Interview with Jasper Johns', *Fragments: Incompletion and Discontinuity*, pp. 287–8.

54 Andrew Bush, 'The Expanding Eye: The Allegory of Forgetting in Johns and Beckett' in *Foirades/Fizzles: Echo and Allusion in the Art of Jasper Johns*, p. 132, makes the point that the relation of the anatomical parts of *Target with Plaster Casts* 'is almost, but not quite synecdoche. The parts do not represent the whole; the whole rather, is what cannot be represented in the sum of these parts.'

55 Roberta Bernstein, *Jasper Johns' Paintings and Sculptures 1954–1974*, p. 219 n. 48.

56 Ibid.

57 S.P., 'Haseltine Views of Italy at Cooper Union', *The New York Times* (Saturday, 25 January 1958), p. 15.

58 'Conversation. Leo Castelli: "Who Knows When Another Epiphany Will Occur?" ', *Art News*, (April 1991), p. 77. Castelli continues: 'Jasper's exhibition was my first successful one. I sold everything except *White Flag* and *Target with Plaster Casts*. At the end of the show, I told Jasper that I would like to keep one of these paintings for myself and that he should decide which one he wanted. The *White Flag* was his choice. So I got *Target with Plaster Casts*, penis and all.' Castelli's story about Barr's discomfort with regard to the penis seems to be confirmed by the Museum of Modern Art, Minutes of the Committee on the Museum Collection, 19 February 1958, pp. 3–4, which show that the picture was not reserved for the Museum 'because certain graphic details would prevent its exhibition'. See Helaine Ruth Messer, *MOMA: Museum in Search of an Image*, unpublished PhD dissertation, Columbia University, New York, 1979, pp. 291–2.

59 Francis Picabia's *Spanish Night* (1922), Ludwig Museum, Cologne, provides me with an example. For an object-lesson in how to make too much of it as a 'Dadaist precedent' – or any kind of 'precedent' – for Johns's *Target with Plaster Casts*, see Roni Feinstein, 'Jasper Johns' "Untitled" (1972) and Marcel Duchamp's Bride', *Arts Magazine* (September 1982), p. 87.

60 This is not to say that Johns meant to prioritize or give greater importance to the penis over any of the other casts. For something of how the presence of the penis – and the nipple – has been seen and understood as catching the spectator 'completely off-guard', see Kenneth E. Silver, 'Modes of Disclosure: The Construction of Gay Identity and the Rise of Pop Art' in *Hand-Painted Pop: American Art in Transition, 1955–62*, exh. cat.; Museum of Contemporary Art, Los Angeles (1993), pp. 188–90.

61 Johns quoted by Leo Steinberg in 'Jasper Johns: The First Seven Years of His Art', *Other Criteria*, p. 31.

62 Max Kozloff, *Jasper Johns* (New York, 1969), p. 14.

63 Leo Steinberg, 'Jasper Johns: The First Seven Years of His Art', pp. 35–7.

64 Ibid. p. 37.

65 Moira Roth, 'The Aesthetics of Indifference', *Artforum* (November 1977), pp. 46–53, and Calvin Tomkins, *Off the Wall: Robert Rauschenberg and the Art World of Our Time* (New York, 1980). I've also drawn on the following: John Gruen, *The Party's Over Now: Reminiscences of the Fifties – New York Artists, Writers, Musicians and Their Friends* (New York, 1972); John Bernard Myers, *Tracking the Marvellous: A Life in the New York Art World* (New York, 1984); Marjorie Perloff, *Frank O'Hara: Poet*

Among Painters (New York, 1977); and Irving Sandler, *The New York School: The Painters and Sculptors of the Fifties* (New York, 1978).

66 For three studies concerned to see and understand Johns's work in terms of sexual difference, see Jonathan Katz, 'The Art of Code: Jasper Johns and Robert Rauschenberg' in *Significant Others: Creative Partnerships in Art and Literature*, ed. Whitney Chadwick and Isabelle de Courtivron (London, 1993), pp. 189–252; Kenneth E. Silver, 'Modes of Disclosure: The Construction of Gay Identity and the Rise of Pop Art' in *Hand-Painted Pop: American Art in Transition, 1955–1962*, pp. 179–203; and Jonathan Weinberg, 'It's in the Can: Jasper Johns and the Anal Society', *Genders*, 1 (Spring 1988), pp. 40–56.

67 John Clark, Stuart Hall, Tony Jefferson and Brian Roberts, 'Subcultures, Cultures and Class' in *Resistance Through Rituals: Youth Subcultures in Post-War Britain*, ed. Stuart Hall and Tony Jefferson (London, 1976), p. 47.

68 See, for example, Richard M. Fried, *Nightmare in Red: The McCarthy Era in Perspective* (Oxford, 1990), pp. 167–8, and Stephen J. Whitfield, *The Culture of the Cold War* (London, 1991), pp. 43–5.

69 Leo Steinberg, 'Jasper Johns: The First Seven Years of His Art', *Other Criteria*, p. 37.

70 Alan R. Solomon, 'Jasper Johns', *Jasper Johns* (New York, 1964), p. 8; (London, 1964), p. 9. See also Jonathan Katz, 'The Art of Code: Jasper Johns and Robert Rauschenberg', *Significant Others*, p. 200: 'Is it a flag or is it a painting of a flag? Whatever the answer, it has nothing to do with the artist's sense of self.'

71 John Cage, 'Jasper Johns: Stories and Ideas', *Jasper Johns*, exh. cat.; The Jewish Museum, New York (1964), p. 22; Whitechapel Gallery, London (1964), p. 29.

72 Michael Crichton, *Jasper Johns*, p. 13.

73 Roberta Bernstein, *Jasper Johns' Paintings and Sculptures 1954–1974*, p. 226 n. 1, recalls that 'In 1970, when Johns was arranging a chronological list of his works, he commented, "the mood changes," when he got to 1961. . . .'

74 Leo Steinberg, 'Jasper Johns: The First Seven Years of His Art', *Other Criteria*, p. 53.

75 Ibid., p. 51.

76 For Rudolph Burckhardt's photograph of *No* before Johns reworked it, see Leo Steinberg, *Jasper Johns* (New York, 1963), p. 41.

77 Johns went to Paris for an exhibition of his work at the Galerie Rive Droite, 13 June–13 July, the gallery which in the same year produced an edition of Duchamp's *Female Fig Leaf* – Johns's cast is one of eight.

78 Michael Crichton, *Jasper Johns*, p. 54.

79 Ibid., p. 48.

80 Jasper Johns, 'Sketch Book Notes', *Art and Literature*, 4 (Spring 1965), p. 185; reprinted in *Pop Art Redefined*, ed. John Russell and Suzi Gablik (London, 1969), p. 84: 'Dish with photo & color names. Japanese phonetic "NO" (possessive "of") stencilled behind plate? Determine painting size from plate size – objects should be loose in space.' The note relates to *Souvenir* (private collection) and *Souvenir 2* (collection of Mrs Victor W. Ganz) of 1964 that use plates Johns acquired during a visit to Toyko that year. The plates are decorated with the names of the primary colours and a passport-style photograph of Johns. Richard S. Field, *Jasper Johns: Prints 1970–1977*, p. 36, connects *No* to *Souvenir* in this way: 'Uncertainty operates with regard to content as well as form. The painting and print NO have given rise to several discussions about the nature of multiple meanings and mutually excluding denials. In the painting *No*, for example, how are we to read the imprint of

Duchamp's *Female Fig Leaf*? In the painting *Souvenir 1*, how are we to interpret the hidden "NO" Johns painted behind the plate?'

81 Richard S. Field, *Jasper Johns: Prints 1960–1970*, exh. cat.; Philadelphia Museum of Art (1970).

82 Roberta Bernstein, *Jasper Johns' Paintings and Sculptures 1954–1974*, p. 77.

83 John Cage, 'Jasper Johns: Stories and Ideas', *Jasper Johns* (New York, 1964), p. 22; (London, 1964), p. 28.

84 Duchamp's *Première Lumière*, 1955, is illustrated in George H. Bauer, 'Duchamp's Ubiquitous Puns' in *Marcel Duchamp: Artist of the Century*, ed. Rudolf Kuenzli and Francis M. Naumann (Cambridge and London, 1989), p. 131. My guess is that Johns did not know this work – not in 1961.

85 Johns would have known Duchamp's *Musical Erratum* of 1913. It was illustrated and discussed in Robert Lebel's *Marcel Duchamp* (London, 1959), pp. 16, 58 and 165, and published as part of *The Bride Stripped Bare By Her Bachelors, Even: a typographic version by Richard Hamilton of Marcel Duchamp's 'Green Box' translated by George Heard Hamilton* (London, Bradford and New York, 1960). Johns reviewed the latter in *Scrap*, 1 (23 December 1960).

86 Anne d'Harnoncourt and Walter Hopps, *Etant donnés: 1° la chute d'eau 2° le gaz d' éclairage. Reflections on a New Work by Marcel Duchamp* (Philadelphia Museum of Art, 1973), p. 35.

87 See note 65 above. Rauschenberg also had a show in Paris that year, in April, at the Galerie Daniel Cordier. He then participated in the group exhibition *Les 41 présentent Iris Clert*, which opened 15 May at the Galerie Iris Clert and stayed around for Johns's show at the Galerie Rive Droite in June. He was instrumental in organizing a performance by David Tudor of John Cage's *Variations II* at the American Embassy Theatre on 20 June – an event that also involved Jean Tinguely, Niki de Saint-Phalle and Johns. For an account of Johns's and Rauschenberg's visit to Paris in the summer of 1961 and, on their return to New York, of the former's non-participation in the latter's performance *The Construction of Boston*, 5 May 1962, Maidman Playhouse, New York, as an indication that 'they were going in opposite artistic directions' and growing apart from each other, see Calvin Tomkins, *Off the Wall: Robert Rauschenberg and the Art World of Our Time*, pp. 190–97.

88 Frank O'Hara's 'In Memory of My Feelings' is dated 27 June–1 July 1956; it was first published in *Evergreen Review* (1958) and reprinted in *The New American Poetry: 1945–1960*, ed. Donald Allen (New York, 1960). See *The Collected Poems of Frank O'Hara*, ed. Donald Allen (New York, 1971), pp. 252–7.

89 Perloff, *Frank O'Hara: Poet Among Painters*, and Alan Feldman, *Frank O'Hara* (Boston, 1979) provided me with basic texts on O'Hara and his poetry. Feldman's discussion of 'queer talk' is crucial for reading and understanding O'Hara's poetry and seems useful – no more than that – for understanding something of Johns's mode of signification also. 'Queer talk' and Strauss's 'writing between the lines' are not that dissimilar in their causes and effects. See Feldman, p. 49: ' "queer talk" – a pattern of speech characteristic of certain homosexuals. Such speech, in some ways, is related to the "feminine" speech patterns of women. It suggests that the poet and the reader are joined in a private understanding of the world that is set apart from the ordinary public rhetoric of "straight" society. The poet is placing his poem "between the two of us," between himself and reader, creating a kind of gossipy intimacy, and a shared set of private values and truths that displace the false values of public speech.'

90 Perloff, *Frank O'Hara: Poet Among Painters*, p. 203 nn. 41 and 44.
91 'Joe's Jacket' (10 August 1959) in *The Collected Poems of Frank O'Hara*, pp. 329–30.
92 'What Appears To Be Yours' (13 December 1960) in *The Collected Poems of Frank O'Hara*, pp. 380–81.
93 'Dear Jap' (10 April 1963) in *The Collected Poems of Frank O'Hara*, pp. 470–71.
94 The intention was 'to make a portfolio of poems and images, but only one lithograph was accomplished'. See 'Jasper Johns', interview with Bryan Robertson and Tim Marlow, *Tate: The Art Magazine* (1993), p. 47; also note 104 below.
95 The idea of the 'hinge' comes into my text from Jacques Derrida, *Of Grammatology*, trans. Gayatri Chakravorty Spivak (Baltimore, 1974); see 'The Hinge [La Brisure]', pp. 65–73. For a useful gloss on 'the hinge', see Hugh J. Silverman's discussion of 'deconstructive indicators' in the writing of Jacques Derrida: 'Writing (on Deconstruction) at the Edge of Metaphysics', *Research in Phenomenology*, XIII (1984), p. 108. For more on how the title of a painting by Johns sometimes functions as a 'hinge' between the painting and another painting or text, linking the one to the other, bringing them together and at the same time separating them, see Fred Orton, 'On Being Bent "Blue" (Second State): An Introduction to Jacques Derrida/A Footnote on Jasper Johns', *Oxford Art Journal*, XII/1 (1989), pp. 37–8. Stephen Melville's idea of the 'hinge' – also developed from Derrida's work – is somewhat different, but not that different. See Stephen Melville, 'Notes on the Reemergence of Allegory, the Forgetting of Modernism, the Necessity of Rhetoric, and the Conditions of Publicity in Art and Criticism', *October*, 19 (1981), p. 81, where he sees and understands Cindy Sherman's mock film stills and Robert Longo's drawings and reliefs 'as exemplary presentations of "hinges" whose significance is neither simply present nor simply borne away into story, but is rather given (not here, not now) as an undecidable crossing of narratives – stories of death or dancing, histories of menace or aspiration.'
96 Perloff, *Frank O'Hara: Poet Among Painters*, p. 141.
97 Ibid., p. 141.
98 Ibid.
99 Ibid., pp. 141–6, and Feldman, *Frank O'Hara*, pp. 91–7.
100 Feldman, *Frank O'Hara*, p. 92.
101 Perloff, *Frank O'Hara: Poet Among Painters*, p. 142, and Feldman, *Frank O'Hara*, p. 92.
102 Feldman, *Frank O'Hara*, p. 97.
103 Sketchbook note quoted in John Cage's 'Jasper Johns; Stories and Ideas', *Jasper Johns* (New York, 1964), p. 26; (London, 1964), p. 35.
104 Perloff, *Frank O'Hara: Poet Among Painters*, p. 167. O'Hara also offered Johns 'Poem (The Cambodian Grass is Crushed)' (17 June 1963) and 'Bathroom' (20 June 1963); see *The Collected Poems of Frank O'Hara*, pp. 555–6. James Cuno, 'Voices and Mirrors/Echoes and Allusions: Johns's "Untitled", 1972', *Foirades/Fizzles: Echo and Allusion in the Art of Jasper Johns*, p. 232 n. 42, pointed out that the coming together of poem and print was prompted by 'Francine du Plessix who edited an anthology of artists' responses to poems for an issue of *Art in America*. Du Plessix had written to twenty-two American painters during the winter of 1964 asking them to make a work in response to a contemporary poem of their choice. Three New York painters chose Frank O'Hara but Johns was the first to reply (not just with the choice of O'Hara but the first to reply to the project at all – a sign of his interest in poetry) and so got his choice.' See *Art in America* (October–November 1965), p. 24.

105 Perloff, *Frank O'Hara: Poet Among Painters*, p. 167.

106 Ibid.

107 Roberta Bernstein, *Jasper Johns' Paintings and Sculptures 1954–1974*, pp. 78–9, relates *Painting Bitten By a Man* (private collection) to *No*, *Liar*, and *Water Freezes* (private collection), and p. 80, by way of a sketchbook note that ' "looking" is and is not "eating" and "being eaten" ' to *In Memory of My Feelings – Frank O'Hara* and *The Critic Sees*. Bernstein illustrates *Painting Bitten By a Man* as pl. 31.

108 *'In Memory of My Feelings': A Selection of Poems by Frank O'Hara*, ed. Bill Berkson (New York: Museum of Modern Art, 1967), a commemorative volume of O'Hara's poetry illustrated by thirty American artists.

109 Perloff, *Frank O'Hara: Poet Among Painters*, p. 215 n. 23.

110 Riva Castleman, *Jasper Johns: A Print Retrospective*, exh. cat.; Museum of Modern Art, New York (1986), p. 24, has suggested that Johns concluded *Voice*, 1966–7, (private collection) by suspending a fork and spoon at its right side in memory of Frank O'Hara. For more thoughts on Johns's use of cutlery, see James Cuno, 'Jasper Johns', review of *Jasper Johns: A Print Retrospective* by Riva Castleman, *Print Quarterly*, IV (1987), pp. 91–2, and James Cuno 'Voices and Mirrors/Echoes and Allusions: Jasper Johns "Untitled", 1972', pp. 220–21.

111 Bernstein, *Jasper Johns' Paintings and Sculptures 1954–1974*, p. 84.

112 Ibid., pp. 84–5.

113 Johns cited by Jill Johnston, 'Tracking the Shadow', *Art in America* (October 1987), p. 132. A journalistic and curatorial industry concerned to identify and catalogue the component parts of *The Seasons* has burgeoned since they were first shown at the Leo Castelli Gallery, New York, 31 January–7 March 1987, accompanied by Judith Goldman's catalogue essay; see, for example: Barbara Rose, 'Jasper Johns – The Seasons', *Vogue* (January 1987), pp. 192–9, 259–60; Jill Johnston, 'Tracking the Shadow', *Art in America* (October 1987), pp. 129–43; Mark Rosenthal, *Jasper Johns: Work Since 1974* (London, 1974), pp. 89–103; and James Cuno, 'The Seasons' in *Jasper Johns: Printed Symbols*, exh. cat.; Walker Art Centre, Minneapolis (1990), pp. 77–89.

114 Calvin Tomkins, *Off the Wall: Robert Rauschenberg and the Art World of Our Time*, pp. 197–8.

115 Perloff, *Frank O'Hara: Poet Among Painters*, p. 210 n. 5.

116 Ibid., p. 162, and Feldman, *Frank O'Hara*, p. 82.

117 Hart Crane, 'Voyages V', *Complete Poems*, (1933; revd edn Newcastle upon Tyne, 1984), p. 58.

118 'Interview with Jasper Johns' in Christian Geelhaar, *Jasper Johns: Working Proofs*, p. 52.

119 D.R. Rickborn, 'Art's Fair-Haired Boy. Allendale's Jasper Johns Wins Fame With Flags', *The State Magazine* [Columbia, South Carolina] (15 January 1961), p. 21.

120 Alan R. Solomon, 'Jasper Johns', *Jasper Johns* (New York, 1964) p. 16; (London, 1964) p. 21. For Hart Crane's 'Cape Hatteras', see Part IV of 'The Bridge' (1930) in *Complete Poems*, pp. 85–91.

121 Alan R. Solomon, 'Jasper Johns', *Jasper Johns* (New York, 1964), p. 16; (London, 1964, p. 21.

122 For Hart Crane's 'Passage', see *Complete Poems*, pp. 43–4.

123 For a sampling of readings see: Philip Horton, *Hart Crane: Life of an American Poet* (New York, 1937); Brom Weber, *Hart Crane: A Biographical and Critical Study* (New York, 1948); Vincent Quinn, *Hart Crane* (New York, 1963); R.W.B. Lewis, *The Poetry of Hart Crane: A Critical Study* (Princeton, 1967); R.W. Butterfield, *The Broken Arc: A Study of Hart Crane* (Edinburgh, 1969); M.D. Uroff, *Hart Crane: The Pattern of His Poetry* (Urbana, Chicago and London, 1974); *Hart Crane. A Collection of*

Critical Essays, ed. Alan Trachtenberg (Englewood Cliffs, NJ, 1982); and
Thomas E. Yingling, *Hart Crane and the Homosexual Text: New
Thresholds, New Anatomies* (London, 1984).

124 Yingling, *Hart Crane and the Homosexual Text*, p. 129.

125 On 'Passage' as an instance of homosexual autobiography see
Yingling, *Hart Crane and the Homosexual Text*, pp. 124–30.

126 Richard Francis, *Jasper Johns*, p. 98.

127 Rosalind Krauss, 'Jasper Johns: The Functions of Irony', *October*, 2
(Summer 1976), pp. 91–9, and Charles Harrison and Fred Orton,
'Jasper Johns: "Meaning What You See" ', *Art History*, vii/1 (1984),
pp. 83–5, 88, 92.

128 Philip Leider, 'Abstraction and Literalism: Reflections on Stella at the
Modern', *Artforum* (April 1970), p. 44.

129 Though it is done elegantly and inventively, I remain unconvinced by
James Cuno's argument that 'Johns began to work out his relation to
Pollock in the "sea" pictures of the period 1961 to 1963.' See James
Cuno, 'Voices and Mirrors/Echoes and Allusions: Jasper Johns
"Untitled", 1972', pp. 221–5.

130 David Bourden, 'Jasper Johns: "I Never Sensed Myself as Being
Static" ', *Village Voice*, (31 October 1977), p. 75.

131 Frank O'Hara, *Jackson Pollock* (New York, 1959), p. 116.

132 'Once I asked Jackson why he didn't stop painting when a given image
was exposed. He said, "I choose to veil the imagery." ' Lee Krasner
quoted in 'An Interview with Lee Krasner' by B.H. Friedman, *Jackson
Pollock*, exh. cat.; Marlborough-Gerson Gallery, New York (1969).

133 Jasper Johns, 'Sketch Book Notes', *0 to 9* (July 1969), p. 2, reprinted in
Richard Francis, *Jasper Johns*, p. 112.

134 Picasso's *Women of Algiers (Femmes d'Alger)* was the subject of a long
essay by Leo Steinberg, 'The Algerian Women and Picasso at Large',
first published in *Other Criteria*, pp. 125–234.

135 Mark Rosenthal, *Jasper Johns: Works Since 1974*, p. 27.

136 Ibid.

137 For Johns's comments on the way he took 'the same (formal) attitude'
toward all four panels see Roberta J.M. Oslon, 'Jasper Johns: Getting
Rid of Ideas', *SoHo Weekly News* (3 November 1977), pp. 24–5, cited in
Riva Castleman, *Jasper Johns: A Print Retrospective*, pp. 31–2.

138 Roberta Bernstein, 'An Interview with Jasper Johns', *Fragments:
Incompletion and Discontinuity*, p. 288.

139 Roberta Bernstein, *Jasper Johns' Paintings and Sculptures 1954–1974*,
p. 228 n. 2. Johns's interest in Magritte's work seems to date from
March 1954 when he saw the exhibition 'Magritte: Word vs. Image' at
the Sidney Janis Gallery, New York; see Bernstein, *Jasper Johns'
Paintings and Sculptures*, p. 4, and 'An Interview with Jasper Johns',
Fragments: Incompletion and Discontinuity, p. 287.

140 Harrison and Orton, 'Jasper Johns: "Meaning What You See" ',
pp. 97–8.

141 Roberta Bernstein makes this comparison with Magritte's *The Literal
Meaning* and the point that, because it was in the collection of
Rauschenberg, it would have been familiar to Johns first-hand; see
Bernstein, *Jasper Johns' Paintings and Sculptures*, p. 129.

142 Nelson Goodman, 'Seven Strictures on Similarity', *Problems and Projects*
(Indianapolis, 1972), pp. 437–46, reprinted in Harrison and Orton,
Modernism, Criticism, Realism, pp. 86–92. Goodman points out that
'similarity' has its place and uses, but it is usually found where it
doesn't belong, professing powers it doesn't possess. In art history the
identification of 'similarity' or resemblance is usually a premature
closure on enquiry and explanation.

143 Here I am thinking of Jacques Derrida's way of writing *sous rature* and the strategic undecidability it effects. Derrida is interested in placing words *sous rature*, writing them and crossing them through, because Martin Heidegger had crossed out 'Being' in *'Zur Seinsfrage'*. Heidegger was writing about the difference between 'Being' and 'beings'. However, writing is not thematized in his texts. Though he appeals to 'speaking' or 'calling' and 'hearing', writing is not a special thing for him. Heidegger just writes. But writing 'Being' is problematic. 'Being' cannot be a concept or a word. So in order to say 'Being' – which can't be said – in writing, Heidegger writes it and then crosses it out. He engimatizes it: ~~Sein~~. Derrida adapts this strategy as a way of moving beyond the Heideggerian 'in between'. See Hugh J. Silverman, *Inscriptions Between Phenomenology and Structuralism* (London, 1987), pp. 56–62, 283. Writing *sous rature* is Derrida's way of operating according to the vocabulary of the thing he is delimiting. The crossing-out marks the inadequacy of the terms he uses and the fact that he cannot manage without them; it marks their untenability and their for-the-moment-at-least necessity. Johns does something that looks like writing and painting *sous rature*. He has written and crossed-out his signature on several prints made in the early 1970s, see for example, the lithograph *Hinged Canvas* (published by Gemini G.E.L., 1971) and the silkscreen print *Untitled (Skull)* of 1973, and painted surfaces or bits of surfaces and then crossed them out; see for example *Corpse and Mirror* of 1974 (Collection of Mrs Victor W. Ganz). I think it is possible to see when Johns is painting *sous rature* even when he is not marking the place with a crossing-out; he might be adding to the surface by painting over it or by scribbling on it, but these incidents seem never to signify changing his mind, never to negate something completely. Like Heidegger and Derrida, Johns uses the only available language for making advanced art while not subscribing to its conceptual and practical premises. Crossing-out and painting *sous rature* mark the attempt to break with that which has the power not to be broken with. Derrida's strategy of writing *sous rature* is discussed by Gayatri Chakravorty Spivak in her 'Translator's Preface' to *Of Grammatology*, (Baltimore, 1974), pp. xii–xx. For more on Johns's use of the crossed-out signature and painting *sous rature*, see Fred Orton, 'On ~~Being~~ Bent "Blue" (Second State): An Introduction to Jacques Derrida/A Footnote on Jasper Johns', *Oxford Art Journal* xii/1 (1989), pp. 39–41 and p. 45 nn. 23, 24, 25 and 26.

2 *A Different Kind of Beginning*

1 Emile de Antonio and Maurice Tuchman, *Painters Painting* (New York, 1984), based on transcripts from the film *Painters Painting* made by Emile de Antonio in 1972, p. 99.
2 Ibid.
3 The literature on the United States flag is enormous. Three books I have found useful are: William Rea Furlong and Byron McCandless, assisted by Harold D. Langley, *So Proudly We Hail: The History of the United States Flag* (Washington, D.C., 1981); Whitney Smith, *The Flag Book of the United States* (New York, 1970); and Milo M. Quaife, Melvin J. Weig and Roy E. Appleman, *The History of the United States Flag From the Revolution to the Present, Including a Guide to its Use and Display* (New York and Evanston, 1961).
4 Smith, *The Flag Book of the United States*, p. 74.
5 Ibid., p. 75.
6 Ibid.

7 President William. H. Taft, Executive Order No. 1556, 24 June 1912 and Taft, Executive Order No. 1637, 29 October 1912. See also, President Woodrow Wilson, Executive Order No. 2390, 29 May 1916.

8 Furlong and McCandless, *So Proudly We Hail*, p. 213.

9 Smith, *The Flag Book of the United States*, p. 79.

10 *United States Statues at Large*, LXI, p. 642, ch. 389, 1947, 'Use of flag for advertising purposes; mutilation of flag'. See also the story of the 'Living Flag' in Garrison Keillor's *Lake Wobegon Days* (London, 1985), pp. 98–100, which, by the time the Sons of Knute took it over in 1950, needed 400 persons to make a good one.

11 *World Book Encyclopaedia*, F (Chicago, 1990), pp. 222–3.

12 Smith, *The Flag Book of the United States*, p. 80.

13 Ibid. Public Law 829 – 77th Congress, Chapter 806 – 2nd. Session, H.J. Res. 359, approved 22 December 1942, which amended Public Law 623, 'Joint resolution to codify and emphasise exiting rules and customs pertaining to the display and use of the flag of the United States of America.' See also *World Book Encyclopaedia*, F (1990), pp. 213–17.

14 As far as the Museum of Modern Art, New York, is concerned *Flag* is to be dated 1954–5. However, the checklist of the 'Permanent Collection' (1989) notes that it is dated on the reverse '1954'. In *Jasper Johns*, the catalogue of the retrospective exhibition organized by Alan R. Solomon for The Jewish Museum, New York, 1964, it is dated '1955'. That is also the date given in the catalogue of the retrospective organized by the Whitney Museum of American Art, New York, 1977. Leo Steinberg in *Jasper Johns* (New York, 1963) illustrated *Flag above White* and dated it '1954'. Max Kozloff, *Jasper Johns* (New York, 1969) dated *Flag* to 1954. Roberta Bernstein, *Jasper Johns' Paintings and Sculptures 1954–1974: 'The Changing Focus of the Eye'* (Ann Arbor, 1985), who had access to Johns's chronological listing of his works, dated it '1954–1955' but placed it at the head of those works made in 1955. Rachel Rosenthal, in conversation with the author, 9 June 1992, recollected that it was begun and completed entirely in 1955. These discrepancies of chronology do not cause me any anguish. In my history, *Flag* is understood as a work produced neither in 1954 nor 1955 but in both 1954 and 1955 – and then repaired/resumed in 1956 (see Joan Carpenter, 'The Infra-Iconography of Jasper Johns', *Art Journal* (Spring 1977), p. 224).

15 See Irving Sandler, *The New York School: The Painters and Sculptors of the Fifties* (London, 1978), pp. 282–3 and p. 288 n. 22. For the date of the Club panel 'Has the Situation Changed?', see Sandler, p. 212 n. 19.

16 See, for example, Stuart Preston, 'To Help Our Art. Council Will Circulate Exhibitions Abroad', *The New York Times*, x (30 December 1956), p. 15. See also Russell Lynes, *Good Old Modern: An Intimate Portrait of the Museum of Modern Art* (New York, 1973), p. 384, and Eva Cockcroft, 'Abstract Expressionism, Weapon of the Cold War', *Artforum* (June 1974), pp. 39–41.

17 It is often overlooked that Alfred H. Barr Jr was the first person to write about Abstract Expressionism as the 'triumph' of American painting. See the last paragraph of his 'Introduction' to *The New American Painting*, exh. cat.; Museum of Modern Art, New York (1959; Arno Reprint, 1972), p. 19: 'To have written a few words of introduction to this exhibition is an honour for an American who has watched with deep excitement and pride the development of the artists here represented, their long struggle – with themselves even more than with their public – and their present triumph.'

18 For a useful but all too-brief glimpse of Barr's attitude to Abstract

Expressionism, see Helaine Ruth Messer, *MOMA: Museum in Search of an Image*, unpublished PhD diss., Columbia University, New York, 1979, pp. 286–9 and 293–4. In Emile de Antonio and Maurice Tuchman, *Painters Painting*, p. 101, Leo Castelli makes the comment that Barr 'never liked Abstract Expressionism'.

19 Helaine Ruth Messer, *MOMA: Museum in Search of an Image*, p. 291, citing the Museum of Modern Art, Minutes of the Committee on Museum Collections, 19 February 1958, pp. 3–4.

20 Ibid.

21 See the fragment of Alfred H. Barr Jr's letter to Jasper Johns published in Michael Crichton, *Jasper Johns* (New York, 1977), pp. 67–8; *The Museum of Modern Art Bulletin* XXVI/4 (July 1959), 'Painting and Sculpture Acquisitions. 1 January 1958–31 December 1958'; and Ben Heller, 'Jasper Johns' in *School of New York: Some Younger Painters*, ed. B.H. Friedman (London, 1959), p. 30.

22 Russel Lynes, *Good Old Modern: An Intimate Portrait of the Museum of Modern Art*, p. 299, and Messer, *MOMA: Museum in Search of an Image*, p. 292.

23 Messer, *MOMA: Museum in Search of an Image*, p. 292.

24 Ibid. See also Museum of Modern Art, Jasper Johns' file, the letter from George Heard Hamilton to Philip Johnson, 23 February 1973, on receiving the gift of *Flag* in honour of Alfred H. Barr Jr: 'It is hard to imagine that such a mood could have existed only fifteen years ago, but that is what the minutes of the time reveal. I must say we owe you a great debt of gratitude, and I send you my thanks, on behalf of the other Trustees (even those who once voted against the Johns) for this marvellous gift.'

25 Messer, *MOMA: Museum in Search of an Image*, pp. 291 and 292 n. 1.

26 Samuel Beckett, *'Waiting for Godot'* in *The Complete Dramatic Works* (London, 1986), p. 59.

27 Alan R. Solomon, 'Jasper Johns', *Jasper Johns*, exh. cat.; The Jewish Museum, New York (1964), p. 6; Whitechapel Gallery, London (1964), p. 7. Solomon overlooks the fact that Johns had exhibited *Construction with Toy Piano*, 1954, in the 'Third Annual' invitation show at the Tanager Gallery, New York, January 1955; Fairfield Porter commented on it in his review 'Third Annual', *Art News* (January 1955), p. 48. It is worth recalling that a small encaustic *Flag* was exhibited in the Stable Gallery, New York, April–May 1955, as part of Robert Rauschenberg's combine-painting *Short Circuit*; see *Robert Rauschenberg*, exh. cat.; National Collection of Fine Arts, Smithsonian Institution (Washington, D.C., 1976), p. 85, where *Short Circuit* is illustrated and discussed. A *Flag* (with sixty-four stars) drawing was also exhibited in 'Group Drawings' at the Poindexter Gallery, New York, 19 December–4 January 1956 – the show attracted little or no critical comment – see Nan Rosenthal, Ruth E. Fine with Marla Prather and Amy Mizrahi Zorn, *The Drawings of Jasper Johns*, exh. cat.; National Gallery of Art, Washington, D.C. (1990), no. 5, pp. 94–5.

28 Edward W. Said's *Beginnings: Intention and Method*, (New York, 1975) is an indispensable resource for anyone concerned with the problems of beginnings. I have used it here, especially ch. One, 'Beginning Ideas', and ch. Two, 'A Meditation on Beginnings'.

29 Walter Hopps, 'An Interview with Jasper Johns, *Artforum* (March 1965), p. 33. See also Leo Steinberg, *Jasper Johns*, New York: Wittenborn (New York, 1963), p. 8, and 'Jasper Johns: The First Seven Years of His Art' in *Other Criteria: Confrontations with Twentieth-century Art* (Oxford, 1972), p. 21, where he seems to quote Johns as saying 'he was no longer "going to be a painter," the time having come to start being one'.

30 Michael Crichton, *Jasper Johns*, p. 26: 'One day in 1954, Jasper Johns, then twenty-four, methodically destroyed all the work in his possession. This was the first of several acts of self-destruction by an artist who would eventually be known for his skill and daring at rebuilding his past.' See also Johns quoted by Mark Stevens and Cathleen McGuigan, 'Super Artist: Jasper Johns, Today's Master', *Newsweek* (24 October 1977), p. 42: 'It was an attempt to destroy some idea about myself . . . It gets to sound very religious, which I don't like, but it's true.'

31 Though the surviving fragment of *Cross* is, indeed, very small, it is a fascinating fragment. Rachel Rosenthal, in conversation with the author, 9 June 1992, recalled that *Cross* 'was built of wood, and then had collage. The wood . . . was like a frame; and the frame was . . . thick and the collage was at the bottom, and the wood came up from that; and then that was covered with glass; and it was an object.'

32 Stevens and McGuigan, 'Super Artist: Jasper Johns, Today's Master', *Newsweek*, p. 42.

33 Alan R. Solomon, 'Jasper Johns', *Jasper Johns* (New York, 1964), p. 6; (London, 1964), p. 7.

34 Peter Fuller, 'Jasper Johns Interviewed', Part I, *Art Monthly* (July–August 1978), p. 10.

35 Johns quoted in 'Art. Trend to the "Anti-Art" ', *Newsweek* (31 March 1958), p. 96: 'I have no ideas about what the paintings imply about the world . . . I don't think that's a painter's business. He just paints paintings without a conscious reason. I intuitively like to paint flags.'

36 See note 33 above.

37 Leo Steinberg, 'Jasper Johns: The First Seven Years of His Art', *Other Criteria*, p. 31; Walter Hopps, 'An Interview with Jasper Johns', *Artforum* (March 1965), p. 34; and Michael Crichton, *Jasper Johns*, p. 28.

38 Calvin Tomkins, *Off the Wall: Robert Rauschenberg and the Art World of Our Time* (New York, 1980), p. 177, mentions Rachel Rosenthal, who, in conversation with the author, 9 June 1992, did not remember Johns telling her about his dream though she did recall that 'Johns was very much into dreams, and he wrote poetry about his dreams.' Rauschenberg is mentioned by Deborah Solomon, 'The Unflagging Artistry of Jasper Johns', *The New York Times Magazine* (19 June 1988), p. 63.

39 See note 33 above.

40 Johns interviewed in Alan R. Solomon, director, and Lane Slate, producer, *U.S.A. Artists 8: Jasper Johns* (1966) quoted in Riva Castleman, *Jasper Johns: A Print Retrospective*, exh. cat.; Museum of Modern Art, New York, (1986), p. 28.

41 Emil de Antonio and Maurice Tuchman, *Painters Painting*, p. 97.

42 See Deborah Solomon, 'The Unflagging Artistry of Jasper Johns', *The New York Times Magazine* (19 June 1988), p. 63.

43 Moira Roth, 'The Aesthetic of Indifference', *Artforum* (November 1977), p. 49.

44 On Joe McCarthy's demise see, for example, Thomas C. Reeves, *The Life and Times of Joe McCarthy* (New York, 1982), ch. 22, 'Point of Order', pp. 595–637.

45 See 'President Heralds Flag Day', *The New York Times* (4 June 1954), p. 25.

46 See 'President Hails Revised Pledge', *The New York Times* (15 June 1954), p. 31. For an account of how the pledge of 1892 came to have 'under God' added to it to serve the needs of Cold War ideology see Paul A. Carter, *Another Part of the Fifties*, (New York, 1983), ch. 5, 'Under God, by Act of Congress', pp. 114–39.

47 See *The New York Times* (10 June 1954), p. 25.
48 See 'Flag Display is Urged – Wagner Calls for Observance of Tomorrow's Holiday', *The New York Times* (13 June 1954), p. 15.
49 Ibid.
50 David Eggenberger. 'Flag Day Fancy and Fact', *The New York Times* (13 June 1954), section 6, p. 37.
51 'The Discipline of the Flag', *The New York Times* (14 June 1954), p. 20.
52 Ibid.
53 Ibid.
54 See 'Iwo Jima Memorial is Dedicated', *The New York Times* (11 November 1954), p. 31.
55 Italo Calvino, translated by William Weaver, *Invisible Cities* (London, 1979), p. 36.
56 Michael Crichton, *Jasper Johns*, p. 67 n. 34. It was Charles F. Stuckey who first brought Sergeant William Jasper into the literature on 'Jasper Johns'; see his letter 'Johns: Yet Waving?', *Art in America* (May–June 1976), p. 5.
57 Paul Taylor, 'Jasper Johns', *Interview* (July 1990), pp. 96–101 and 122–3.
58 Ibid., p. 96.
59 On Sergeant William Jasper's bravery at Fort Sullivan in 1776, see the letter from Major B. Elliott to Mrs Elliott, 29 June 1776, and the 'Account of the Attack on Fort Moultrie' in *The South Carolina and American General Gazette* (2 August 1776) included in *Documentary History of the American Revolution* (Arno Reprint, 1971). On his actions at Charleston and Savannah in 1777, see Eva March Tappan, *The Little Book of the Flag* (Cambridge, MA: Riverside Press, 1917), pp. 22–4. See also the *Dictionary of American Biography*, x (New York, 1933), p. 1. Emmanuel Leutze's painting, *Sergeant Jasper Rescuing the Flag on Fort Moultrie*, mentioned by Michael Crichton, *Jasper Johns*, p. 67 n. 34, was destroyed with the contents of the Charleston Gallery, Charleston, during the Civil War. There is a Currier & Ives print of Sergeant Jasper in action at Charleston.
60 Charles C[ullock] Jones Jr, 'Sergeant William Jasper', *Magazine of History and Queries*, VIII (1908), pp. 262–8, 351–5, and IX (1909), pp. 153–8, 216–20.
61 Ibid., VIII, pp. 354–5.
62 Ibid., IX, p. 219.
63 The 'Moultrie Flag' is illustrated in 'Flags in American History', *World Book Encyclopaedia*, F (1990), p. 206.
64 John Cage, 'Jasper Johns: Stories and Ideas', *Jasper Johns* (New York, 1964), p. 23; (London, 1964), p. 30.
65 Peter Fuller, 'Jasper Johns Interviewed', Part II, *Art Monthly* (September–October 1978), p. 7.
66 Here are three of those stories about childhood. (i) 'As a young child living in his grandfather's house, he remembers being dressed in the kitchen, by the cook, in a new white linen suit. He didn't want to wear it, and threw off the suit, which landed on a skillet of hot grease on the stove. His grandfather came in and began throwing him in the air, catching him, and spanking him as he fell. He was terrified.' (Michael Crichton, *Jasper Johns*, p. 20.) (ii) 'He lived with his grandfather, but his father lived in the same town and Johns saw him intermittently. Once his father promised him his watch when he was grown up. Soon after, Johns decided that he was grown up; he went to his father's house and took the watch. His father came and took it back. "I guess I wasn't grown up, after all." ' (Crichton, *Jasper Johns*, pp. 20–21.) (iii) 'Asked why he lived with father's sister as opposed to his father, Johns sits quietly before replying. "He didn't invite me," he finally says,

erupting with laughter.' (Deborah Solomon, 'The Unflagging Artistry of Jasper Johns', *The New York Times Magazine*, 19 June 1988, p. 23).

67 'Interview with David Sylvester' in *Jasper Johns Drawings*, exh. cat.; The Arts Council of Great Britain (London, 1974), pp. 13–14.

68 Emile de Antonio and Maurice Tuchman, *Painters Painting*, p. 97.

69 Ibid.

70 Leo Steinberg, 'Jasper Johns: The First Seven Years of His Art', *Other Criteria*, p. 44.

71 John Yau, 'Famous Paintings seen and not looked at, not examined' in *Hand-Painted Pop: American Art in Transition, 1955–62*, exh. cat.; Museum of Contemporary Art, Los Angeles (1993), p. 133, tells us that 'in the list of paintings accompanying his [Johns'] first exhibition *Flag* is listed as being in "encaustic and collage on fabric" '. The Museum of Modern Art's description is 'encaustic, oil and collage on fabric mounted on plywood'. *Flag* got its plywood support when it travelled to the Venice Biennale in 1958.

72 James Ayres, *The Artist's Craft. A History of Tools, Techniques and Materials* (Oxford, 1985), p. 78.

73 See Ayres, *The Artist's Craft*, pp. 95–8, for a brief history of encaustic painting.

74 This discussion of collage, 'depicted' and 'literal flatness' derives from Clement Greenberg's essay of 1958, 'The Pasted-Paper Revolution', revised and published as 'Collage' in the 1961 anthology *Art and Culture: Critical Essays* (Boston, 1965), pp. 70–83.

75 Max Kozloff, *Jasper Johns*, p. 16.

76 Ibid.

77 Ben Heller, 'Jasper Johns', *School of New York: Some Younger Artists*, p. 34.

78 Jasper Johns [Statement], *Sixteen Americans*, exh. cat.; Museum of Modern Art, New York (1959), p. 22: 'At every point in nature there is something to see. My work contains similar possibilities for the changing focus of the eye.'

79 For a useful discussion of Cézanne as one of Johns' 'teachers', see Roberta Bernstein, *Jasper Johns' Paintings and Sculptures 1954–1974*, pp. 68–74. Johns' interest in Cézanne's work seems to date from April–May 1952 when he saw *Cézanne: Paintings, Watercolours and Drawings* at the Metropolitan Museum of Art, New York; see Roberta Bernstein, *Jasper Johns' Paintings and Sculptures 1954–1974*, pp. 68 and 225, n. 27.

80 Richard Shiff, 'Constructing Physicality', *Art Journal* (Spring 1991), pp. 42–47, esp. pp. 43 and 47.

81 Ibid., p. 43. For more of Richard Shiff's writing on 'touch', see 'Performing an Appearance: On the Surface of Abstract Expressionism' in *Abstract Expressionism: The Critical Developments*, ed. Michael Auping (New York, 1987), pp. 94–123; 'Picasso's Touch: Collage, Papier Collé. "Ace of Clubs" ', *Yale University Art Gallery Bulletin* (1990), pp. 38–47; and 'Cézanne's Physicality: The Politics of Touch' in *The Languages of Art History*, ed. Salim Kalim and Ivan Gaskell (Cambridge, 1991), pp. 129–80.

82 Robert Rosenblum, 'Jasper Johns', *Arts* (January 1958), p. 53.

83 Robert Rosenblum, 'Jasper Johns', *Art International* (September 1960), p. 77.

84 Ben Heller, 'Jasper Johns', *School of New York: Some Younger Artists*, p. 34.

85 Ibid.

86 William Rubin, 'Younger American Painters', *Art International* (January 1960), p. 26.

87 Leo Steinberg, *Jasper Johns* (New York, 1963), p. 12. Steinberg changed

the 'young woman' into a 'woman' for the rewritten version published as 'Jasper Johns: The First Seven Years of His Art', *Other Criteria*, p. 28.

88 Max Kozloff, 'Jasper Johns', *The Nation* (16 March 1964) reprinted in Max Kozloff, *Renderings: Critical Essays on a Century of Modern Art*, (New York, 1968), pp. 206–11; see p. 209.

89 Max Kozloff, *Jasper Johns*, p. 17.

90 T.J. Clark, 'Jackson Pollock's Abstraction' in *Reconstructing Modernism: Art in New York, Paris and Montreal 1945–1964*, ed. Serge Guilbaut (London, 1990), p. 229.

91 Robert Rosenblum, 'Jasper Johns', *Arts* (January 1958), p. 53.

92 Robert Rosenblum, 'Jasper Johns', *Art International* (September 1960), p. 75.

93 Ibid.

94 Ben Heller, 'Jasper Johns', *School of New York: Some Younger Artists*, p. 30.

95 William Rubin, 'Younger American Painters', *Art International*, January 1960, p. 26.

96 Ibid.

97 Ibid.

98 Ibid.

99 Clement Greenberg, 'After Abstract Expressionism', *Art International* (October 1962), p. 25.

100 Michael Fried, 'New York Letter', *Art International* (February 1964), p. 60.

101 Ibid.

102 John Cage, 'Jasper Johns: Stories and Ideas', *Jasper Johns* (New York, 1964), p. 25; (London, 1964), p. 34.

103 Ibid.

104 Alan R. Solomon, 'Jasper Johns', *Jasper Johns* (New York, 1964), pp. 6–7; (London, 1964), p. 7).

105 Ibid. (New York, 1964), p. 6; (London, 1964), pp. 7–8.

106 Ibid. (New York, 1964), p. 9; (London, 1964), p. 10 and p. 11.

107 Harold Rosenberg, 'Jasper Johns: "Things the Mind Already Knows" ', *Vogue* (February 1964), reprinted in Harold Rosenberg, *The Anxious Object* (London, 1966, Phoenix edn, 1982), p. 179.

108 Ibid.

109 Max Kozloff, 'Jasper Johns' (1964), *Renderings: Critical Essays on a Century of Modern Art*, p. 209.

110 The first person to pay attention to *Flag*'s textual matter seems to have been Joan Carpenter, 'The Infra-Iconography of Jasper Johns', *Art Journal* (Spring 1977), pp. 221–7. Roberta Bernstein calls our attention to it but only as something 'interesting' and 'perhaps coincidental'; see *Jasper Johns' Paintings and Sculptures 1954–1974*, pp. 3–4. See also John Yau, 'Famous Paintings seen and not looked at, not examined' in *Hand-Painted Pop: American Art in Transition 1955–62*, pp. 142–3.

111 *Daily News* (Wednesday, 15 February 1956), p. c18, and Joan Carpenter, 'The Infra-Iconography of Jasper Johns', p. 224.

112 *Daily News* (Wednesday, 15 February 1956), p. c18.

113 Ibid., p. c12.

114 Ibid., p. c16.

115 Rodgers and Hammerstein's *Pipe Dream*, based on John Steinbeck's novel *Sweet Thursday*, had the biggest advance in Broadway history and was the least successful of all their musicals. See Blake Green, 'The Canon', *Fan Fare* (21 March 1993), p. 17. John Yau, 'Famous Paintings seen and not looked at, not examined', *Hand-Painted Pop: American Art in Transition 1955–62*, p. 142, notes that 'the phrase alludes to his [Johns'] dream; to his recognition that his painting, and maybe all

painting, is nothing more than a fantastic hope; and to René Magritte, whose work he saw at the Sidney Janis Gallery in 1954. Titled "Magritte: Word vs. Image", the exhibition included several versions of the "Ceci n'est pas une pipe" motif.' (For the possible relation of *Flag* to Magritte's *Ceci n'est pas une pipe* see Roberta Bernstein, *Jasper Johns' Paintings and Sculptures 1954–1974*, p. 4.) In my account, these possible references are taken as of no more value than the direct reference to Rodgers and Hammerstein's *Pipe Dream* – the musical.

116 Rachel Rosenthal, in conversation with the author, 9 June 1992, recollected that the studio fire – which was so serious as to need attention by the N.Y. Fire Department – occurred in the winter of 1955.

117 See Joan Carpenter, 'The Infra-Iconography of Jasper Johns', *Art Journal* (Spring 1977), p. 225.

118 I have taken 'rummaging' from Rachel Rosenthal, conversation with the author, 9 June 1992, who recollected that 'we were continually rummaging. It was visual rummaging, tactile rummaging. It was really absorbing the city, in every aspect: all its textures; all the matter that accumulated on the streets; and it all got put into the work one way or another.'

119 Amongst the first commentators on Johns's art, Jean Yves Mock was the only person to discuss it as 'camp'. See his 'Notes from London and Paris', *Apollo* (March 1959), p. 90, where reviewing Johns's show at the Galerie Rive Droite he wrote: 'This exhibition, apart from the flag, also contains pictures of rows of numbers, evenly arranged, in numerical order, some on canvas, some on newspaper, all with a great sense of lovingly nuanced and successfully varied monochrome. These pictures represent a kind of "camp" humour which is as funny as any other kind, I suppose, and is less trying than the seriousness of the pretentious.'

120 Quoted from Andrew Ross, *No Respect* (London, 1989), p. 146. For a brief but useful discussion of 'camp', see Jonathan Dollimore, *Sexual Dissidence: Augustine to Wilde, Freud to Foucault* (Oxford, 1991), pp. 55–8 and 310–12. Rachel Rosenthal, conversation with the author, 9 June 1992, related 'rummaging' to 'camp' via the move away from Abstract Expressionism: 'So, anyway, this business of rummaging, I think, came from those things, and the fact that there was a big reaction against Abstract Expressionism. . . . I think it's that gay sensibility. It used to be called, and still is called, "camp" . . . a certain way of looking at things and accepting things in a very vulgar context of pop culture and of being able to enjoy it and embrace it and recreate it in a flamboyant, witty, humorous and sometimes very sexual manner.'

121 Alan R. Solomon, 'Jasper Johns', *Jasper Johns* (New York, 1964), p. 8; (London, 1964), p. 9.

122 Robert Rosenblum, 'Jasper Johns', *Arts* (January 1958), pp. 57–8.

123 Fairfield Porter, 'Jasper Johns', *Art News* (January 1958), p. 20.

124 Ibid.

125 Ibid.

126 Leo Steinberg, *Jasper Johns* (New York, 1963), p. 8.

127 Ibid., p. 10. 'Contrariety' was changed – weakened – into 'contrariness' when the essay was rewritten and published as 'Jasper Johns: The First Seven Years of His Art' in *Other Criteria*, see p. 25. Max Kozloff, *Jasper Johns*, p. 24, also identified 'contrariety' as one of the 'fundamental premises of Johns' art'.

128 Leo Steinberg, *Jasper Johns* (New York, 1963), p. 10.

129 Ibid., p. 9.

130 Ibid., p. 10.

131 Clement Greenberg, 'After Abstract Expressionism', *Art International* (October 1962), p. 26.

132 Ibid.
133 Ibid.
134 Ibid., pp. 26–7.
135 Ibid., pp. 25–6.
136 Ibid., p. 25.
137 Max Kozloff, *Jasper Johns*, p. 14.
138 Ibid.
139 Ibid., p. 22.
140 Alan R. Solomon, 'Jasper Johns' (New York, 1964), p. 7; (London, 1964), p. 8.
141 Ibid. (New York, 1964), p. 8; (London, 1964), pp. 8–9.
142 Ibid.
143 Ibid. (New York 1964), p. 8; (London, 1964), p.9.
144 'Interview with David Sylvester' in *Jasper John Drawings*, p. 13.
145 Ludwig Wittgenstein (1921/22) trans. D.F. Pears and B.F. McGuiness, *Tractatus Logico-Philosophicus* (London and Henley, 1961), 2.173, p. 10.
146 Ibid., 2.174, p. 10.
147 I have developed this way of explaining *Flag*'s effect from reading the work of Jacques Derrida on signs that have an undecidable value. Derrida gives some examples of 'undecidables' in *Positions*, trans. and annotated by Alan Bass (London, 1987), p. 43. For a useful gloss on this part of *Positions*, see Hugh J. Silverman, 'Writing (On Deconstruction) at the Edge of Metaphysics', *Research in Phenomenology*, XIII (1984), p. 107.
148 Robert Rosenblum, 'Castelli Group', *Arts* (May 1957), p. 53.
149 Emile de Antonio and Maurice Tuchman, *Painters Painting*, p. 102.
150 Philip Fisher, *Making and Effacing Art: Modern American Art in a Culture of Museums* (Oxford, 1991), ch. 3, 'Jasper Johns and the Effacing of Art', pp. 48–89.
151 John Cage, 'Jasper Johns: Stories and Ideas', *Jasper Johns* (New York, 1964), p. 23; (London, 1964), p. 29.
152 Ben Heller, 'Jasper Johns', *School of New York: Some Younger Artists*, pp. 30, 34.
153 Ibid., p. 30.
154 'Interruption' here accords well with Max Kozloff's idea of 'interference' in 'Jasper Johns' (1964), *Renderings: Critical Essays on a Century of Modern Art*, p. 209: 'But it is to misunderstand Johns greatly to suppose him intrinsically interested in his motifs . . . or to think him concerned with new formal discoveries, an idea repudiated by his employment of systems in which every relationship is predetermined. What constantly interferes with either interpretation, and tells you that image is not reality, is a non descriptive bushy activity. Composition-ally all over, but delicately pressured and nuanced, Johns' handling acts as a palpable *interference* to meaning and metaphor.'
 I have taken the idea of 'interruption' from John Hart Ely's 'Comment. Flag Desecration: A Case Study in the Roles of Categorisation and Balancing in First Amendment Analysis', *Harvard Law Review*, 88 (1975), pp. 1502–8, and especially p. 1504, where he opines that in protecting the flag: 'the state may assert an interest – which justifies control over even privately owned flags – similar to that asserted in the case of the interrupting audience. The state's interest in both of these cases might be characterised as an interest in preventing the jamming of signals, an interest not in preventing the defendant from expressing himself but rather in keeping him from interfering with the expression of others. Thus we do not care what the interrupter is saying: all that matters is that he is interrupting another's expression. The flag too is the embodiment of a set of ideas – surely no

one defending against a charge of disfigurement is in a position to
deny *that* – and our case can therefore be seen in much the same light.
The state does not care what message the defendant is conveying by
altering the flag: all that matters is that he is interrupting the message
conveyed by the flag.'
I have taken the idea of 'rowdyism' from this source also; see
p. 1506, where John Hart Ely points out that 'while flag desecration
(and the interruption of speakers as well) can undoubtedly claim a
lengthy historical lineage, the only "tradition" with which the Court is
likely to associate them is a tradition of rowdyism.'

155 Robert Rosenblum, 'Castelli Group', *Arts* (May 1957), p. 53.
156 *The Dada Painters and Poets: An Anthology. The Documents of Modern Art*
9, ed. Robert Motherwell (New York, 1951).
157 *Duchamp Brothers and Sisters, Works of Art*, Rose Fried Gallery, New
York, March 1952; Winthrop Sergeant, 'Dada's Daddy. A new tribute
to Duchamp, pioneer of nonsense and nihilism', *Life* (28 April 1952);
International Dada Exhibition, Sidney Janis Gallery, New York, April–
May, 1953; *Marcel Duchamp, Francis Picabia*, Rose Fried Gallery, New
York, April–May 1953; 'The Dada Movement', *The New York Times*,
Literary Supplement (23 October 1953). For a chronological listing of
exhibitions and reviews, see Robert Lebel, *Marcel Duchamp*, (London,
1959), pp. 182–3, 187–8.
158 *Dada: Monograph of a Movement*, ed. Willy Verkauff (London, 1957).
159 Robert Rosenblum, 'Castelli Group', *Arts* (May 1957), p. 53.
160 *Art News*, 56, no. 9. (January 1958).
161 Ibid., p. 5.
162 Ibid., p. 20.
163 'Art. Trend to the Anti-Art', *Newsweek* (31 March 1958), p. 94.
164 Ibid.
165 Ibid., p. 96.
166 Hilton Kramer, 'Month in Review', *Arts* (February 1959), pp. 48–51, see
p. 49. Kramer's review article prompted a reply from Johns; see
'Letters. "Collage" ', *Arts* (March 1959), p. 7. Johns objected to lots of
things including Kramer's characterisation – as he read it – of
Rauschenberg's work as 'OFFENSE WHICH IS DELIGHT' and his own
work as 'DADA WHICH IS NOT DADA'. He also pointed out, correctly,
that 'a kind of rottenness runs through the entire article'. Johns
commented that Kramer's reference to him and Rauschenberg 'Like
Narcissus at the pool, they see only the gutter' was 'funny and vicious'
– it wasn't funny, and it was vicious.
167 *Fantastic Art, Dada, Surrealism*, exh. cat., ed. Alfred H. Barr Jr; Museum
of Modern Art, New York, 1936 (Arno reprint, 1968), p. 10.
168 Ibid.
169 Before I break with this discussion of Johns and Dada, note his
comment during a panel discussion 'Art 1960', 21 August 1960, New
York University, as reported by Irving Sandler, *The New York School:
The Painters and Sculptors of the Fifties*, p. 195, n. 36: 'The Dadaists were
Dadaists by agreeing to be; it was political rather than stylistic. I am
identified with Dada . . . [because I] use "readymades", but aside from
this, I have little to do with Dada.'
170 See notes 22, 23 and 24 above.
171 See Museum of Modern Art, New York, John Hightower's papers, File
1.3.24, letter from Mildred Constantine, 5 May 1971: 'although
recommended by the collections committee it [*Flag*] was turned down
by the trustees – Ralph Colin being the motivating force here – as
perhaps too cynical a portrayal of the flag, and of course without
regard to the esthetic qualities of the work. In order to save it

eventually for the Museum's Collection, it was purchased by Philip Johnson who has promised it eventually for the Museum.' The context of this remark was the planning of the Museum of Modern Art's *Artist as Adversary* show of 1971.

172 Ibid.

173 See, for example, Philip Fisher, *Making and Effacing Art: Modern American Art in a Culture of Museums*, pp. 54–60.

174 Jacques Derrida, *Positions*, pp. 42–3.

3 *Figuring Jasper Johns*

1 Roland Barthes, 'Reading Brillat-Savarin', Preface to Brillat-Savarin's *Physiologie du goût* (C. Hermann, 1975) in *The Rustle of Language*, trans. Richard Howard, ed. François Wahl (Oxford, 1986), p. 250.

2 Jasper Johns, 'Sketch Book Notes', *Art and Literature* (Spring 1965), p. 192, reprinted in *Pop Art Redefined*, ed. John Russell and Suzi Gablik (London, 1969), p. 84.

3 Alan R. Solomon, 'Jasper Johns', *Jasper Johns*, exh. cat.; The Jewish Museum, New York, p. 18; Whitechapel Gallery, London, p. 24 (New York and London, 1964).

4 For example, ibid., and Roberta Bernstein, *Jasper Johns' Paintings and Sculptures 1954–1974: 'The Changing Focus of the Eye'* (Ann Arbor, 1985), p. 55.

5 Walter Hopps, 'An Interview with Jasper Johns', *Artforum* (March 1965), p. 36.

6 John Cage, 'Jasper Johns: Stories and Ideas', *Jasper Johns*, exh. cat.; The Jewish Museum, New York, p. 22; Whitechapel Gallery, London, p. 28–29 (New York and London, 1964).

7 Edmund Spenser, *The Faerie Queene*, ed. A.C. Hamilton (London, 1980), I, i, 13 (cited in M. Quilligan, *The Language of Allegory: Defining the Genre*, London, 1979, p. 33).

8 Roberta Bernstein, *Jasper Johns' Paintings and Sculptures, 1954–1974*, pp. 146–7, lists 22 sculptures made between 1958 and 1970.

9 Alan R. Solomon, 'Jasper Johns', *Jasper Johns* (New York, 1964), p. 18; (London, 1964), p. 23.

10 Wittgenstein on 'asides' is quoted by Richard Francis, *Jasper Johns* (New York, 1984), p. 6: 'We could easily imagine beings who do their private thinking by means of "asides" and who manage their lies by saying one thing aloud, following it up by an aside which says the opposite' (from *The Blue and Brown Books*, 1959).

11 Richard Francis, *Jasper Johns*, pp. 7–11.

12 Max Kozloff, *Jasper Johns* (New York, 1969), p. 9.

13 Ibid.

14 Ibid.

15 Ibid.

16 Ibid.

17 Ibid.

18 Ibid.

19 Ibid.

20 Ibid., p. 10.

21 Ibid.

22 Ibid., p. 9 and 10.

23 As far as I am aware, the earliest mention of allegory in the literature on Johns is in Leo Steinberg, 'Jasper Johns', *Metro*, 4/5 (1962); revised and published as *Jasper Johns*, New York: Wittenborn (New York, 1963), p. 7; further revised and reprinted as 'Jasper Johns: The First Seven Years of His Art' in *Other Criteria: Confrontations with Twentieth-*

century Art (Oxford, 1972), p. 17, where he asks of *Liar*, 1961: 'Does it mean anything? It need not. It's a device for painting an indispensable word. Or just Painting with a bit of Dada provocation on top (but we are too sly to be had by a four-letter word). Or it's an allegory concerning the hinges that hold life to art.' It might be allegory or it might not. Steinberg's thinking about allegory is confined to this individual picture. It is not extended to inform his understanding of Johns's practice as a whole. However, what Steinberg does write, and the way he writes it, is, of course, very much to the point.

24 G.W.F. Hegel, *Vorlesungen uber die Aesthetik* (Frankfurt am Main, 1970), 13, p. 512, quoted by Paul de Man, 'Reading and History' in *The Resistance to Theory* (Manchester, 1986), p. 68.

25 Maureen Quilligan, *The Language of Allegory*, p. 290.

26 On allegory in general, see Edwin Honig, *Dark Conceit: The Making of Allegory* (1959; New York, 1966); Angus Fletcher, *Allegory: The Theory of a Symbolic Mode* (Ithaca, NY, 1964); Rosemund Tuve, *Allegorical Imagery: Some Medieval Books and Their Renaissance Posterity* (Princeton, 1966); Michael Murrin, *The Veil of Allegory: Some Notes Towards a Theory of Allegorical Rhetoric in the English Renaissance* (Chicago, 1969); David Lodge, *The Modes of Modern Writing: Metaphor, Metonymy, and the Typology of Modern Literature* (Ithaca, NY, 1977); Maureen Quilligan, *The Language of Allegory* (Ithaca, NY, 1979); and Jon Whitman, *Allegory: The Dynamics of an Ancient and Medieval Technique* (Oxford, 1987), whose Appendix 1, 'On the History of the Term Allegory', pp. 263–8, is exemplary.

27 Honig, *Dark Conceit: The Making of Allegory*, pp. 12–14 and Quilligan, *The Language of Allegory*, pp. 97–155.

28 Quilligan, *The Language of Allegory*, pp. 97–8.

29 Ibid., pp. 51–2. Quilligan adapts the idea of the 'threshold text' from Honig's 'threshold symbol'; see Honig, *Dark Conceit: The Making of Allegory*, pp. 71–4.

30 Thomas Elyot, *Bibliotheca Eliotae: Eliotes Dictionarie*, ed. Thomas Cooper (London, 1559), cited in Fletcher, *Allegory: The Theory of a Symbolic Mode*, p. 2 n. 1.

31 Fletcher, *Allegory: The Theory of a Symbolic Mode*, p. 2.

32 See Quilligan, *The Language of Allegory*, p. 26: 'The "other" named by the term *allos* in the word "allegory" is not some other hovering above the words of the text, but the possibility of an otherness, a polysemy, inherent in the very words on the page; allegory therefore names the fact language can signify many things at once.'

33 See Walter Benjamin, trans. John Osborne, *The Origin of German Tragic Drama*, (1977, London, 1985), p. 162, also pp. 175–6, where Benjamin discusses allegory as writing or script as the written word tending towards the visual and opposed, in its lack of organic unity, to the artistic or plastic symbol: 'For sacred script always takes the form of certain complexes of words which ultimately constitute, or aspire to become, one single and inalterable complex. So it is that alphabetical script, as a combination of atoms of writing, is the farthest removed from the script of sacred complexes. These latter take the form of hieroglyphics. The desire to guarantee the sacred character of any script – there will always be a conflict between sacred standing and profane comprehensibility – leads to complexes, to hieroglyphics. This is what happens in the baroque. Both externally and stylistically – in the extreme character of the typographical arrangement and in the use of highly charged metaphors – the written word tends towards the visual. It is not possible to conceive of a starker opposite to the artistic symbol, the plastic symbol, the image of organic totality, than this

amorphous fragment which is seen in the form of allegorical script. In it the baroque reveals itself to be sovereign opposite of classicism, as which hitherto, only romanticism has been acknowledged. And we should not resist the temptation of finding out those features which are common to both of them. Both, romanticism as much as baroque, are concerned not so much with providing a corrective to classicism, as to art itself. And it cannot be denied that the baroque, that contrasting prelude to classicism, offers a more concrete, more authoritative, and more permanent version of this correction. Whereas romanticism inspired by its belief in the infinite, intensified the perfected creation of form and idea in critical terms, at one stroke the profound vision of allegory transforms things and works into stirring writing.'

34 Quilligan, *The Language of Allegory*, p. 25.

35 Fletcher, *Allegory: The Theory of a Symbolic Mode*, p. 2.

36 Whitman, *Allegory: The Dynamics of an Ancient and Medieval Technique*, p. 265.

37 Fletcher, *Allegory: The Theory of a Symbolic Mode*, p. 71.

38 Ibid., p. 84.

39 Ibid. Fletcher is here quoting Quintilian, trans. H.E. Butler, *The Institutes of Oratory*, IX, 2, Sections 44–7.

40 Ibid., p. 85.

41 Ibid., p. 87.

42 Thomas Pynchon, *The Crying of Lot 49* (London, 1979), p. 48.

43 Susan Sontag, 'In Memory of their Feelings' in *Dancers on a Plane: Cage. Cunningham. Johns.* exh. cat.; Anthony d'Offay Gallery, London (1989), p. 23.

44 Nan Rosenthal, Ruth E. Fine with Maria Prather and Amy Mizrahi Zorn, *The Drawings of Jasper Johns*, exh. cat.; National Gallery of Art, Washington, D.C. (1990), p. 244.

45 Andrew Bush, 'The Expanding Eye: The Allegory of Forgetting in Johns and Beckett' in *Foirades/Fizzles: Echo and Allusion in the Art of Jasper Johns*, ed. James Cuno; Grunwald Centre for the Graphic Arts, Wright Art Gallery, University of California, Los Angeles (1987), p. 143, describes the trope in this way: 'The transformation that Johns performs upon his own work engages what is perhaps his own aboriginal trope by which the flat surface of the picture plane is figured forth as a cylinder, or, rendering the cylinder two-dimensionally, a circle. The procedure is most evident in the metonymic displacement of painting to brushes (effect to cause) enacted in the sculpture of the cylindrical Savarin can (but recall the ale cans as well), which comes to be impressed synecdochally (part, rim or base, for whole) upon the surface of the paintings in such circular figures as the stencils in *According to What*, 1964 and the outline in *Dutch Wives*, 1975.'

46 See, for example, the entry on *Untitled*, 1978 in Nan Rosenthal and Ruth E. Fine, *The Drawings of Jasper Johns*, which is very concerned with entomology and metaphor.

47 Richard Francis, *Jasper Johns*, p. 94, and for a different description of the photograph of the Pope at Auschwitz see Nan Rosenthal and Ruth E. Fine, *The Drawings of Jasper Johns*, p. 247.

48 Ajit Mookerjee, *Tantra Art: Its Philosophy and Physics* (Kumar Gallery: New Delhi, New York, Paris, 1966; Basel, 1971), see plate 9, p. 30; the painting is also illustrated in *Tantra*, exh. cat. by Philip S. Rawson; Hayward Gallery, London (1971), no. 237, where it is titled *The Terrible Devatā Samvara who has seventy-four arms, with his female wisdom (sakti) with twelve arms*. Nepal, gouache on cloth, 17th century; it is reproduced in colour in *Dancers on a Plane: Cage. Cunningham. Johns*, p. 8.

49 See *Tantra*, 1971, no. 163, for 'The Principle of Fire, a page from a

manuscript of the Bhagarata Purāna, guache on paper, Rajasthan, 17th century; and no. 50 for the 'Icon of the lingram (phallus) set in the yoni (vulva), the standard emblem of the double-sexed deity as used in shrines as a principal icon; pūjā offerings are laid on it, and the honorific umbrella is broken', gouache on paper, Kangra, Himachel Pradesh, 18th century; both Tantra images are reproduced in Rosenthal and Fine, *The Drawings of Jasper Johns*, p. 248, along with a Kali yantra, Rajasthan, 18th century.

50 Mark Rosenthal, *Jasper Johns: Works Since 1974* (London, 1989), p. 42.

51 See the entry for *Dancers on a Plane*, 1980–81, in *The Tate Gallery 1980–82: Illustrated Catalogue of Acquisitions* (London, 1984), p. 146, and Richard Francis, *Jasper Johns*, p. 95.

52 'Interview with Jasper Johns', in Rosenthal and Fine, *The Drawings of Jasper Johns*, p. 81.

53 Ibid., pp. 81–2. See also Johns cited in *The Tate Gallery 1980–82: Illustrated Catalogue of Acquisitions*, p. 146: 'In "Dancers on a Plane" the frame brackets the painting with symbols of creation and destruction, principles which are central in the Tibetan works.'

54 See Mookerjee, *Tantra Art: Its Philosophy and Physics*, p. 30.

55 Rosenthal, *Jasper Johns: Works Since 1974*, p. 44.

56 *The Tate Gallery 1980–82: Illustrated Catalogue of Acquisitions*, p. 145.

57 See ibid., which points out that ' "Merce Cunningham" indicates the person to whom the picture is dedicated. Johns insists that the work is *for* Cunningham and not *about* him. (Merce Cunningham is America's leading contemporary dance choreographer; he and Johns as his artistic advisor, collaborated for many years.)' Johns did his last work as Advisor for the Merce Cunningham Company in 1978 – Mark Lancaster took over the position in 1980. The *Cicada, Dancers on a Plane* and *Tantric Detail* pictures seem to have a beginning in this moment.

58 Rosenthal, *Jasper Johns: Works Since 1974*, p. 48. Rosalind Krauss, 'Jasper Johns', *The Lugano Review*, 1/2 (1965), p. 97 n. 20, was convinced that *Painting with Two Balls* referred to 'the myth of masculinity surrounding the central figures of abstract-expressionism, the admiration for the violence with which they made their attack on the canvas, and the sexual potency read into their artistic acts.' For more on *Painting with Two Balls* see Ronald Paulson, 'Jasper Johns and Others', *Bennington Review* (April 1978), pp. 70–71.

59 It is worth noting that it is here, when asked about the use of material from Tantra art, that Johns says 'Seeing a thing can sometimes trigger the mind to make another thing. In some instances the new work may include, as a sort of subject matter, references to the thing that was seen. And, because works of painting tend to share many aspects, working itself may initiate memories of other works. Naming or painting these ghosts sometimes seems a way to stop their nagging.' See *The Tate Gallery 1980–82: Illustrated Catalogue of Acquisitions*, p. 146, and Francis, *Jasper Johns*, p. 98.

60 'Interview with Jasper Johns' in Christian Geelhaar, *Jasper Johns: Working Proofs* (London, 1980), p. 44.

61 See Jon Whitman, *Allegory: The Dynamics of an Ancient and Medieval Technique*, 'Appendix II, On the History of the Term "Personification" ', pp. 269–72.

62 Kozloff, *Jasper Johns*, p. 10.

63 This is the gloss that Paul de Man put on our understanding of prosopopeia. The effect can be mortifying. See, for example, de Man's 'Autobiography as De-Facement' in *The Rhetoric of Romanticism* (New York, 1984), p. 78, where he points out, during his reading of Wordsworth's 'Essays upon Epitaphs', that such is 'the latent threat

that inhabits prosopopeia . . . that by making the death [sic] speak, the symmetrical structure of the trope implies, by the same token, that the living are struck dumb, frozen in their own death.'

64 Kozloff, *Jasper Johns*, p. 9.
65 Walter Hopps, 'An Interview with Jasper Johns', *Artforum* (March 1965), p. 36.
66 Johns quoted in Michael Crichton, *Jasper Johns*, p. 43.
67 See 'Conversation. Leo Castelli: "Who Knows When Another Epiphany Will Occur" ', *Art News* (April 1991), p. 75, where Castelli explains that, though he was very involved with the Abstract Expressionists, when he had a gallery he 'tried deliberately to detect that other thing and stumbled upon Rauschenberg, Johns and Twombly'.
68 Alfred H. Barr Jr, 'Introduction', *The New American Painting*, exh. cat.; Museum of Modern Art, New York (1959; Arno reprint, 1972), p. 19.
69 According to Michael Crichton, *Jasper Johns*, 1977, p. 38, 'Johns denies that his earliest paintings were a reaction to Abstract Expressionism. He says that he didn't know enough, hadn't seen enough, to make such a response.' But note also these two – not necessarily contradictory – recollections of Robert Rauschenberg: (i) 'Jasper and I used to start each day by having to move out from Abstract Expressionism', quoted by May Lynn Kotz in *Rauschenberg: Art and Life* (New York, 1990), p. 90; and (ii) 'We were the only people who were not intoxicated with the abstract expressionists. We weren't against them at all, but neither one of us was interested in taking that stance. I think both of us felt that there was too much exaggerated emotionalism around their art.' in Paul Taylor, 'Robert Rauschenberg: "I can't even afford my works anymore" ', *Interview* (December 1990), p. 148.
70 A. H. Barr Jr, 'Introduction', *The New American Painting*, p. 15.
71 Ibid. For glimpses of the 'scene' at the Cedar Bar see Irving Sandler, *The New York School: The Painters and Sculptors of the Fifties* (London, 1978), pp. 30, 32, and 33; see also Jonathan Katz, 'The Art of Code: Jasper Johns and Robert Rauschenberg' in *Significant Others: Creative Partnerships in Art and Literature*, ed. Whitney Chadwick and Isabelle de Courtivron (London, 1993), pp. 192–4.
72 Max Kozloff, *Jasper Johns* (New York, 1969), p. 31.
73 Roberta Bernstein, *Jasper Johns' Paintings and Sculptures 1954–1974*, p. 54.
74 See Jonathan Katz, 'The Art of Code: Jasper Johns and Robert Rauschenberg', *Significant Others*, p. 197. See also *The Dancer and the Dance: Merce Cunningham in Conversation with Jacqueline Lesschaeve* (London, 1985), p. 150, where Cunningham recollects that 'Occasionally during those years, John Cage, Bob Rauschenberg, Jasper Johns and I would have dinner together in a bar on University Place, not the old famous Cedar Bar where Willem de Kooning, Franz Kline and the abstract expressionists would go.' David Revill, *The Roaring Silence. John Cage: A Life* (London, 1992), p. 184, tells us that 'their haunts included the San Remo bar in the village'.
75 See note 45 above.
76 Michael Crichton, *Jasper Johns*, p. 19.
77 Roberta Bernstein, *Jasper Johns' Paintings and Sculptures 1954–1974*, p. 223 n. 9, who also informs us that a photograph of it appears in Johns's lithograph and painting, *Decoy*, 1971.
78 *Anchorage* and *relay* come into my text from Roland Barthes's 'Rhetoric of the Image' (1964) in *Image, Music, Text*, ed. and trans. Stephen Heath (Glasgow, 1977). *Author-function* comes from Michael Foucault's 'What is an Author?' (1969), *Language, Counter-Memory, Practice: Selected*

Essays and Interviews, trans. Donald F. Bouchard and Sherry Simon (Oxford, 1977).

79 See note 60 above.

80 Mark Stevens and Cathleen McGuigan, 'Super Artist: Jasper Johns, Today's Master', *Newsweek* (22 October 1977), pp. 38–44.

81 See also the photograph of Johns in front of *Between the Clock and the Bed*, 1981, (collection of the artist) on the cover of the *New York Times Magazine* (19 June 1988). The title of *Between the Clock and the Bed* works as a hinge between the surface it names and Edvard Munch's painting of the same name. The title of Munch's painting *Between the Clock and the Bed* of 1940–42 (Munchmuseet, Oslo) directs our attention to what is between the clock and the bed, the artist (78 years old with two years to live) and some pictures (his own maybe) visible on a wall in an adjoining room (his studio maybe). But what is there in Munch's picture is absented from its title; which is to say, the objects absented from the title are there in the picture – in particular Munch himself. Evidently Johns had been struck by the coincidence between the pattern on the bedspread in Munch's picture and his own crosshatchings – that's the story – and used the title *Between the Clock and the Bed* as the title of his own work. The photograph of Johns in front of his own *Between the Clock and the Bed* on the cover of the *New York Times Magazine* puts him into the self-portrait place of the picture and in doing so makes clear – as did the photograph that re-presented *Savarin* on the cover of *Newsweek* ten years before – its metonymic significance.

82 Here I had in mind this fragment from Jacques Derrida's 'Restitutions of the truth in pointing [*pointure*]' in *The Truth in Painting*, trans. Geoff Bennington and Ian McLeod (London, 1987), pp. 260–61: 'without even looking elsewhere or further back, *restitution* re-establishes in rights and property by placing the subject upright again, in its stance, in its institution.'

83 Max Kozloff, *Jasper Johns* (New York, 1974), p. 21.

84 Richard Francis, *Jasper Johns*, p. 9, asks 'In *Painted Bronze*, are we to believe that the brushes have been or are about to be used again? – i.e., are they active tools of the artist's imagination or, more darkly, are they embalmed, both impotent and dead?'

85 See Riva Castleman, *Jasper Johns: A Print Retrospective*, exh. cat.; Museum of Modern Art, New York (1986), p. 100, for a 'transitional' *Savarin*, 1978, lithograph and monotype, printed in colour (69.5 × 49.1 cm), collection of Carol and Morton Rapp, Toronto where the wood pattern below the Savarin can has been replaced with a freely brushed skeletal hand and arm making the reference to Munch. For Judith Goldman, *Jasper Johns: 17 Monotypes* (West Islip, NY: ULAE, 1982), unpaginated, who discusses the reference to Munch, death is the subject of *Savarin*. She also notes that 'The Savarin can holds a constant place in Johns' iconography of systems and things. It operates according to its own set of rules. The Savarin can does not travel through the paintings like the Watchman or rotate like the circle . . . wholeness is its chief characteristic.' Goldman also points out that it is always 'head on standing alone'. The personification is clear – see note 63 above.

86 Johns, cited in G.R. Swenson, 'What is Pop Art?', Part 2, *Art News* (February 1964), reprinted in *Pop Art Redefined*, ed. John Russell and Suzi Gablik, p. 82.

87 Johns quoted in Vivien Raynor, 'Jasper Johns: "I have attempted to develop my thinking in such a way that the work I've done is not me" ', *Art News* (March 1973), p. 21.

88 Rosalind Krauss, 'Using Language to do Business as Usual', *Visual*

Theory, ed. Norman Bryson, Michael Ann Holly and Keith Moxey (Cambridge, 1991), p. 88.

89 J.W. von Goethe, *Maximen and Reflexionen* (1824), trans. as 'Reflections and Maxims on Life, Character, Art and Literature' by W.B. Rönnfeldt in *Criticisms, Reflections, and Maxims of Goethe* (London, 1897), pp. 137–261, see particularly pp. 193–4 and 246–7; F.W.J. Schelling, *The Philosophy of Art* (1854), ed. and trans. David Simpson (Minneapolis, 1989), pp. 45–50; and S.T. Coleridge, *The Stateman's Manual; or The Bible The Best Guide to Political Skill and Foresight: A Lay Sermon, Addressed To The Higher Classes of Society* (1816) in *Lay Sermons*, 2nd edn, ed. Henry Nelson Coleridge (London, 1839), pp. 228–31.

90 Coleridge, *The Stateman's Manual*, in *Lay Sermons*, pp. 230–31.

91 Ibid., p. 229.

92 Walter Benjamin, *The Origin of German Tragic Drama*, p. 160. (Of course, the Greek term *symbol* which meant nothing more than what we now call a representative sign or mark, antedates the theological symbol.)

93 Ibid., p. 161.

94 Clement Greenberg, 'Towards a Newer Laocoon', *Partisan Review* (July–August 1940), reprinted in *Clement Greenberg, The Collected Essays and Criticism, Volume 1: Perceptions and Judgments, 1939–1944*, ed. John O'Brian (Chicago, 1986), pp. 23–38; see also 'Avant-Garde and Kitsch', *Partisan Review* (Fall 1939), reprinted in *Clement Greenberg, The Collected Essays and Criticism, Volume 1*, pp. 5–22.

95 Clement Greenberg, 'Towards a Newer Laocoon', *Clement Greenberg, The Collected Essays and Criticism, Volume 1*, p. 29.

96 Ibid., p. 30.

97 Ibid., p. 28.

98 Ibid., p. 31.

99 Ibid., pp. 31–2.

100 Ibid., p. 34.

101 Clement Greenberg, 'Complaints of an Art Critic', *Artforum* (October 1967), reprinted in *Modernism, Criticism, Realism: Alternative Contexts for Art*, ed. Charles Harrison and Fred Orton (London, 1984), pp. 3–8.

102 Clement Greenberg, 'Complaints of an Art Critic', in *Modernism, Criticism, Realism*, p. 7.

103 Clement Greenberg, '3 New American Painters', *Canadian Art* (May–June, 1965), p. 175. Six paintings are illustrated: Kenneth Noland's *Rest*, 1958 (177.8 × 168.2 cm) and *New Problem*, 1962 (176.5 × 181.6 cm); Morris Louis's *Gamma*, 1960 (205.7 × 135.4 cm) and *No. 33*, 1962 (235 × 87.6 cm); and Jules Olitski's *Purple Passion Company*, 1962 (233.7 × 142.2 cm) and *Green Jazz*, 1962 (233.7 × 142.2 cm).

104 For a useful discussion of the 'definite and broad expressionistic side of Greenberg's art criticism' including the 'way art expresses the time, and . . . artist', see Michael Danoff, *Six Apologists for the New American Art*, PhD diss. Syracuse University, 1970 (Ann Arbor: University Microfilms, 1971), pp. 109–17.

105 Clement Greenberg, 'Complaints of an Art Critic' in *Modernism, Criticism, Realism*, p. 4.

106 Clement Greenberg, 'The New Sculpture', *Partisan Review* (June 1949), reprinted in *Clement Greenberg, The Collected Essays and Criticism, Volume 2: Arrogant Purpose, 1945–1949*, ed. John O'Brian (Chicago, 1986), pp. 313–19.

107 Ibid., pp. 315–16.

108 See 'The New Sculpture' in Clement Greenberg, *Art and Culture: Critical Essays* (Boston, 1961), pp. 144 and 145.

109 Ibid., pp. 143 and 144.

110 Ibid., p. 140.

111 Ibid., p. 143.

112 Greenberg was preparing *Art and Culture* for press when he met Anthony Caro in 1959. On the ways Greenberg enabled Caro to align his ambitions with the concerns of advanced art in the Modernist tradition see, for example, Michael Fried, *Anthony Caro*, exh. cat.; Arts Council of Great Britain (London, 1969), pp. 6–8 and Tim Hilton, 'On Caro's Later Work' in *Anthony Caro: Sculpture 1969–1984*, exh. cat.; Arts Council of Great Britain (London, 1984), pp. 60–61.

113 Clement Greenberg, 'Anthony Caro', *Arts Yearbook 8: Contemporary Sculpture*, 1965, pp. 196–209, reprinted in *Studio International* (September 1967), pp. 116–17.

114 Paul de Man, 'The Rhetoric of Temporality' in *Blindness & Insight: Essays in the Rhetoric of Contemporary Criticism*, 2nd edn (London, 1983), p. 208.

115 Johns, cited in Vivien Raynor, 'Jasper Johns: "I have attempted to develop my thinking in such a way that the work I've done is not me".' *Art News* (March 1973), p. 22.

116 Paul de Man, 'The Rhetoric of Temporality', *Blindness & Insight*, pp. 192–3. Note that de Man is reading Coleridge's *The Statesman's Manual*, edited by W.G.T. Shedd (New York, 1875), pp. 437–8, as cited in Angus Fletcher, *Allegory: The Theory of a Symbolic Mode*, p. 16 n. 29.

117 Ibid., p. 192.

118 Ibid., pp. 192–3.

119 Ibid., pp. 200–4.

120 Ibid., pp. 205 and 206.

121 Ibid., p. 207.

122 Hal Foster, 'The Expressive Fallacy', *Art in America* (January 1983), reprinted in *Recodings: Art, Spectacle, Cultural Politics* (Seattle, 1985), pp. 59–77.

123 Hal Foster, 'The Expressive Fallacy', *Recodings: Art, Spectacle, Cultural Politics*, p. 60.

124 Ibid., p. 61.

125 Ibid.

126 Ibid.

127 Ibid.

128 Ibid.

129 Ibid., p. 62.

130 Johns, cited in Vivien Raynor, 'Jasper Johns: "I have attempted to develop my thinking in such a way that the work I've done is not me".' *Art News* (March 1973), p. 22.

131 Peter Fuller, 'Jasper Johns Interviewed', Part II, *Art Monthly* (September–October 1978), p. 7:
Peter Fuller. I once read something by you where you said you tried to make your work 'not me'; you explained that you didn't want to 'confuse my feelings with what I produced.' Why are you so concerned about not letting feelings through?'
Jasper Johns. I think that I either made that quote some time ago, or I intended it to refer to earlier work. Let me put it this way. My feeling about myself on the subjective level is that I'm a highly flawed person. The concerns that I have always dealt with picture-making didn't have to do with expressing my flawed nature, or my *self*. I wanted to have an idea, or an image, or whatever you please, that was not *I* . . . I don't know how to put it. I don't know what supports what. I wanted something that wouldn't have to carry my nature as part of its message. I think that's less true now . . . I don't know whether my work now has by-passed that concern, or includes it, or what. But I don't think that I'd express that thought now.

132 Ibid.
133 Johns quoted in Vivien Raynor, 'Jasper Johns: "I have attempted to develop my thinking in such a way that the work I've done is not me".' *Art News* (March, 1973), p. 22.
134 See Walter Benjamin, *The Origin of German Tragic Drama*, pp. 174–7.
135 Paul de Man, 'The Rhetoric of Temporality', *Blindness & Insight*, p. 207.
136 John Cage, 'Jasper Johns: Stories and Ideas', *Jasper Johns* (New York, 1964), p. 25; (London, 1964), p. 34.
137 Peter Fuller, 'Jasper Johns Interviewed', Part II, *Art Monthly* (September–October 1978), p. 7.

List of Illustrations

21 Marcel Duchamp, *Female Fig Leaf*, 1961 bronze cast of 1950 plaster original, 8.9 × 14.6 × 12.7. Philadelphia Museum of Art, Gift of Mme Marcel Duchamp. © ADAGP, Paris/DACS, London 1994

22 Transilluminated x-ray photographs of illus. 8, *In Memory* Photo: courtesy of Stefan T. Edlis, Chicago

23 *Arrive/Depart*, 1963–4, oil on canvas, 173 × 131. Bayerische Staatsgemäldesammlungen, Munich

24 *Untitled (Skull)*, 1973, silkscreen, from the portfolio *Reality & Paradoxes*, 61 × 83.8. Published by Multiples, Inc, New York. Photo: Universal Limited Art Editions, Inc., West Islip, NY

25 *Study for 'Skin I'*, 1962, drafting paper with powdered graphite, 55.9 × 86.4. Collection of the artist. Photo: Rudolph Burckhardt

26 *Skin with O'Hara Poem*, 1963–5, lithograph, 55.9 × 86.4. Published by Universal Limited Art Editions, Inc., West Islip, NY

27 Illustration for *'In Memory of My Feelings'*, 1967, graphite and graphite wash on plastic sheet, 31.9 × 48.4. The Museum of Modern Art, New York, Gift of the artist. Photo: © 1994 The Museum of Modern Art, New York

28 *Portrait – Viola Farber*, 1961–2, encaustic on canvas with objects, 122 × 157.5. Private collection. Photo: Rudolph Burckhardt

29 Jackson Pollock, *Scent*, 1955, oil on canvas, 198.1 × 146.1. Collection of Larry Gagosian. © 1995 The Pollock-Krasner Foundation/ARS, New York

30 *Weeping Women*, 1975, encaustic and collage on canvas, 127 × 259.7. Private collection. Photo: Leo Castelli Photo Archives

31 Pablo Picasso, *Women of Algiers* (version 'O'), 1955, oil on canvas, 116.8 × 149.9. Collection of Mrs Victor W. Ganz. © DACS 1994

32 René Magritte, *The Literal Meaning*, 1929, oil on canvas, 73.3 × 54.5. Collection of Robert Rauschenberg. Photo: Dorothy Zeidman © ADAGP, Paris/DACS, London 1994

33 René Magritte, *The Six Elements*, 1929, oil on canvas, 77.3 × 99.7. Philadelphia Museum of Art. © ADAGP, Paris/DACS, London 1994

34 *Target with Four Faces*, 1955, assemblage: encaustic and collage on canvas with objects, surmounted by four tinted plaster faces in wood box with hinged front; canvas, 66 × 66; with box closed, 75.6 × 66 × 8.9, with box open, 85.3 × 66 × 7.6. The Museum of Modern Art, New York, Gift of Mr & Mrs Robert Scull. Photo: © 1994 The Museum of Modern Art, New York

35 *Green Target*, 1955, encaustic on newspaper and cloth over canvas, 152.4 × 152.4. The Museum of Modern Art, New York, Richard S. Zeisler Fund. Photo: © 1994 The Museum of Modern Art, New York

36 Alexander Doyle, *Statue of Sergeant William Jasper (Jasper Monument)*, 1879, bronze. Madison Square, Savannah, GA. Photo: Georgia Historical Society, Savannah, GA

37 Detail of illus. 41, *Flag*. Photo: © 1994 The Museum of Modern Art, New York

38 Detail of illus. 41, *Flag*. Photo: © 1994 The Museum of Modern Art, New York

39 Detail of illus. 41, *Flag*. Photo: © 1994 The Museum of Modern Art, New York

40 Detail of illus. 41, *Flag*. Photo: © 1994 The Museum of Modern Art, New York

41 *Flag*, 1954–5, encaustic, oil and collage on fabric mounted on plywood, 107.3 × 153.8. The Museum of Modern Art, New York, Gift of Philip Johnson in honour of Alfred H. Barr, Jr. Photo: © 1994 The Museum of Modern Art, New York

42 *White Flag*, 1955, encaustic and collage on canvas, 198.9 × 306.7. Collection of the artist, on loan to the National Gallery of Art, Washington, DC. Photo: Richard Carafelli

43 Another view of illus. 47, *Painted Bronze*, 1960. Collection of the artist, on loan to the Philadelphia Museum of Art. Photo: Leo Castelli Photo Archives

44 *Flashlight I*, 1958, sculpmetal over flashlight and wood, 13.3 × 23.2 × 9.8 Private collection. Photo: Rudolph Burckhardt

45 *Light Bulb II*, 1958, sculpmetal, 7.9 × 20.3 × 10.6. Collection of the artist, on loan to the Philadelphia Museum of Art. Photo: Rudolph Burckhardt
46 *The Critic Sees*, 1961, sculpmetal over plaster with glass, 8.3 × 15.9 × 5.4. Present location unknown. Photo: Rudolph Burckhardt
47 *Painted Bronze*, 1960, painted bronze, 34.3 × 20.3 diameter. Collection of the artist, on loan to the Philadelphia Museum of Art
48 *Painted Bronze (Ale Cans)*, 1960, painted bronze, 14 × 20.3 × 12.1. Museum Ludwig, Cologne. Photo: Rheinisches Bildarchiv
49 *Untitled*, 1978, watercolour, pencil and ink on paper, 44.5 × 45.7. Private collection. Photo: Dorothy Zeidman
50 Nepalese, 17th century, *The Terrible Devatā Samvara, who has seventy-four arms, with his female wisdom (shakti) with twelve arms*, gouache on cloth, 71.1 × 48.3. Ex-collection Ajit Mookerjee; present location unknown
51 *Cicada*, 1979, watercolour, crayon and pencil on paper, 109.2 × 73. Collection of the artist. Photo: Dorothy Zeidman
52 *Dancers on a Plane*, 1979, oil on canvas with objects, 197.5 × 162.5. Collection of the artist. Photo: Bevan Davies
53 *Dancers on a Plane*, 1980, oil and acrylic on canvas with painted bronze frame and objects, 200 × 161.9. The Tate Gallery, London
54 *Tantric Detail I*, 1980, oil on canvas, 127.3 × 86.5. Collection of the artist. Photo: Eric Pollitzer
55 *Tantric Detail II*, 1981, oil on canvas, 127.3 × 86.5. Collection of the artist. Photo: Zindman/Fremont
56 *Tantric Detail III*, 1981, oil on canvas, 127.3 × 86.5. Collection of the artist. Photo: Bevan Davies
57 *Painting with Two Balls*, 1960, encaustic and collage on canvas with objects, 167.6 × 137. Collection of the artist, on loan to the Philadelphia Museum of Art
58 *Savarin (Whitney Museum)*, 1977, lithograph, 121.9 × 81.3. Published by Universal Limited Art Editions, Inc., West Islip, NY
59 *Between the Clock and the Bed*, 1981, oil on canvas, 183 × 321. Collection of the artist, on loan to the National Gallery of Art, Washington, DC. Photo: Leo Castelli Photo Archives
60 *Field Painting*, 1963–4, oil on canvas with objects, 183 × 93. Collection of the artist, on loan to the National Gallery of Art, Washington, DC. Photo: Rudolph Burckhardt
61 *In the Studio*, 1982, encaustic and collage on canvas with objects, 183 × 192. Collection of the artist, on loan to the Philadelphia Museum of Art. Photo: Steigelman
62 *Untitled*, 1977, lithograph, 69.9 × 101.6. Published by Universal Limited Art Editions, Inc., West Islip, NY
63 *Savarin*, 1977, lithograph, 114.3 × 88.9. Published by Universal Limited Art Editions, Inc., West Islip. NY
64 *Corpse and Mirror II*, 1974–5, oil on canvas with painted frame, 145.3 × 173. Private collection
65 Front cover, *Newsweek*, 24 October 1977. Photo: © Newsweek, Inc. All rights reserved. Reprinted by permission
66 *Untitled*, 1977, ink, watercolour and crayon on plastic, 48.3 × 30.5. Private collection. Photo: Jim Strong
67 *Savarin*, 1977–81, lithograph, 127 × 96.5. The Museum of Modern Art, New York, Celeste Bartos. Photo: Universal Limited Art Editions, Inc., West Islip, NY
68 Kenneth Noland, *Drought*, 1962, acrylic on canvas, 176.5 × 176.5. The Tate Gallery, London. Photo: © Kenneth Noland/DACS, London/VAGA, New York 1994
69 Anthony Caro, *Midday*, 1960, painted steel, 233.1 × 95 × 370.2. The Museum of Modern Art, New York, Mr & Mrs Arthur Weisenberger Fund. Photo: © 1994 The Museum of Modern Art, New York